OUTSTANDING
SPECIAL EFFECTS
PHOTOGRAPHY
ON A LIMITED BUDGET

W9-AHF-437

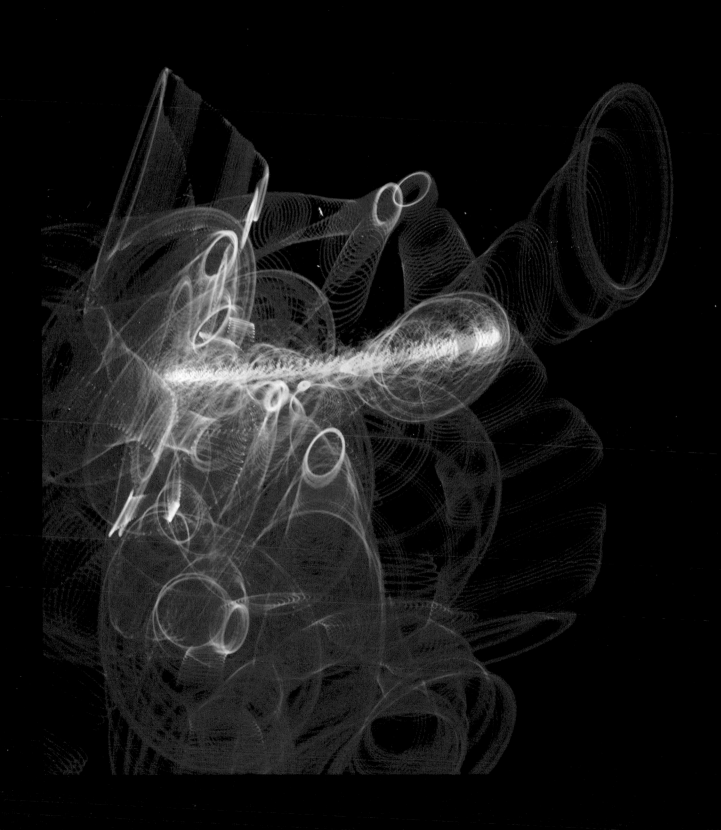

OUTSTANDING
SPECIAL EFFECTS
PHOTOGRAPHY
ON A LIMITED BUDGET

Jim Zuckerman

Cincinnati, Ohio

About the Author

Jim Zuckerman left his medical studies in 1970 to pursue his love of photography. He has taught creative photography at the University of California, Los Angeles and Kent State University in Ohio, but he now prefers to teach seminars and in the field on international photo tours.

Zuckerman is a contributing editor to *Petersen's Photographic Magazine*. His images, articles and photo features have been published in both books and magazines including several Time-Life books, textbooks, publications of the National Geographic Society, Australia's *Photo World*, and Greece's *Opticon*. He is the author of two other books: *Visual Impact* and *The Professional Photographer's Guide to Shooting and Selling Nature and Wildlife Photography*. A third book, *Wildlight*, is due to be published soon.

His work has been used for packaging and for advertising. Zuckerman's images have appeared in calendars and are used on posters. He resides in Northridge, California, and his stock photography is represented by Westlight in Los Angeles.

Outstanding Special Effects Photography on a Limited Budget.
Copyright © 1993 by Jim Zuckerman. All rights reserved. No part of this book may be reproduced in any form or by any electronic or mechanical means including information storage and retrieval systems without permission in writing from the publisher, except by a reviewer, who may quote brief passages in a review. Published by Writer's Digest Books, an imprint of F&W Publications, Inc., 1507 Dana Avenue, Cincinnati, Ohio 45207. 1-800-289-0963. First edition.

Printed and bound in Hong Kong.

97 96 95 94 93 5 4 3 2 1

Library of Congress Cataloging-in-Publication Data

Zuckerman, Jim.
 Outstanding special effects photography on a limited budget / Jim Zuckerman.
 p. cm.
 Includes index.
 ISBN 0-89879-553-2
 1. Photography—Special effects—Handbooks, manuals, etc.
 I. Title.
TR148.Z813 1993
778.8—dc20 93-17148
 CIP

Edited by Mary Cropper
Designed by Clare Finney
Cover illustration by Jim Zuckerman

To my mother, who was my lifelong best friend.

Acknowledgments

I'd like to thank Mary Cropper for her efforts in making this book possible. She packaged the proposal, saw it through the approval process and did a wonderful job in editing the text.

I'd also like to express my appreciation to Terri Boemker, the production editor, for overseeing the project. And to Clare Finney, the book designer, I'd like to say thank you for using your wonderful artistry in making my work look so good.

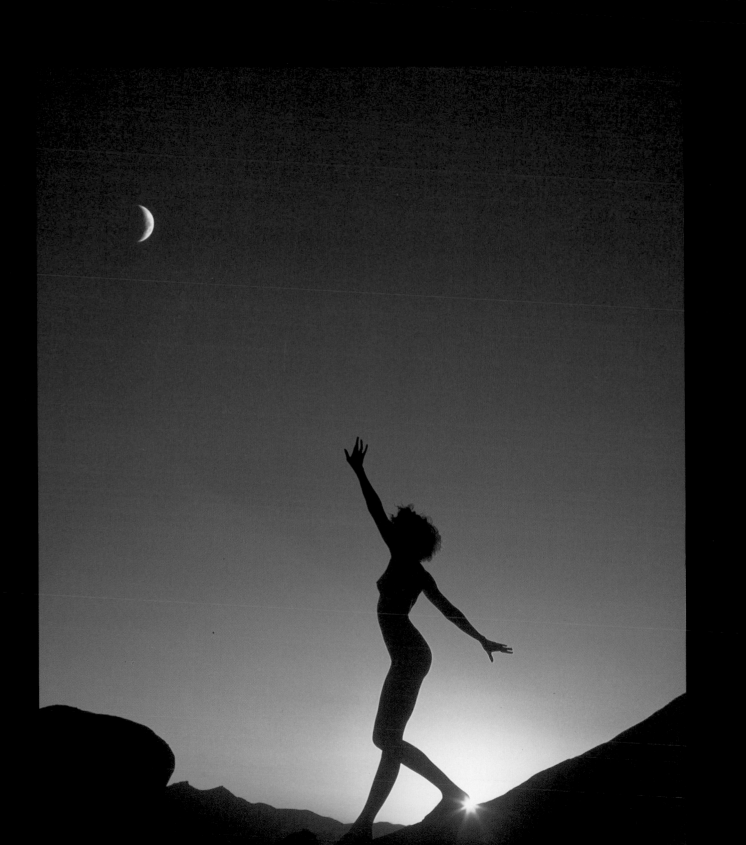

Contents

Introduction

I had owned my first 35mm camera, a Canon FT QL, only six months when I became captivated by special effects. In 1969 I was working for the U.S. Navy in Pearl Harbor as a summer job between college semesters. On an old drydock, I found a piece of red glass that came from a World War II vintage darkroom. I held the glass up to the morning sun and was simply dazzled by the red color. From that moment, I began experimenting with photography by putting all kinds of things in front of my lens—colored cellophane, textured glass, warped pieces of plastic, prisms, sheer fabric, and anything else that caught my fancy. When I look back on those initial efforts, I am amazed at how simplistic many of those images seem when compared to my work today. But that is growth. No one can run before they learn to crawl.

I eventually graduated to more sophisticated techniques, but always within a narrow budget. My first 35mm slide duplicator cost seventy dollars, and I used it for ten years to produce some amazing images. Even today, you can still delve into special effects photography with very modest expenditures. Techniques that look very complex can be achieved with simple equipment that often costs less than a typical 35mm lens. It is also true, however, that for maximum control and high resolution in some cases, more expensive gear can make your life a lot easier.

Most of my work now is done in medium format photography, as you will note in the captions throughout this book. To be competitive in the marketplace and to maintain a high degree of resolution, I prefer the 6x7cm format. But do keep in mind that all of the techniques described in this book can be accomplished with 35mm camera and film. It was in 35mm format that I first learned to master these effects. I hope you will find the techniques described here helpful as you begin or continue creating your own special effects.

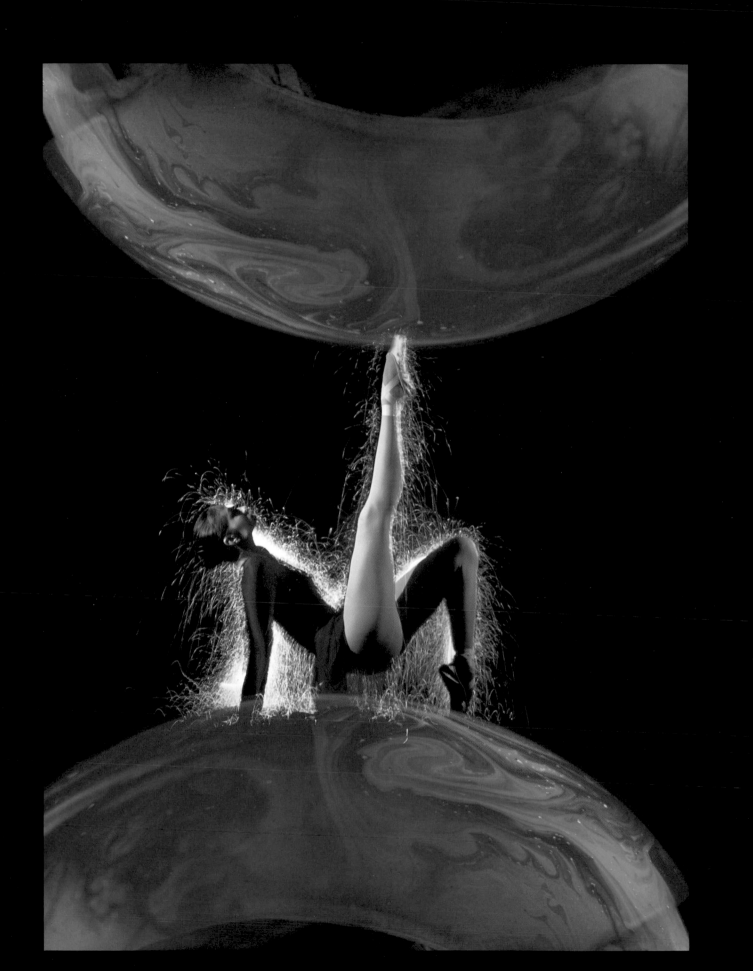

There are two steps in creating photographic special effects images. The first is conceptual. You must see in your mind's eye an image. The second is the actual manipulation of equipment and materials to put this idea on film.

Learning the various techniques described in this book is not difficult. Most of them are straightforward and simple to master. The real challenge is coming up with innovative visual concepts that will produce dynamic photographs. Sometimes ideas will pop into your mind when you don't expect them. They may not be fully formed in your thinking, but once the seed of an idea presents itself, it can be embellished and altered until it pleases you. But there are moments when you are anxious to create a new series of effects and you draw a complete blank.

Even though you can see many unique pictures in this book, I also have days when my creative juices just aren't flowing. Nothing that comes to mind seems worthy of committing to film. Over the years I've developed techniques for working through these periods, and I think it's important to begin this book with some guidelines for helping you develop your creativity.

Where Do Ideas Come From?

This is such a great question—I wish I had a great answer. The truth is I have no inside information where ideas and creativity come from. I frequently feel like a channel, a conduit, through which my photographic concepts flow almost without my express permission. I could just as well be a bystander, watching it happen, amazed at the results.

However, I would like to offer you some powerful techniques for stimulating your own creativity—even if you don't think it's there. Perhaps by following these suggestions the mystery of creativity will be replaced by simple, practical procedures. You can follow these guidelines knowing that, within a short time, visual concepts will begin to form within your consciousness. I still use these techniques myself. Many of the pictures in this book are a direct result of taking my own advice.

Getting the Creative Process Started

Special effects involve one of two scenarios. First, you can artistically manipulate a single image. This can be done in dozens of ways, but no matter how beautiful the photographic technique might be, the original photo should have one important characteristic: It must be able to stand on its own. You cannot take a mediocre image that is weak in composition, poorly exposed, or simply uninteresting and make it great through darkroom manipulation. It should be superb when it comes out of your camera.

This means that you shouldn't take the slide of your family posing in front of the Grand Canyon and attempt to create a work of art with it. You may end up with a successful multiple exposure or zoom blur, but the effect will be the picture. The manipulated snapshot will still be just that—a strange-looking snapshot.

Go through your files and find one of your best images. It could be anything—a portrait, a scenic, a macro shot of a flower, or a classic architectural study. Examine the picture and imagine it turned into a painting. It might look good as a French impressionistic painting or as a moody Renaissance work of art with muted, dark tones. Can you see it in bold neon colors? How about

with a canvas texture or as a negative image with the light and dark values reversed?

Even if you don't know how to accomplish any of these techniques yet, you can visualize many of your pictures rendered in artistic ways. Look through this book, as well as photographic magazines that illustrate special effects, to get ideas of how your pictures might look if they were hand-colored or manipulated dozens of other ways. This exercise will spark the creative process.

The next step is to imagine a composition in your viewfinder as a special effect. Point your camera at objects in your home, your backyard, a national park, or even a studio, and see in your mind's eye a favorite effect that will enhance the subject. Would that tree silhouette on the hill look good if the colors were the reverse of what they are in nature? Can a close-up of a butterfly be hand-colored with fluorescent paints and rephotographed with a black light? Can a portrait of a young model be abstracted with a zoom lens?

The second scenario that will produce a special effect is the combination of two pictures in a final composite. Combining a lovely tree silhouette with a fantastic sunset is an example. Or you can combine several unrelated pictures, such as the Earth and a ballet dancer; or an abstract made with light, a lightning bolt and a model's face.

To combine photographs, whether or not they relate to each other, first create a collection of slides that can be candidates for the many techniques you'll learn. This means knowing which kinds of shots to take.

The first category of pictures you should take are those with lots of color, texture and patterns. This includes almost everything, from the repeating pattern of the windows on a mirrored skyscraper to a heap of dried rose petals. Here are some suggestions:

- bark patterns
- cracked earth in the desert
- reflections in water
- neon lights at night
- macro shot of a feather
- hot-air balloons
- rows of cultivated flowers
- close-up of colorful fabric
- spokes of a wheel

I wanted to create an alien landscape. The sand dunes of Death Valley, California, are perfect because they look like they're on another planet. I took the original photograph of the dunes with an orange Cokin filter covering only the top half of the frame. Because it was placed right over the camera lens, the demarcation between the two halves is out of focus.

A special effects technique, converting the shot into a negative, produced the change in color you see here. Changing the sky to the dark blue also made it possible for me to combine this image with one of a lightning bolt from my files.

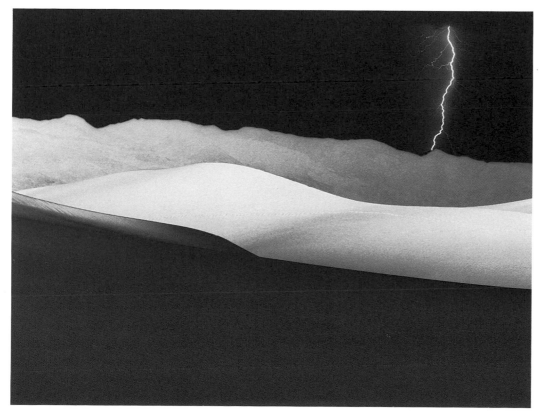

Reducing the size of the lightning image so it would fill only a small portion of the scenic made the two picture elements fit together in a more realistic manner.

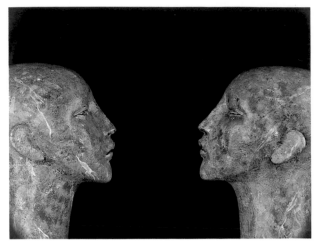

Mannequins are frequently used in conceptual photographs because they can represent men or women of any nationality or group.

I chose this laser abstract to add color.

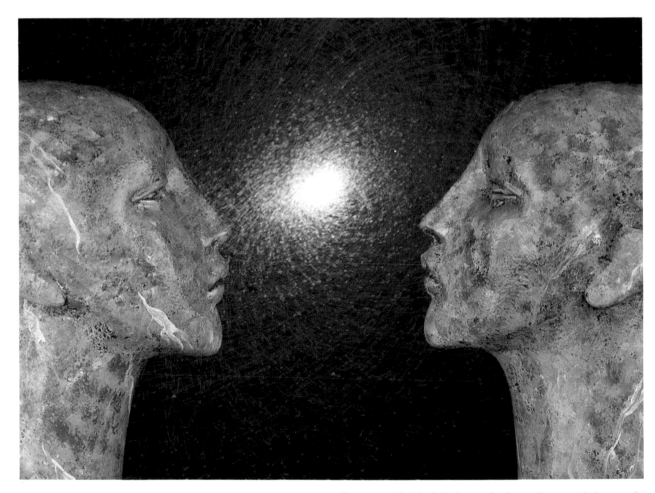

One concept that stock photo agencies frequently request is "communication." Because they always look for new ways to express familiar concepts, I'll submit this new interpretation to my agency. The laser light abstract gives this image the kind of cutting-edge look that agencies want to stay ahead of their competition.

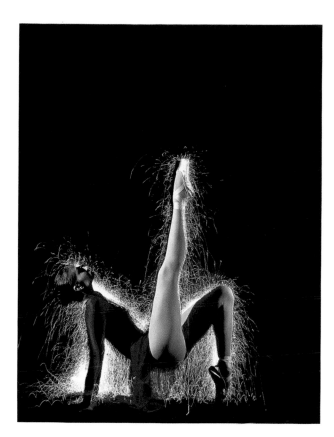

(Left) I liked this picture of the dancer so much that I wanted to combine it with many different images.

(Below left and below) The message of the picture changes considerably, depending on what it's combined with. The image of the dancer with the bubble reinterprets the notion of dance and fluidity, while the dancer balancing Earth on her toe conveys "Earth in the balance." If Earth were large relative to the size of the model, the image would suggest that Earth was burdensome. If it were small relative to the size of the model, that could imply that Earth was insignificant. Making Earth this size is a good compromise between those two extremes.

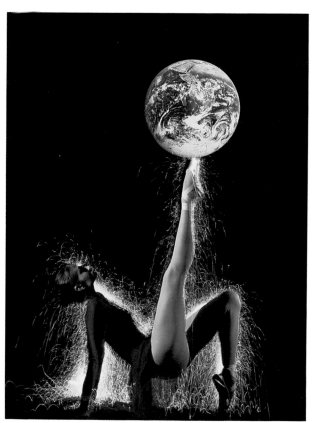

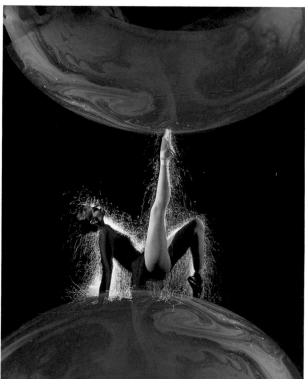

- weathered barn wood
- peeling paint
- several paint colors swirled together
- veins in a leaf
- autumn foliage designs
- fire
- texture of gravel, stucco, brick or sand
- fireworks
- clouds
- pile of black marbles or coffee beans
- large sun, taken with a long lens
- rainbow

All of these images, once they are captured on slide film, can be used over and over again for hundreds of special effects. You probably won't have any idea how or when they'll be used, but as you become more and more immersed in the techniques I present in this book, you will begin to see their value.

The second important category of pictures that you will use repeatedly is those that have a strong graphic shape. For example, any compositionally pleasing silhouette will work, such as a tree on a hill against a bright sky, a dancer's beautiful pose, or a fisherman backlit by intense reflections on a lake. Any time you see objects with a strong design, you have a possibility for a great shot. Just make sure that the main subject is uncluttered by miscellaneous foreground and background elements. Here are some more ideas:

- sports figures — football, baseball, ski jumper, archer, etc.
- classic architecture
- statue
- nude figure
- animals with strong graphic lines, such as a giraffe or elk
- military jet
- hunter being affectionate with his dog
- motorcyclist doing a "wheelie"
- city skyline
- spider web
- sailboats
- dynamic mountain range, such as the Grand Tetons in Wyoming
- birds in flight
- ferris wheel
- American flag

Each of these subjects could produce an entire series of special effects for you when combined with images in the first list. For instance, you could combine the military jet with a large sun, or a statue of Christ with beautiful clouds. A sand texture could be paired with the silhouette of a famous cathedral in Europe, and a motorcyclist might be sandwiched with a shot of fire or fireworks. Once you start collecting all of these elements, the possibilities will jump out at you.

Stimulating Your Creative Juices

The easiest way to help yourself find these combinations is to put a few dozen slides on a large light table. With lots of colors, textures and patterns alongside strong graphic shapes, you will be overwhelmed at the possibilities. To see if two pictures look good together in a sandwich, you can simply hold them in contact with each other to see what happens. For the techniques of multiple exposure, hand-coloring, negative transparencies, kaleidoscopic images and others, you must stretch your imagination. But I can guarantee that you will be excited to discover how many different types of special effects become immediately apparent.

A light table is also an opportunity to look over your collection of images to see what's missing. If you have a large stock of classic city skylines from all over the world, you may want to put a beautiful crescent moon above many of them for dramatic—yet understated—effect. But if you don't have several moons to chose from, you will know which kind of pictures to pursue next.

Being Visually Aware

Photography has taught me to really see things. As I look back on my visual awareness before I picked up a camera, I swear I must have been blind. So much of my environment never made an impact on my consciousness until I started taking pictures.

Heightened visual awareness is crucial for all aspects of photography, but the discipline of special effects requires a different kind of acuity. You must learn to see beyond the data supplied by your eyes. You must see as much with your imagination as with your retina. This doesn't mean that all photographers who produce special effects have a per-

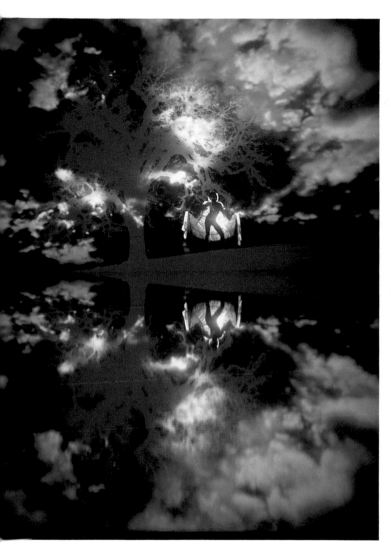

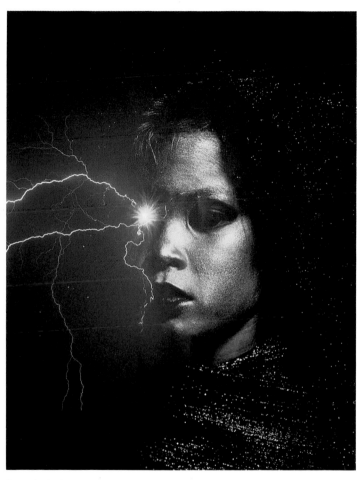

I've created a number of pictures to convey the concept of "mystery" in order to sell some images for book covers. What came to my mind was the ghostlike appearance of a young woman wearing sheer clothes outdoors at night with strong backlighting. I made the shot and then combined it with a surreal background. Once you've mastered some of the techniques in this book, you'll also be able to produce anything you can imagine on film.

Instead of using a normal portrait, I painted the image of the model with a nontoxic metallic powder to give her a mannequinlike quality. I thought this would suggest that she was robotic, with fewer emotions and more brain power. Lightning, or energy of some sort, emanating from a person suggests superhuman powers, such as clairvoyance or spiritual insight.

fect mental image of each picture they create before it's finished. But it does mean that you train yourself to stretch—to imagine—what is possible.

This skill can only come with practice. And the easiest way I can think of to help you develop this ability is to carry with you, as you shoot, several examples of a technique you want to apply. If you are especially interested in hand-colored portraits of children, use the examples in this book and any magazine articles you can find on the sub-ject as visual reminders of what your shots can be turned into. Study a young girl through the viewfinder and see in your mind her dress tinted in a pastel turquoise blue. Imagine the rosy hues you will add to her cheeks and the pale green touch to the eyes. Look at the hand-colored photos you have on hand, and then look at your subject. In a short time you'll be able to visualize the final photograph before it's a reality.

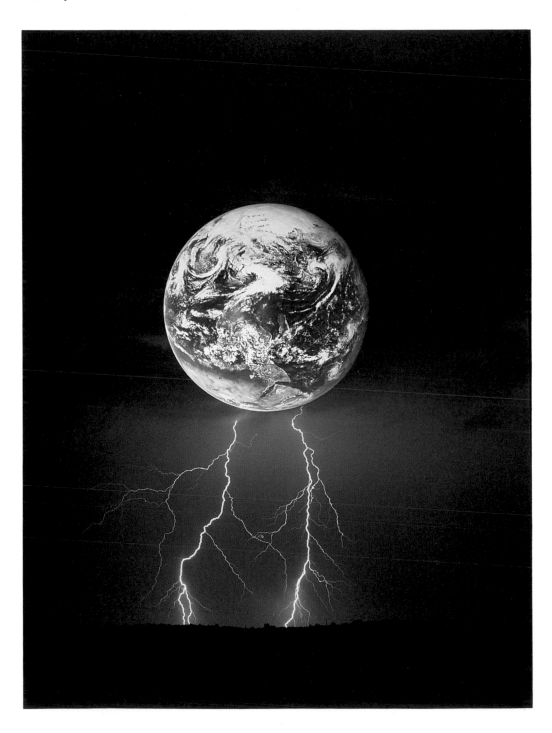

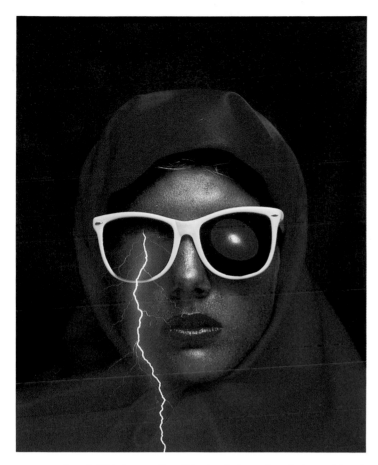

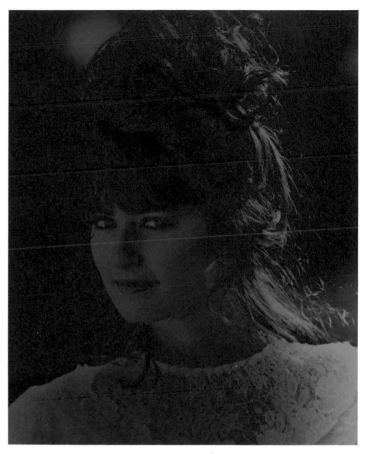

I created this image with nothing in mind except producing an interesting image. I shot the original portrait of the girl with black velvet replacing the glass lenses so I could later superimpose any picture element I wanted into the black. (Another version of this image appears on the cover of this book.) I've also used fireworks, the sun and a star-filled sky.

(Opposite page) The earth's renewable resources are discussed in many circles today. The most powerful and dramatic of these resources is lightning, where the temperature in the channel of a single bolt can be five times the surface of the sun. Lightning is a universal symbol of energy, so I combined these two pictures to show that our planet is fragile—a beautiful blue pearl floating in space—yet quite capable of fending for itself. If, of course, we don't destroy it first.

I was thinking of ways to illustrate an article for a psychology magazine when I created this shot. Using a black light and phosphorescent paint, I created a strange portrait that suggests the inner self. The touch of hot orange in the eyes asks the viewer to look deep into the mind of this woman, to forget superficial qualities and go to the core of her.

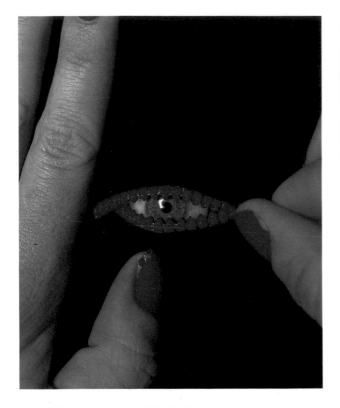

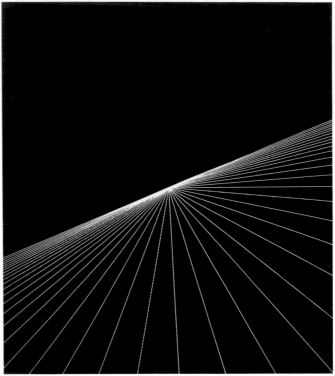

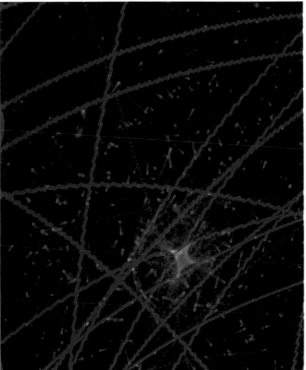

(Above left) Often I create separate components over a period of several months and make a connection between them only on the light table. I had photographed this eye against black velvet using a single strobe head and Photoflex soft box to diffuse the light source. To simulate eyelids around an artificial eye, I bought a red plastic zipper and had a friend hold it in place to frame the eye while I photographed it. I applied opaque with a fine brush to cover unwanted elements in the frame.

(Above right) I often use perspective grids in special effects shots. I drew this one by hand on white poster board and then photographed it onto litho film.

(Left) I took a series of laser light abstracts, including this one, during a commercial laser light show.

(Right) Sometimes I put various picture elements together with no particular message in mind. I do it simply to please myself and no one else. I will lay out many kinds of transparencies on a light table and then let my creative juices flow. These four images were among several dozen on my light table and were combined solely from my love of bizarre imagery. When combining images, I also consider what could be added to a combination to make it more interesting. Here I added the yellow color to the grid while making the final image.

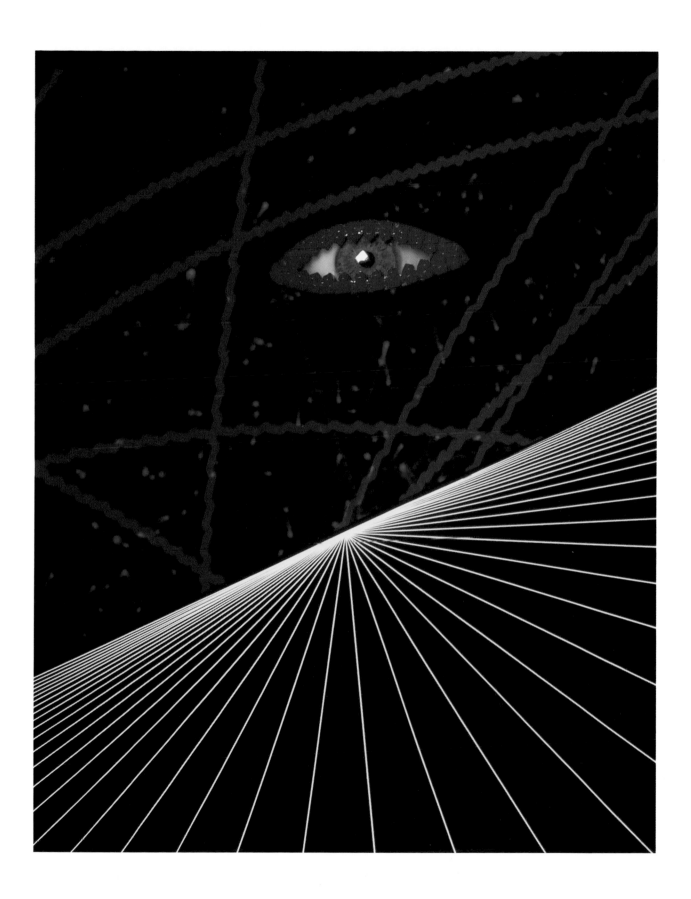

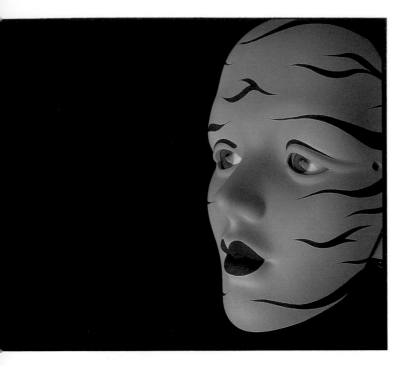

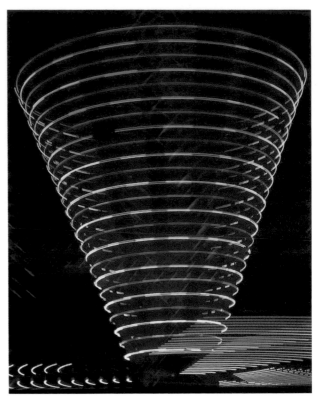

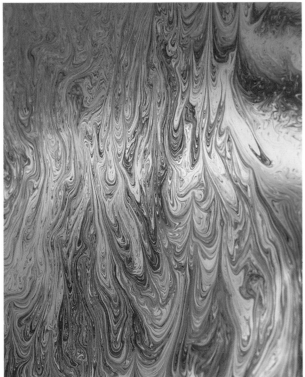

(Above left) When I travel, I always look for interesting picture elements that may work their way into one of my composites. I found this mask in New Orleans. I borrowed two artificial human eyes from a local ophthalmologist and taped them behind the mask. This gives the face a more compelling appearance.

(Above) This light funnel, which is really a time exposure at night of an amusement park ride, reminds me of a TV program in the 1960s called Time Tunnel.

(Left) After I had chosen the mask and the light funnel for a composite, I put streaks of color from this abstract over the mask. The abstract is actually a shot of a soap bubble solution.

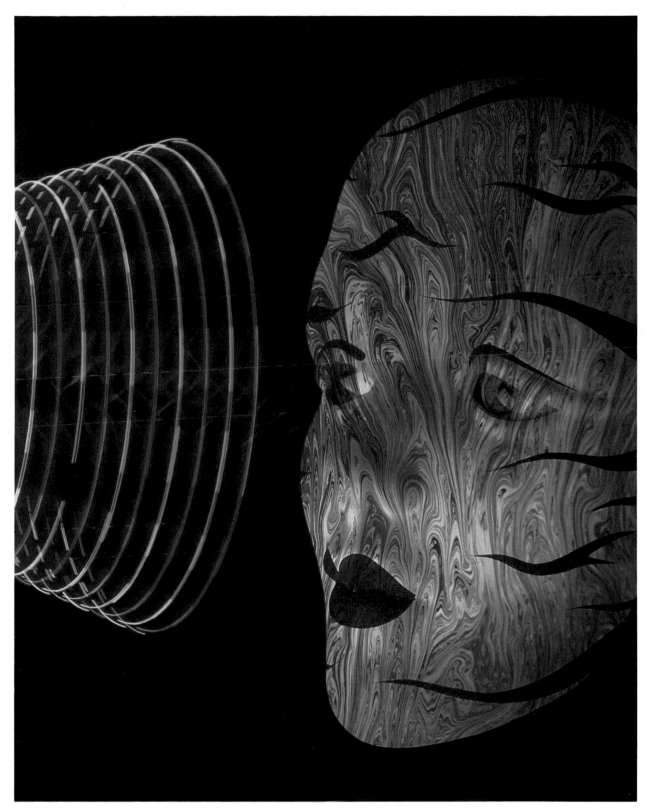

Because the concept "looking into the future" is popular for my stock agency, I created this image. Only the top portion of the funnel could be included, but this gave the impression that the face was looking into something with depth.

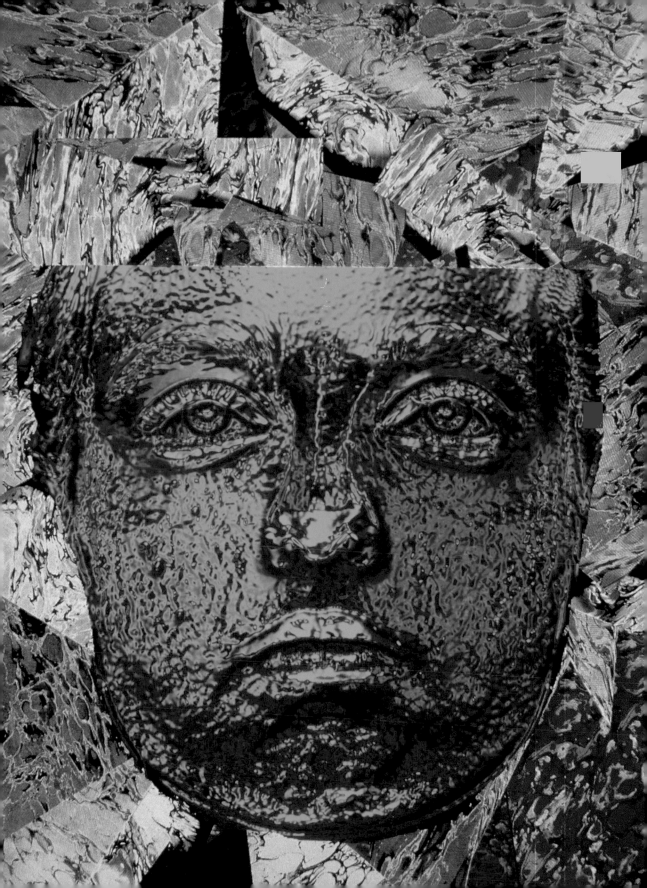

Before you can embark on the adventure of creating your own special effects, you'll need some special, relatively inexpensive equipment that I'll describe in this chapter. You'll also need to master the fundamental technique for creating most special effects—duplicating an image—if you haven't already. It's the basis for most of the techniques you'll learn about in this book.

Although it may seem quite difficult to create special effects, many techniques in this book are easy to learn and use. Most of the shots that I'll demonstrate for you only look complex; they are actually relatively simple to create. Even better, it won't cost much to produce them. Your biggest investment will be time.

Many special effects techniques demonstrated in this book don't require a darkroom, but some do. If you don't like spending hours in the dark or don't want to invest a lot of money in new equipment, custom photo labs will often provide certain types of effects. Just be sure the lab is very clear about what you want. The lab I use in Los Angeles, for example, will do sandwiching, multiple exposures, masking and C-41 processing if I provide the original transparencies with a detailed explanation of what the final image should look like. (If you enjoy the experience of making darkroom magic, however, you'll discover many techniques that will provide countless hours of creativity and self-fulfillment.)

Equipment

To create special effects shots, you'll need to have—and master the use of—some special equipment. But that doesn't necessarily mean an initial big investment. You will probably have several of these items in your camera bag or darkroom already.

Zoom lens. Many interesting special effects can be done with a zoom lens. You should have at least one in your arsenal.

Transparent oils. One of my favorite techniques is hand-coloring black-and-white or sepia-toned prints. A set of Marshall's Photo Oils, which are specially created for photographic work, will open up a whole new world for you. I would also recommend a set of Marshall's Photo Pencils for small areas of a print.

Unicolor easel. An important tool for doing composite images is an inexpensive easel made by Unicolor (see photo top right). It allows you to bypass, in many instances, the laborious task of masking. The plastic dividers that come with the easel are used to cover the dupe film between exposures. Two edges of the 4x5 dupe film are held flat by inserting them under a narrow lip that runs around the periphery of the easel. The opposite two edges are held down by 4x5 and 5x7 plastic dividers. Two 2x3 dividers are used to make the actual composite. One of them covers half of the sheet film while the other half is exposed. When both of the small dividers cover the film, you can turn on the enlarger light for exact placement of the easel under the lens.

Since focusing is critical, you must be careful to do it correctly. You cannot focus on the divider because it is one-eighth inch closer to the lens than the film plane on the easel. With the room lights off and both small dividers in place, I move the easel so the projected image is positioned in the bottom half of the easel (the 5x7 portion). I then remove the 5x7 divider so the transparency in the negative carrier is projected directly on the film plane of the easel. The film itself is still protected from exposure under the two small dividers. I use my grain focuser for critical focusing on the actual grain of the original transparency that is in the negative carrier. Then, I put the 5x7 divider back in place and reposition the easel under the enlarging lens for the first exposure of my composite.

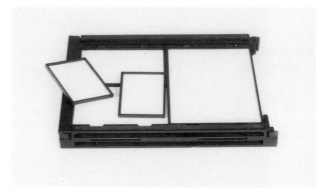

The Unicolor easel I use to make composite images is a simple plastic unit with dividers for covering and uncovering different portions of an 8x10 area. When the original transparencies are projected onto a 4x5 sheet of duplicating film, I can put two 6x7 cm images on one sheet. The two 2x3 plastic dividers you see in the photo are used to make the actual composite. One covers half the film while the other half is exposed. When both dividers cover the film, you can turn on the enlarger light for exact placement of the easel under the lens. The 4x5 and 5x7 plastic dividers help hold down the edge of the duplicating film so it is flat.

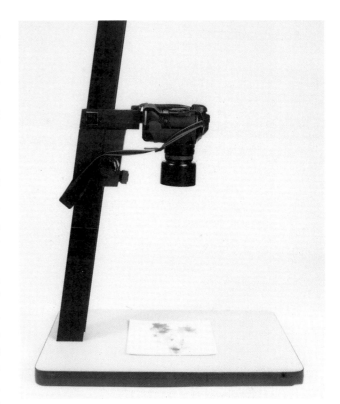

To save myself the expense of buying a separate copy stand, I use the baseboard and column of one of my enlargers. The lamp assembly slides off, and with an accessory screw mount I can tighten the camera right on the column. Two photofloods or two strobes can then be positioned at forty-five-degree angles on either side of the setup.

Then, I change transparencies in the negative carrier and do the exact same thing for the second exposure.

Source of compressed air. This is used to dust original pieces of film before they are either duplicated or combined into a composite. The compressed air is available in cans of various sizes for less than twelve dollars. Depending on how long you make each burst of air, the small cans should allow you to clean perhaps a hundred slides, while the larger ones will give you double that amount. Be careful to hold the can upright when using it; don't tilt it at an angle. If you do, there is a good chance that the chemical propellant will come out with the air and damage a slide.

To avoid this danger, and to save money, I bought a three-foot-high metal canister at an art supply store and had it filled with compressed carbon dioxide. A refill that costs about ten dollars lasts me a year. I use the cheapest airbrush I could find, about eighteen dollars, as the trigger. With a push of my thumb on the valve, I get a sustained and powerful stream of air. The advantages of this type of system over the commercially available cans of compressed air are: (1) it is cheaper over the long run, (2) there are no propellants to accidentally damage your film, and (3) no ozone-destroying CFCs are released into the atmosphere.

Two-hole punch. This tool punches two holes in 4x5 sheet film used in masking, a technique that will be covered in Chapter Seven. The film is positioned on registration pins that keep it in place for the critical alignment of picture elements. The punch is inexpensive and available at art and stationery stores.

Registration pin assembly and pins. Registration pins hold sheet film in place during masking. Two pins are firmly secured with tape onto a smooth surface (usually a piece of glass) to make up the registration assembly. The pins should be set the same distance apart as the two holes of your hole punch. Registration pins cost about five dollars at your local photo supply store.

Copy stand. A copy stand is handy for rephotographing prints, such as in montages or photograms. Most better enlargers can be converted to a copy stand by using the upright calibrated column minus the lamp housing. The camera is mounted on the column using an adapter available through the manufacturer. If you don't have the type of enlarger that can do this, and don't wish to purchase a copy stand, maneuvering your tripod so that the camera can be pointed straight downward to frame at least an 8x10 area will work fine.

Enlarger. If you have or can afford a simple darkroom setup, you'll quickly find many uses for a color enlarger. You don't have to own one to use the techniques in this book; however, if you do a lot of special effects work, it would be a good investment. For example, you can create multiple exposures in-camera or with a duplicator, but I have found that you will have more control over the process with an enlarger. I produced for ten years many kinds of special effects with my 35mm camera and a slide duplicator; now I am committed to the 6x7 format and find the enlarger essential. But I produce—and sell—a lot of special effects work, and I know I'll recover my investment. If you're just starting out in this field, you'll do fine with your camera and duplicator. Some techniques, such as masking, will be harder to control, so you'll have to spend time practicing until you can do them correctly. When I used the 35mm duplicator, there were certain types of effects that took four or five attempts before they were perfect.

Photofloods. These are inexpensive sources of light that will prove invaluable when you start shooting components for special effects. Photofloods are much cheaper than studio strobes and provide continuous illumination that lets you examine the shadows and highlights carefully before you take the picture. Photofloods don't provide as much light as strobes, however, and they do get warm. A model sitting under photofloods will start to perspire, but for tabletop work the heat factor usually is irrelevant.

Studio strobes. Power packs and strobe heads are expensive, but they let you easily photograph many types of subjects for special effects. Make sure that you get strobes with a modeling light, which will give you an approximation of the relationship between the highlights and shadows before you take the shot. The amount of power you should have is ideally at least 1200 watt-seconds. If you make an investment in studio strobe equipment, a flash meter is necessary to determine the proper exposure without making tests all the time.

Filters

A good collection of filters is an invaluable asset. A number of my photographs that have been published in the Stock Workbook (where stock photo agencies publish their best shots) were effects done with nothing more than a simple filter. I carry at least ten with me wherever I travel. The Cokin line of creative filters is excellent, but so are many other brands such as Hoya and Tiffen. Here is a list of filters that I highly recommend:

- Polarizing filter—intensifies colors, increases contrast
- Sunset filter—adds sunsetlike colors to any scene
- Graduated filter—one-half of filter is toned a particular color, the other half is clear; used to add color to a boring, overcast sky without affecting the terrain below. A half-gray/half-clear filter is used to lower the contrast ratio between a brilliant sky and the darker landscape below so you can properly expose both sky and ground in a single shot.
- Diffusion filter—adds diffusion, softens image
- Star filter—turns any point light source into a multipointed starburst
- Color filter—adds impact to colorless scenes; carry a variety with you. These filters are available from Cokin in plastic or from many other manufacturers in glass. Plastic filters are light to carry and are made of optically fine material, but they scratch easily. Handle them with care. I like to carry blue filters to add mood; pink for a shock of color; amber to give a mellow, earth-tone type of look; and orange for silhouettes (and because photo buyers like it).
- FLD filter—prevents most fluorescent and mercury vapor illumination from turning greenish on film
- Fog filter—introduces an ethereal fog quality to scenes

Film

The key to making professional-quality dupes is using film that is specifically made for the duplication process. It is available in 35mm rolls, 70mm in 100-foot rolls (70mm film gives you virtually the same picture area as 120 or 220 film), and 4x5 sheets. This film is unique in two respects. First, it requires a filter pack to achieve a correct color balance. A typical filter pack could be 25M, 42Y (which means 25 units of magenta and 42 units of yellow). This pack is good only for film with a certain emulsion number. When you buy dupe film with another emulsion number, the filter pack will most likely change.

The second unique feature is that duplicating film minimizes contrast gain during the duping process. An increase in contrast means that the highlights of the original are washed out a bit in the dupe, while the shadow areas go too dark—both of which cause a loss of detail. I recommend Kodak 4x5 Ektachrome Slide Duplicating Film 6121, which keeps this contrast problem to a bare minimum.

Litho film is another useful film for special effects work. It is a black-and-white material that renders an image with the maximum contrast possible—all black and all white. There are no gradations of tone. Any original photo, either color or black-and-white, can be turned into a high-contrast image with litho film. You can either work with this material in 35mm or 4x5 and 8x10 sheets.

Film for Originals

I use many slide films in my work for producing original images that are later manipulated. I prefer Fujichrome Velvia for rich, deep colors and a sharp grain structure, although it's too reddish for skin tones. Fuji rates this film at 50 ISO, but its speed is really 40. Therefore, shoot the film at 40 ISO and develop it normally.

I also use Fujichrome 50D and 100D extensively. The latter emulsion is one stop faster but it still offers fine grain and is quite sharp. I have pushed the 100D two stops to 400 ISO and was amazed at how sharp it remained with only a tiny gain in granularity. The 50D emulsion is my film of choice for rephotographing montages, for creating photograms, and for general copy stand work.

When I want to shoot with a grainy film, I go with Agfachrome 1000. This is a very fast transparency film that can be pushed one or two stops. It's low in contrast, and the colors are very muted.

Ektachrome 64 is an excellent film for skin tones in the studio. I don't use this film outside anymore, since Fuji now offers such brilliant col-

ors in its slide films. Fujichrome 64T is my tungsten film of choice for copy stand work when photofloods are used for illumination, as well as when working with the rear projection technique (see pages 46-47). The tungsten-balanced 64T produces proper colors with the quartz lamp of the projector.

The only negative films I shoot now are black and white, when I know the pictures will be hand-colored. I use Kodak's T-Max films, Tri-X, and sometimes black-and-white infrared (with a red filter). For hand-coloring purposes, almost any black-and-white emulsion will work.

Slide Films vs. Negative Films

You may be accustomed to shooting color negative films, such as Kodacolor or Fujicolor, of your family and your vacations. This is fine for making prints of memorable moments that get put in albums and taken out once in a while. But for special effects photography, the only kind of film that makes sense is slide film. Here's why:

1. To make thirty-six prints from one roll of negatives is about twice as expensive as developing a roll of slides.
2. If you put two negatives physically together to combine the images (sandwiching, see Chapter Five), you cannot make any sense of what you've done. The dense orange color of negative films is compounded when two negatives are sandwiched together, so the combination is too dense to see through. Combining two negatives creates nothing more than an unreadable, visual mess. However, physically combining slides is easy to do.
3. The color in slide film is more brilliant than negative film.
4. There are many more slide films than color negative films that offer creative properties such as pronounced grain, exaggerated color saturation and muted tonality.
5. Many special effects techniques, such as rear projection, will only work with slides.
6. For commercial purposes, photo buyers for magazines, books, posters, calendars and greeting cards will usually accept only slides. The best color separations for the printing process are scanned from transparencies.
7. It's easier to learn from your mistakes and

improve your techniques when you shoot slides. Slide film processed in E-6 chemistry is always developed following the same procedure at the photo lab. There is no subjective interpretation on the part of a lab technician. The film and processing specifications are followed as closely as possible for every roll. If your slides turned out poorly exposed or with an unattractive color, you will know that you must correct your technique.

When you make a print from a favorite slide, there is, again, virtually no interpretation of the original. You simply tell the lab to match the colors and the density (exposure value) of the slide.

Negative films are developed in C-41 with the same degree of precision as slide films. But—and here's the critical difference—when the negative is printed on paper, someone or something (some labs are fully automated) in the darkroom interprets it. You can't simply tell the lab to match the negative because you don't want the print to look like the negative. The lab technician or the lab's equipment must subjectively analyze the negative to determine the best colors and exposure for the print. As soon as someone else tries to guess what you want, there is a lot of room for error.

Let me give you some examples of how your artistry can be lost when a print is made from a negative. In night photography, when there are extreme contrasts between the black night sky and city lights, the lab may try to average the exposure between the two. If it does that, the lights become overexposed and the black sky turns into dull gray in the print. In somber, moody scenes such as a Louisiana swamp, when you specifically want to keep the tones dark, a lab will inevitably lighten the print on the assumption that you want a properly exposed image. If you experiment with color and put a warming filter over the lens when shooting a portrait, the lab will probably try to print a neutralized effect to obtain normal skin tone values.

What often happens when you get your prints back from the lab is that you think your experiment with a creative technique failed. This may not be the case. It's quite probable that the lab didn't know what you were trying to achieve. It's also possible that you did make a mistake, but often you won't know whether you did, because it

isn't clear if the problem was with your technique or with the lab's interpretation of your work.

Slide Duplicators

Many types of duplicators are on the market. The least expensive 35mm models simply replace the camera's lens and attach to the camera body. These cost between forty and one hundred dollars. I used this type of unit for many years before I invested in a more sophisticated system. If you invest more money in a duplicator, you will get more sophisticated features, such as a modeling lamp plus a strobe for exposure, built-in filters, greater magnification when cropping, and increased ease of operation. Midpriced duplicators, including the Bowens Copy Tray, Multiblitz, and the Bowens Illumitran 3SC, make both 35mm and medium-format dupes.

I use the Beseler Dual Mode Duplicator, one of the top-of-the-line models, for much more control and convenience in making 35mm, medium-format and 4x5 dupes. This device has a number of important features. The camera is mounted on a calibrated column with a set of bellows that permits very close focusing on the original transparency, giving you considerable flexibility in cropping. When you work with tungsten-balanced films, such as duplicating emulsion, a tungsten lamp that operates with a fan allows you to focus and compose before making the exposure. A flash unit just below the Plexiglas diffusion panel enables you to use a brief exposure time and daylight-balanced film. A built-in dichroic color head permits you to dial in up to 200 units of cyan, magenta and yellow. Combinations of these three colors can make any other color; for example, 20 cyan and 40 magenta produce a reddish purple.

You also can use the enlarger in your darkroom as a duplicating setup. The enlarger projects the original transparency onto 4x5 sheets of duplicating film. If you have an enlarger, you only need a duplicator for 35mm duplicating. Medium- or large-format dupes don't require a specialized unit.

A Homemade Duplicator

You also can make a duplicator quite easily for only a few dollars. You'll need the following materials:

1. A piece of 12"x12" frosted glass or white Plexiglas
2. A box that measures about twelve inches cubed; it can be made out of practically any material
3. A small flash unit
4. A sixty-watt light bulb and socket
5. A black mat with a window cut in it to accommodate the film format to be duplicated

Inside the box, secure the light bulb and socket to the center of the base. Mount the portable flash next to the light bulb, facing up toward the open end of the box. It won't cause problems if either the bulb or flash is not perfectly centered.

Next, place the frosted glass or Plexiglas over the opening in the top of the box to diffuse the light coming up from the base. Position the black mat on the diffusion surface and place a slide over the precut window; you now have a duplicating unit. You can position the mat so that the window is directly over either the bulb or the flash.

Mount your camera on a tripod, or on the calibrated column of a copy stand or an enlarger, and point it toward the backlit slide framed by the mat window. Make sure the film plane in the camera is parallel to the slide being copied for maximum depth of field. You can focus and compose using the light bulb, and then make the final exposure using either the bulb or the flash unit. For correct color balance with each emulsion batch of film used, camera stores sell a pack of color-compensating filters (also called "CC" filters) that can be held in place either in front of the camera lens or on the underside of the diffusion panel. CC filters are not optically superior gel filters, so it is better to place them below the diffusion surface. Tape the CC filters in place or support them with a sheet of clear glass that acts as a shelf.

If the interior of the box gets too warm, use a lower wattage bulb. Several holes for ventilation will help solve this problem, as will a small fan that draws air out of the box.

To determine the proper exposure during duping, use the in-camera meter to get a correct reading when you use the light bulb for the actual exposure. When exposing dupe film with the flash unit, you must conduct a test to determine the lens aperture. Shoot the same original using the flash, bracketing in $1/2$ f/stop increments. For example, if

This inexpensive 35mm slide duplicator replaces the camera's lens and fits right on the body. A T-adapter that screws onto one end of the duplicator enables the device to fit virtually any camera body. A slide is inserted in the end of the unit, and the plastic diffuser at the end spreads the illumination evenly across the transparency. This diffusion is often responsible for eliminating minor scratches seen in the original. The duplicator shown here costs around sixty dollars.

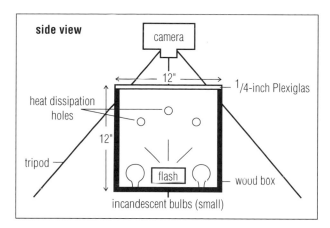

This side-view, cutaway diagram shows you how to assemble a home-made slide duplicator. The top is a 4 1/2 x 5 1/2 inch sheet of 1/4-inch-thick Plexiglas, while the bottom and the three 12-inch-high sides are made of wood. Heat dissipation holes should be cut in two sides of the box. A mat frame can be cut out of matboard to block out light around the slide.

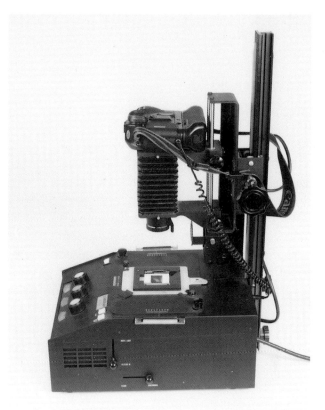

The Beseler Dual Mode Duplicator is a sophisticated unit with a dichroic color head that enables you to dial in any type of color correction, from the most subtle to the most garish. A tungsten lamp permits you to focus and compose, while a built-in strobe gives you the option of a brief exposure time and daylight-balanced film. You can copy slides up to 6x7 cm in size.

you make the first shot at f/4, take the next frame between f/4 and f/5.6, the third test exposure at f/5.6 and so on. When you get the film back from the lab, choose the best exposure for a particular lens aperture. Keep detailed notes so you can repeat good results.

How to Duplicate an Image

One of the fundamental techniques used in this book—and the one that underlies most special effects work—is the duplication of slide film. This permits you to take two or more original images and put them together on another piece of film, creating a composite that is often far more dynamic than the originals were separately. It's important, therefore, that you produce duplicates that are high quality and tack sharp. Soft dupes that fall apart under a loupe or when they're printed or projected will only be a source of frustration to you.

It's true that a duplicate is a second-generation image and therefore is not as sharp as the original components. In some instances, you can bypass the duping process and create a multiple exposure on a single piece of film in the camera. For example, you can use this technique to combine a mannequin's head with a backlit piece of textured glass. You can take both images in the studio. First, expose the mannequin; then, on the same frame, compose the glass and record it over the first exposure.

If you wanted to combine a bolt of lightning with the same mannequin, however, it would be impossible to do this on an original in-camera frame of film. You'll find that many of your combinations fall into this category. That's why it is so important to produce sharp, clean duplicates with a minimum of contrast gain. I've already introduced some of the equipment required for making duplicates. Let me examine each in detail so you can decide which is right for you.

Think "Clean"

A duplicate that is perfect in every way except for a tiny piece of dust photographed with the original is virtually worthless. Learn from the very beginning to make dupes correctly. Take the time to clean them, and you'll save yourself a lot of grief.

Many photographers use the cans of com-pressed air for dusting original pieces of film. If you make very few duplicates, this system works well. But after a while these get expensive because they don't have much capacity. I have found it much cheaper in the long run to purchase a large canister of compressed carbon dioxide. I bought mine at an art supply store. I paid $150, and it stands about three feet tall. I keep it next to my enlarger, and when I need to dust off slides, an air-brush attached to a hose serves as the outlet valve. There is plenty of air pressure to remove even the most stubborn pieces of dust. It only costs me ten dollars to fill the entire container, which provides at least a year of heavy use.

Antistatic brushes and cloths are helpful if you have a problem with static electricity. After a period of time, however, these products lose their ability to neutralize static.

I cannot emphasize enough the need to make clean duplicates. All your efforts will be for naught if your multiple exposures, sandwiches, and other effects that rely on the duplicating process are dirty. They won't look good for projection, you won't be able to sell them, and you won't be proud of your work.

Determining the Correct Filter Pack

You must run a test to determine the correct filter pack to use. The filter pack, which consists of only two colors—yellow and cyan, cyan and magenta, or magenta and yellow—is used in conjunction with the light source to give you accurate colors. It's important to do this, because different photographers and photo labs use many different light sources with duplicating film (unlike other types of films). Hence, the film isn't necessarily balanced for the particular light source you use at home. It's smart to buy several rolls of film (35mm duping film also comes in preloaded cartridges) or several boxes of sheet film of the same emulsion number so you don't have to go through the testing procedure often.

Unlike slide film made for regular use, duping film requires a filter pack, just like color printing paper does. Each roll or box of duplicating film comes from the manufacturer with a recommended filter pack stamped on the box. A typical pack might be 10M and 36Y, which means 10 units of magenta and 36 units of yellow. You can make

your own filter packs by holding between the light source and the enlarging lens "units" made from a set of gelatin filters available in camera stores. It isn't critical that they be scratch-free or optically perfect. As long as the filters aren't between the lens and the slide, they won't affect the resolution of the dupe. If you have an enlarger that won't accommodate filters above the lens, you'll have to hold them in the optical path between the lens and slide. Although this isn't ideal, it will work. Just make sure you handle the filters with great care to avoid dirt and scratches.

When you make your first test, use the manufacturer's recommended pack as a starting point. But I can guarantee that you'll have to alter this recommendation when your test film is developed. Since the light source you use is different from that used by the manufacturer, you will need a slightly different filtration to produce a perfectly color-matched dupe.

A helpful source of information in determining the exact filter pack for a new batch of dupe film is your local photo lab. The lab is accustomed to making slide duplicates and color prints, and someone usually is there who can tell you what you need to fine tune the color match between your original and the dupe. When you get close to a perfect match but are still a little bit off, it's hard to tell without a lot of experience which color to add to or subtract from a filter pack. Don't be afraid to ask for help from people who have been working with color corrections for years.

35mm On-Camera Duplicator

The least expensive, commercially available system for copying slides is a unit that fits right on your 35mm SLR camera. I bought my first one two decades ago from Spiratone in New York and used it for ten years. These duplicators have a built-in lens set at a fixed aperture (usually f/11 or f/16) and a holder on the end that is capable of holding one mounted slide. Because the fixed f/stop usually is so small, you must point the duplicator at a bright light source, such as a photoflood, to garner enough illumination to adequately see the slide.

Sometimes you can squeeze another slide together with the first one and copy a sandwich without taking either transparency out of its

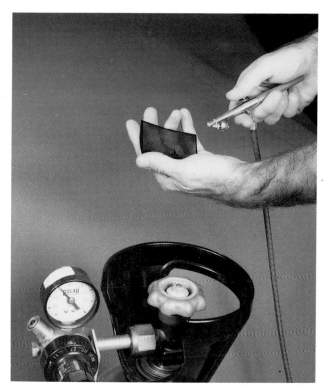

I use compressed carbon dioxide in a tank to blow dust off my transparencies before they are duplicated. One fill-up, costing about ten dollars, lasts me an entire year. The pressure gauge on the top of the tank indicates the force of the air, and the "trigger" I use is actually an airbrush I bought in an art supply store.

When you clean film, hold it a couple of inches away from the air nozzle and blow diagonally across the surface of the slide. Never touch the film with your fingers because you will leave a small amount of oil behind. If there is a stubborn piece of dust that won't be dislodged by several blasts of air, use a static cloth or a fine camel hair brush to remove the speck.

respective mount. Most of the units now permit you to crop an image by enlarging it up to four times.

To make a copy of a slide, simply load the camera with film and point the end of the duplicator toward a light source. There is a translucent, white piece of plastic that diffuses the light and spreads it evenly across the surface of the film. If you want a hot spot for a special effect, simply pull down the diffuser and shoot directly into the light.

If you shoot with daylight-balanced film, the source of illumination can be the sun or a flash unit. For tungsten-balanced film (duplicating film is tungsten balanced), a photoflood works well.

If you use a continuous source of light, such as the sun or a photoflood, with a 35mm on-camera duplicator, the exposure is determined by the camera meter. For flash photography, you'll have to invest one roll of film as a test. Using a portable flash on full power, vary the distance to the end of the duplicator in half-inch increments. For example, begin by placing the flash perhaps six inches away. Use a slide of normal density, and make an exposure. Move the flash to six-and-a-half inches and make a second exposure. Repeat this process until you've finished the roll of film (make sure you use slides). When you get the film back from the lab, determine which flash/subject distance gave the best exposure. That distance is now the standard measurement for normal slides. If you have a darker image that must be lightened, try moving the flash one inch closer to it. This procedure is necessary because the lens inside the duplicator is set at a fixed aperture, usually f/11 or f/16. If you can't vary the aperture to adjust the amount of exposure, the only other method is to change the distance between the flash and the end of the duplicator. The shutter speed you use should be fast enough to avoid picking up ambient light— 1/60th or 1/125th of a second or faster is sufficient.

Duplicators That Offer More Control
Both the midpriced and the top-of-the-line duplicators operate in the same manner. The original slide is placed in the slide holder, the camera is focused on the film plane, and the exposure is made with either the tungsten light source or flash. The proper exposure can't be determined by the in-camera

meter, however, because the camera's lens has been replaced by an enlarging lens mounted on the bellows. (Most electronic camera meters cannot take an accurate light reading without a lens that makes electrical contact with the body.) Therefore, you must use one roll of film as a test in which you bracket in one-half f/stop increments to determine the best settings for the lens aperture. This is true for both the tungsten light source and the strobe unit.

All of these duplicating models can be used under normal room light. However, for exposures in which you use the built-in tungsten bulb, the ambient room light should be dim. Because a typical tungsten exposure is from one second to 1/30th of a second, you don't want the room lights contaminating the exposure during the time the shutter is open.

A high-end model, such as the Beseler Dual Mode Duplicator, has features that give you more control over, and convenience in, making duplicates. You can focus closely on the original transparency, which lets you have great flexibility in cropping. A built-in dichroic color head permits you to dial in up to 200 units of cyan, magenta and yellow to adjust or alter the color of the final image.

A tungsten lamp that operates with a fan allows you to focus and compose before making the exposure. A flash unit just below the Plexiglas diffusion panel enables you to use a brief exposure time and daylight-balanced film. For tungsten-balanced film, such as the duplicating emulsion, you can use the tungsten lamp.

The Beseler unit also features a prefogging device, which is supposed to prevent unwanted contrast gain during the duping process. Personally, I don't find this very useful, and I've disconnected it.

The Enlarger
I use my color enlarger to make duplicates because it offers the maximum flexibility. Most of my multiple exposures involve projecting two or more transparencies, one after the other, onto 4x5 duplicating film that is held by an easel. Instead of committing to an entire roll of film, a photo lab will process a single sheet. Since I have invested in the 6x7 cm system, I can put two images on one 4x5

sheet of duplicating film. Even if you only shoot 35mm, you'll find that many special effects require a bigger piece of film to work with. By projecting the original slides onto the large piece of film, you'll have much more control in creating composite images. Once you have a finished image, you can always reduce it back to 35mm for slide shows.

Making duplicates with an enlarger is different from the other procedures. Instead of placing the original slide on the diffusion surface under the lens, you insert it into the negative carrier of the enlarger above the lens. A 4x5 sheet of dupe film is held in place by an easel, which sits on the baseboard. I use the Unicolor easel that allows the sheet film to be protected from light as the photo is focused and arranged within the 4x5 inch area. Once you do this and dial the correct filtration (based on previous tests) into the dichroic head, set the timer and then you are ready to expose the film.

In total darkness, I remove the easel's protective plastic divider that covers the dupe film (see photo on page 18) and turn on the enlarging light. Duplicating sheet film is much slower than either 35mm or 70mm dupe film, and it therefore requires a longer exposure. A typical exposure for 35mm and 70mm is one second at f/16. For sheet film, my setup requires fifteen seconds at f/16. Again, tests are necessary for both color filter pack and exposure time.

Once the sheet film is exposed, place it into a light-tight box (like the one the film comes packaged in), tape it securely closed, and take it to the lab for developing.

Contact Printing vs. Projection Printing
Thus far, I have discussed the duplicating process only in terms of projecting the original onto dupe film or shooting a transparency with a lens. Contact printing is another option. Working in the dark, you place the original slide physically in contact with the unexposed dupe film. The enlarger's light passes through the original to expose the duplicating stock. You can do this right on the baseboard of the enlarger or on special contact printing easels. In either case, a sheet of thin glass presses down on the two pieces of film to ensure the duplicate is as sharp as possible.

You must test to determine the correct filter pack and proper exposure. The first exposure test will be an educated guess; a local lab can give you initial guidelines. The next exposure test is a correction based on the results. It may take three or four tests until the dupe is perfect, but then you can use that filter pack and exposure data until you buy a new batch of film with new emulsion numbers.

Projection printing offers a major advantage over contact printing. You can keep the original photograph dust-free. It's absolutely critical that you remove all dust from the original before it is copied. When you view a slide either through a camera's lens or a grain focuser in the darkroom, you can examine the entire surface of the film for dust or other imperfections. If you find an unwanted speck, you can remove it before making the dupe. This is no small point. If you've ever felt close to insanity, specks of dust on duplicates can push you over the edge.

During contact printing you must keep six surfaces clean: the top and bottom of both the dupe film and the original, plus both sides of the glass that lies on top of the film. Because the original is placed on the duplicating film in the dark (you can't use even a dim safelight with color film), there is no way of determining if it is dust-free. It's absolutely impossible to consistently make clean dupes in this situation. Even though a contact duplicate is indeed a bit sharper than a projection dupe, the dust problem makes projection printing the better alternative.

I call this chapter "Hand Applications" because the techniques described here are so easy to do. No expensive equipment is required, and no sophisticated understanding of complex darkroom techniques produced any of the pictures illustrated in this chapter.

Hand applications are the cheapest and easiest special effects you can create. They let you invent your own reality as you create colors and even scenes that don't actually exist. The techniques covered in this chapter — changing the film chemistry, zoom blurs, photo montage, hand-coloring photographs and rear projection — all require a minimal investment in equipment and a few materials.

This chapter is placed near the beginning of the book because the images created using these techniques require a minimum of previsualization. Those of you who are accustomed to "taking" pictures (meaning photographing only what you see) as opposed to "making" pictures (creating pictures that initially exist only in your mind) will find it more challenging to begin the process of first creating photographs mentally and then translating these ideas to film. The techniques explained here will introduce you to this kind of thinking.

Changing the Film Chemistry

Most color slide films used today are processed in a line of chemicals called E-6; color negative films are developed in a chemical line called C-41. If you process slide film in C-41 chemistry instead of E-6, the result will be negative slides. Kodachrome, however, is processed in a different chemical line and can't be processed in C-41 with good results.

When you develop slide film into negative images, you'll see major changes in the photograph. First, the light and dark values of the image reverse themselves: Highlights become shadows, and shadows become highlights. Second, the colors revert to their complements. On the color wheel the complement of a color is that color value on the opposite side. Red and cyan are complements, as are blue and yellow, and green and magenta.

Knowing the color wheel means that you can predict which type of effect you'll get when you develop slide film in C-41 chemistry. A typical scenic with a blue sky, puffy white clouds, green vegetation and red flowers will produce the following in negative: The sky will be orange (because a blue sky is not really blue, nor is it cyan. It is between the two hues. Therefore, you will get the opposite color value on the color wheel in between yellow and red, which is orange), the green vegetation will be magenta, and the red flowers will become cyan. The white clouds, of course, will be black.

Most custom photo labs will process slide film in C-41 chemistry for you, or you can easily do it yourself at home. Once you load the film into the developing tank, it's as easy as processing black-and-white negatives.

Long Exposures

Most photography is concerned with rendering each image as sharp as possible. But if you want to imply motion, a classic method of doing so is to use a slow shutter speed while following the subject with the camera as you trip the shutter. The moving subject is slightly blurred, but the background looks greatly blurred because the film sees it as traveling faster. This effect emphasizes a subject's motion and speed and is therefore extremely

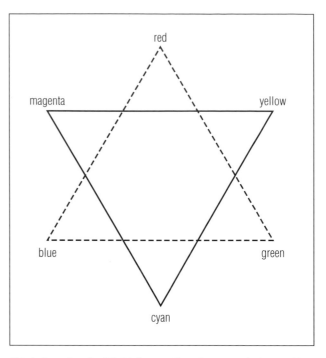

This is the color wheel that influences the colors you get when working with C-41 chemistry. Note that this is not the same color wheel you saw if you took an art class, where red and green are complementary colors. On this color wheel, red and cyan are complementary colors.

(Top left and right) When you develop slide film into negative images, you'll see major changes in the photograph. First, the light and dark values of the image reverse themselves: Highlights become shadows, and shadows become highlights. Second, the colors revert to their complements. This landscape and its negative image illustrate the extreme change that can result from this process. Note how the white snow, the lightest area, has become the darkest area, a deep purple. The yellowish cliff has become blue, and the sky has become orange and magenta.

Technical Data: Original photo—Mamiya RZ 67, 50mm lens, 1/8, f/22, Fujichrome 50D, tripod. Duplicate—Made on Kodak 4x5 Ektachrome Slide Duplicating Film 6121 and developed in C-41.

(Bottom left and right) The kind of film you use will affect the results you get. I used the same colored gels over the strobe heads that illuminated my model in each of these frames. Note the differences in color that resulted when I used different films. The image on the left was shot with Ektachrome 200, the one on the right with Fujichrome 400.

Technical Data: Both frames— Mamiya RZ 67, 110mm lens, between f/16 and f/22. The lighting equipment consisted of two Speedotron flash heads, one covered with a green gel and the other with a magenta gel. In the negative transparency, the green filter produced magenta color and the magenta gel produced green. The exposures were determined by a Minolta Flash Meter IV.

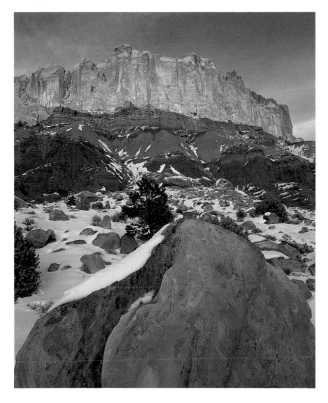

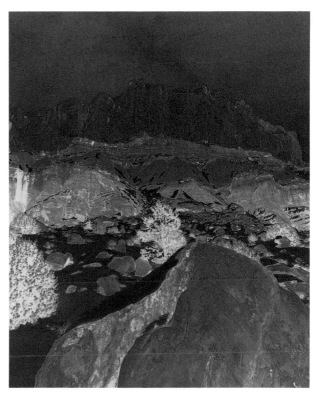

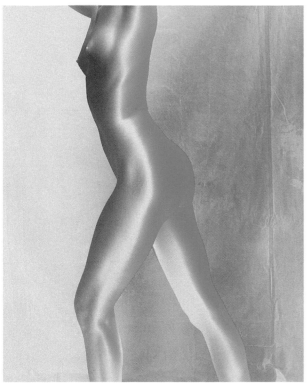

popular in sports photography. It can be quite effective with other subjects, too, such as flying birds or running animals.

A variation on this technique is to keep the camera motionless on a tripod while a subject passes in front of it. With a slow shutter speed, the entire scene will be sharp except for the subject. This isn't just useful for traditional action subjects; it is also effective on rivers and streams, waterfalls, and colorful flowers or autumn foliage blowing in the wind.

Letting the subject blur is especially effective when shooting lights at night. Try capturing the traffic on busy streets where the headlights and taillights create brilliant streaks. Long exposure shots of fireworks create especially beautiful and unusual images. You can combine these often highly abstract shots with other images to create sandwiches (see Chapter Five), montages (see pages 34-36 in this chapter), multiple exposures (see Chapter Six), and when using masking (see Chapter Seven).

The technique for shooting fireworks is simple. With the camera on a tripod, point the lens in the appropriate direction, open the shutter and wait. When one or more fireballs explode, close the shutter. Since fireworks displays occur at night, the film won't be exposed until the explosive

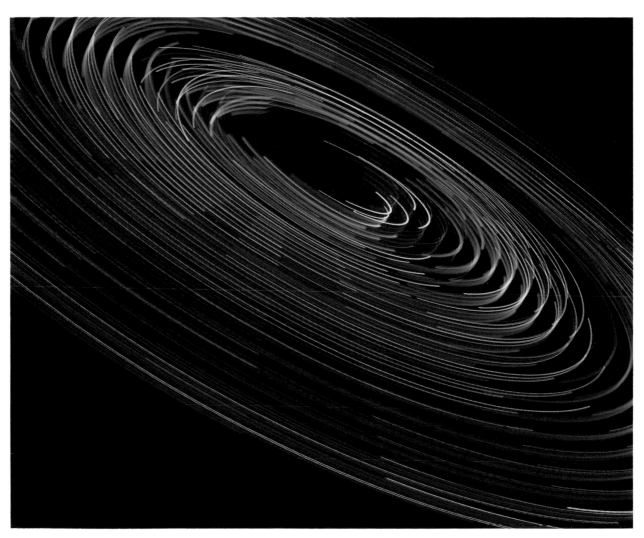

Night abstracts can come in many forms. Traffic patterns are the most common, but amusement parks offer some of the best. This "galactic" design is actually a ride spinning over a ten-second period, leaving a trail of light.

Technical Data: Mamiya RZ 67, 50mm lens, 10 seconds, f/4.5, Fujichrome 50D, tripod.

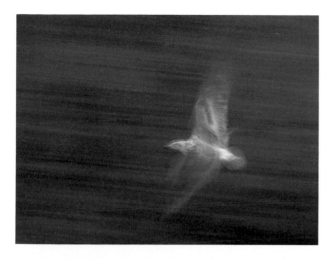

Most photography is concerned with rendering each image as sharp as possible. But if you want to imply motion, a classic method is to use a slow shutter speed (making a long exposure) while following the subject with the camera (panning) as you trip the shutter. The moving subject is slightly blurred, while the background shows a greater degree of blurring because the film sees it as traveling faster. This gull in the San Francisco Bay area was flying past a stand of trees. If a clear sky comprised the background, the result would not have been as effective.

Technical Data: Mamiya RZ 67, 360mm lens, 1/4, f/6, Ektachrome 64, hand-held. This image is enlarged quite a bit from the original to fill more of the frame with the bird.

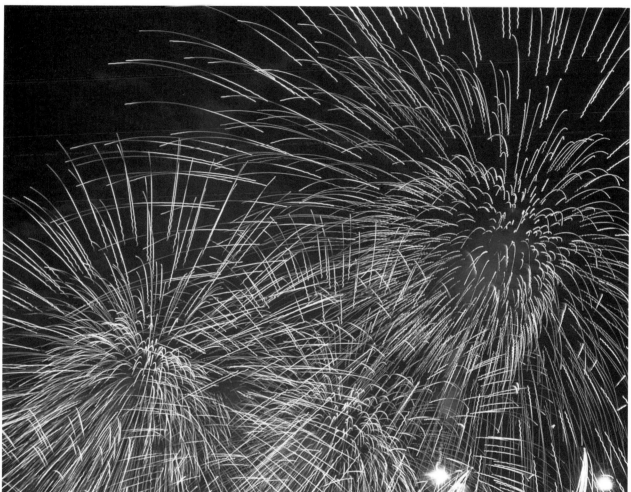

Shooting fireworks is a great way to create unique images for later use in photographic composites. This one was taken from the thirty-seventh floor of a Manhattan apartment building.

With the camera on a tripod, point the lens in the appropriate direction, open the shutter, and wait. When one or more fireballs explode, close the shutter. Since fireworks displays occur al night, the film won't be exposed until the explosive bursts go off. If there is significant ambient light in the sky, you'll have to use a shorter exposure time. Just as the fireworks burst in the sky, open the shutter and keep it open until they are finished, and then close it.

With medium-speed film (ASA 50 to 64), I use f/5.6 if I'm close to

the fireworks action and f/4 when I'm farther away. A medium telephoto—a lens in the 135mm range for 35mm format photography and 250mm for a medium-format camera—is usually adequate, depending on your distance from the action. Each explosive burst covers so much of the sky that a significant part of the frame will be covered.

Technical Data: Mamiya RZ 67, 360mm lens, about 4 seconds, f/6, Fujichrome Velvia, tripod. The maximum aperture on the 360mm lens is f/6. The lens is comparable to a 180mm telephoto in 35mm photography. I used a longer lens than I usually use for shooting the Fourth of July fireworks because I had to crop out a building that was close to the fireworks.

bursts go off. If there is significant ambient light in the sky, such as seen over a large city, you'll have to use a shorter exposure time. Just as the fireworks burst in the sky, open the shutter and keep it open until they are finished, and then close it.

The lens apertures that give the best exposures are f/4 to f/5.6 for medium-speed film (ASA 50 to 64). I use f/5.6 if I'm close to the fireworks action and f/4 when the camera position is farther away. A medium telephoto is usually adequate. Even if you shoot from a distance, each explosive burst covers so much of the sky that a significant part of the frame will be covered with a lens in the 135mm range for 35mm format photography.

Photo Montage

Photo montage allows you to create photographs that are beautiful, humorous, or totally out of this world. Any reality is possible. With no more than two dozen cutout elements in front of you, you can create hundreds of composite images.

Photo montage is an easy and inexpensive effect. All you need are prints of your images, a pair of sharp scissors and a razor knife, a small piece of one-eighth-inch-thick glass, and some means of preserving your new image. This may mean rephotographing it or mounting it on matboard.

Which Images Work Best

The best, and easiest, subjects to use in a montage are those that are easy to cut out. Architecture lends itself to this technique because of the (usually) straight lines of a structure. Flowers such as roses or daisies that have a fairly unified structure work well. Butterflies and other images that have simple silhouettes, such as the silhouette of a person, can be easily used.

Images with complex edges—where there are many tiny details to cut around—can be used, but they will require more work and patience to get an attractive final image. For example, a silhouette of a dancer would work well, but a picture of a woman with frizzy hair would be difficult to use because you couldn't cut around the hair with any accuracy. A silhouette of a winter tree also would be a challenge to use in a montage if the original photo shows much detail of the branches.

Putting the Right Images Together

There are no rules for successful combinations of images, and there are no constraints on your imagination. Anything goes. You can produce montages that are political (the president's head on the body of a homeless person asking for a handout), religious (a cross against a rainbow sky), humorous (three elephants in the front seat of a Volkswagen Beetle), bizarre (a hand coming out of the cracked earth of the desert), or dozens of other possibilities. Some montage concepts may fit together so well that they could be construed to be an unmanipulated photo. Other montages will contain elements that were obviously juxtaposed to produce an artistic expression.

How to Create a Montage

Obviously, the first thing you need are prints of your images from which you'll cut out elements. This doesn't mean that you can't use your transparencies as a source of images, but you'll have to get prints made from them.

You also can create photograms to use in your montages. A *photogram* is an image created by laying objects on photographic paper in the darkroom (or a dark room—a bathroom works well) and then projecting white light through them. You can use paper with emulsion for either black-and-white or color processing, depending on how you want the final image to turn out. In black and white, the paper is negative acting, meaning a negative will produce a positive, and vice versa. If you place your hand on the paper and expose it to light, the result will be an image of a white hand on black paper. Color printing paper I use is positive acting; a negative will produce a negative, and a positive will make a positive.

If you choose opaque items, you get a defined form where the light was blocked from hitting the sensitive emulsion of the printing paper. If you use translucent objects, such as leaves or flower petals, you'll get an image with a soft, transparent look. On colored photographic paper, this will look similar to a watercolor painting; on black-and-white emulsions, you'll get soft shades of gray.

After you've created an attractive arrangement of your elements, use colored markers to darken the edges of the montage pieces so that the edges don't show in the final composite (when you cut

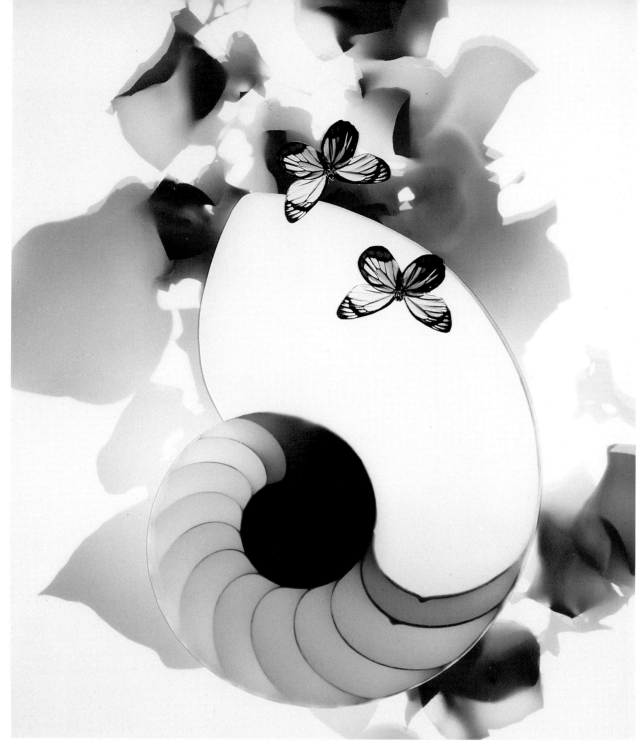

I used three elements to create this photo montage: a macro shot of a butterfly, a color photogram of a seashell, and a color photogram of bougainvillea flowers. I had a local lab make two 4x6 prints from the macro shot and carefully cut the butterfly out of each. Then I used a black marker to darken the edges of the cutouts.

Next I made the photograms. I took a nautilus seashell that had been cut in half. I laid the shell on color photographic printing paper and exposed the print right through the shell with 90 units of color dialed into my enlarger's dichroic color head (you can also achieve this effect by using colored gels the same way you would with a slide duplicator; see page 22). Once I had developed the print, I cut out the shell and colored the edge of the cutout with a yellow marker.

I made the second photogram by placing bougainvillea flowers on 8x10 color printing paper. The projected light from the enlarger went through the petals to make a diffused magenta imprint.

I placed the nautilus shell on the 8x10 print of the flowers. Then I positioned the butterfly prints. To ensure that the cutouts lay flat against the flower print, I placed a one-eighth-inch piece of glass over the entire montage before photographing it. This composition was then rephotographed on slide film with a copy camera.

Technical Data: Shell photogram—Kodak Ektachrome 22 paper, 90 units of color dialed into my enlarger's dichroic color head, 45 seconds, f/5.6. Flower photogram—Kodak Ektachrome 22 paper, 40 seconds, f/5.6. Rephotographed image—Mamiya RZ 67, 110mm lens, and Fujichrome 64T (tungsten-balanced) film to get a proper color balance with the lights. I lit the image with two Speedotron photofloods with a diffusion panel placed over each light source to soften the light, one on each side of the montage. These were placed at forty-five-degree angles to the montage to avoid reflections in the glass.

the paper, the edges are white). It's not crucial that the markers match the colors in the image exactly, since the edge is hardly seen, but they should be close enough to blend the edges with the photo. If you don't attend to this detail, the uncolored edges will be distracting.

To create a permanent, fixed montage you'll need scissors, rubber cement to mount the images, and matboard to mount the images on. To rephotograph montages, you'll need a copy camera (camera mounted on a copy stand, see page 18); something to hold the images perfectly flat against each other; two photofloods mounted on light stands; tungsten-balanced film; and a light meter. It's important to place the elements used in a montage against a firm, flat, smooth surface. (Carpet, for example, doesn't work well.) To hold all the elements perfectly flat against each other when I rephotograph them, I place a one-eighth-inch-thick piece of glass (cleaned very well and free of dust on both sides) on top of the montage design. I take light readings with a Minolta Flash Meter IV (also capable of reading ambient light), although any good TTL meter built into a 35mm camera would work well in most instances.

I place the copy camera directly above the glass, with the film plane parallel to the montage to ensure maximum sharpness. I generally use two photofloods mounted on light stands and placed at forty-five degrees to the plane of the montage, one on each side of the image. This particular angle prevents reflections of the lights in the glass. I use a diffusion panel placed over each light source to soften the light. You can also use strobes or other flash units for lighting, but I find that the photofloods work best because I can see exactly what the results will be before I make the exposure onto film.

Hand-Coloring

You can hand-color a photograph to create the effect, feeling or mood that you want. When you hand-color, you can add colors where none existed—coloring an original black-and-white image—or you can change the colors in an existing scene (by creating a black-and-white print that you then color). You can create realistic effects, where subtle alterations and improvements affect or enhance

I took one of my shots of a butterfly, made a 4x5 print of it, and then carefully cut it out. Then I made an 8x10 print of a small part of a mural I had photographed on a wall in Mexico City. I placed the butterfly cutout on the 8x10 and traced the outline of the insect on the colorful mural detail. When this was cut out, instead of the body of the butterfly I now had a completely different subject within its form.

I placed this one-of-a-kind butterfly on top of an 8x10 print of a laser abstract and rephotographed the montage.

Technical Data: Montage—Mamiya RZ 67, 127mm lens, 1/8, f/11, Fujichrome 64T, and two photofloods with Photoflex diffusion panels set at forty-five-degree angles to the montage.

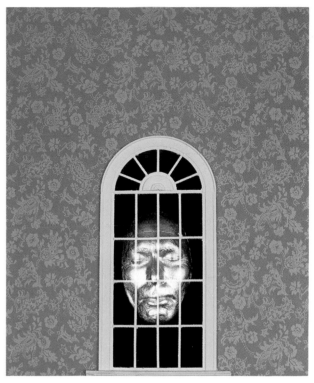

A photo montage can consist of more than photographs. You can even use objects. I created a montage with a dollhouse window that measures about seven inches and wallpaper made specifically for dollhouses. I placed the window on top of a piece of 12x18-inch wallpaper and cut a hole the exact shape of the window in the paper. I could then place photographic prints under the window to create new compositions. In this image I used a picture of an artificial human eye that I had printed as an 8x10 so the eye was big enough for impact.

I used the dollhouse window and wallpaper setup in a second image. This time, I placed an 8x10 print of a plaster mask of my face, painted with gold paint, under the window. It could be easily moved under the window for proper positioning. When I photographed the montage, I did not use glass to flatten the elements. The window had a thickness of about one-eighth inch, and a sheet of glass wouldn't have lain flat.

Technical Data: Plaster mask—Mamiya RZ 67, 110mm lens, Fujichrome Velvia film. Composite—Mamiya RZ 67, Fujichrome 64T (tungsten-balanced) film to get a proper color balance with the lights. I lit the image with two photofloods with a diffusion panel made by Photoflex placed over each light source to soften the light. These were placed at forty-five degrees to the arrangement on opposite sides of it.

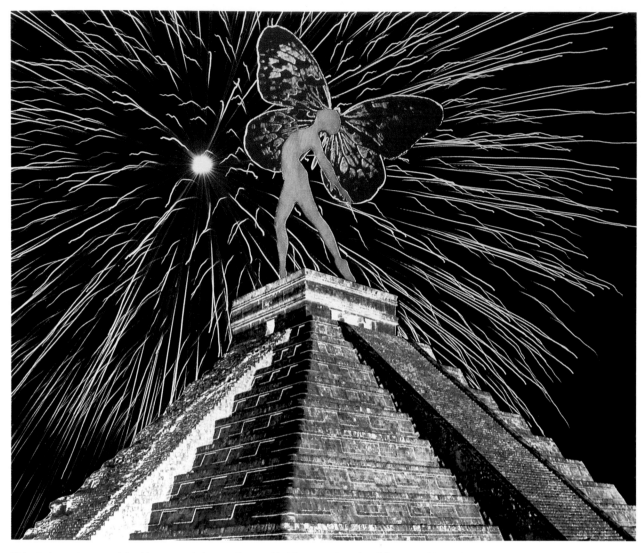

This photo montage consists of four separate images. I assembled them together and rephotographed the arrangement.

A local lab made an 8x10 glossy print of the fireworks shot for me.

The ballet dancer was actually photographed as a silhouette. Since I wanted the dancer to be relatively small in the composition, my lab made a 4x5 print in which the figure was about half of the frame. However, I didn't like the silhouetted dancer positioned against the fireworks because there just wasn't enough contrast between the two images. So, after I cut out the figure from the background, I simply turned the photo over. I colored the back of the white photo paper with a magenta marker and used the colored back instead of the front.

The butterfly slide was turned into a 3x5 black-and-white print that I hand-colored (see pages 36-45 for how to hand-color photographs) with brilliant dyes. It was carefully cut out with a pair of sharp scissors.

The fourth transparency, taken at Chichen Itza in the Yucatan Peninsula of Mexico, was printed in my darkroom onto black-and-white emulsion paper. The normal procedure when making a black-and-white print is to place a negative in the enlarger and then project it onto photographic paper to produce a positive print. I did the reverse. I turned the color slide—a positive —into an 8x10 negative image in black and white. I then cut out the pyramid and arranged it with the other elements.

To make sure that the edges of the montage pieces didn't show in the final composite, I darkened them with different colored markers, depending on the colors in the image. To make sure all four of the elements were perfectly flat against each other when I rephotographed them, I placed a one-eighth-inch-thick piece of glass (cleaned very well and free of dust on both sides) on top of the montage design. The copy camera was placed directly above the glass, with the film plane parallel to the montage to ensure maximum sharpness.

Technical Data: Rephotographed image—Mamiya RZ 67, 110mm lens, Fujichrome 64T (tungsten-balanced) film to get a proper color balance with the lights. I lit the rephotographed image with two photofloods with a diffusion panel made by Photoflex placed over each light source to soften the light, one on each side of the montage. These were placed at forty-five-degree angles to the montage to avoid reflections in the glass.

a photo. When done well, such effects can only be detected by close scrutiny. Soft colors that create a gentle overall effect can enhance the appearance of many subjects. Subtle hand-coloring can add a great deal to a portrait, for example; or you can change a woman's appearance from an understated, natural look to a stylized, high-fashion one. On the other hand, you can alter a photo dramatically by using garish or unnatural colors to startle the viewer. The same is true for landscape work, architecture, and any other type of photography. You can choose a muted look, a more natural rendition, or surrealism.

The Best Images to Hand-Color

Not every subject is suitable for hand-coloring. Unless you want to create a surrealistic landscape, a winter meadow completely covered in monochromatic snow offers few opportunities for creative coloring. Generally, I find subjects with a great deal of detail, such as a woman wearing a print dress or a 1959 Cadillac in front of an old diner, have the most potential as subjects for hand-coloring.

Although most hand-coloring is done on black-and-white prints, you also can add color to, or alter the color of, color prints. This technique is only effective when you want to make an obvious change in the colors of an image; subtle effects usually don't work well.

When you shoot black-and-white film, you may want to consciously seek out images that will work well for hand-coloring. You'll begin to look at many subjects in a new light. You may study the highlights and shadows of a landscape and previsualize how they might be colored. You'll shoot a scene with an overcast sky—even if you wouldn't ordinarily—because you know you can tint the sky to enhance the image or to achieve a unique effect.

Materials, Equipment and Supplies

Hand-coloring requires little special equipment. You'll need a black-and-white print of the image you want to color, a precolor spray to prepare the surface to receive color, and transparent oils and colored pencils to color the image. I usually do my hand-coloring on an 8x10 print. If the print is smaller, it's too hard to work on tiny details. If the print is larger, the image quality can suffer, especially if it was originally shot on 35mm film.

If a local custom lab makes good black-and-white prints, you won't even need a darkroom. Be sure to tell them that you want fiber-based paper, not resin coated (RC) surfaced paper. The surface of fiber paper absorbs the dyes of the colored oils and pencils very well. If you make your own prints, print your black-and-white images on a fiber-based paper as well. Several excellent ones are available. My favorite is Agfa's Portriga, but Oriental, Seagull and Kodak all have excellent fiber papers.

What if you want to "redo" a color image? Since I shoot primarily color transparencies, I've frequently recognized that an image taken in slide form might make a unique hand-colored image. The simple solution to this is to convert the color slide to a black-and-white print. Custom labs offer this service, or you can do it yourself in a darkroom.

To get from color transparency to black-and-white print, first make a black-and-white interneg-ative by copying the slide onto Kodak's Plus-X Pan film to obtain a black-and-white negative. Do this by either projecting the slide from an enlarger onto sheet film and then developing it in a tray, or by using a slide copier. The slide is rephotographed onto the black-and-white film and processed normally. Once you have the negative, make a print as you normally would. If your original is a color print, simply photograph the print onto black-and-white film and then make the print.

I use Marshall's Oil Colors, available in a complete Photo Oils Kit. These oils are produced specifically for hand-coloring photographs and aren't likely to change their colors over time. They also are available as pencils; use Marshall's Photo Pencils or the Design Spectracolor kit. Some people use photographic (retouching) dyes to get more of a watercolor effect, but you can't completely remove these colors from a print if you make a mistake. You can lift a little of a still-damp color with a sponge, but you won't get all of it. If you don't want to purchase a set of photographic oils, pencils or dyes, you can use the translucent markers found in art supply stores. Unfortunately, these won't let you erase your mistakes at all.

(Above) Hand-coloring usually is applied to photographs that were originally shot in black and white, but I originally shot the temple door of the Grand Palace in Bangkok in color. Although it is a lovely picture, I thought the mystique of Thailand could be better communicated through a hand-colored photo.

(Above right) To convert the transparency to a black-and-white print, I first made a black-and-white internegative. I projected the original color slide onto Plus-X Pan Professional Film 4147 in the 4x5 size with an enlarger in the darkroom. The photo was then developed normally and an 8x10 black-and-white print was made. I usually do my hand-coloring on an 8x10. With smaller prints, it's hard to work on tiny details, and larger prints may lose image quality, especially if they were originally 35mm slides. A custom lab can make prints from slides for you.

(Right) I taped the corners of the black-and-white print flat on a table. After lightly coating the print's surface with Marshall's Pre-Color Spray so it would take the color, I began work. I used Marshall's Photo Pencils to apply each color within the small, intricate designs of the glass tiles on the Thai temple. Once the coloring was finished, I photographed the print onto transparency film for use in slide shows and lectures.

Technical Data: Original—Mamiya RZ 67, 50mm lens, 1/125, f/4.5, Fujichrome Velvia, tripod. Rephotographed hand-colored print— Mamiya RZ 67, 110mm lens, f/22, two Speedotron flash heads diffused by Photoflex diffusion panels, Fujichrome 50D.

Preparing the Print for Coloring

Most of my hand-colored images go through a two-step process. First, I immerse the black-and-white print in sepia toner to give the overall image a warm, light brown color. The toner actually replaces the silver in the print, which means that the resulting image is light brown and white instead of black and white. Once the toned print is dried, it is ready to be colored.

Sepia toner is available in most camera stores. It consists of a two-part packet of chemicals—the bleach and the toner—which are dissolved in two separate containers of water to make enough working solution to tone forty 8x10s. The simple instructions on the packet tell you to first immerse the print in water, then in the bleach, followed by a short water wash and, finally, the toner adds the color. All of this takes only a few minutes and the entire process can be done in normal room light.

Coloring Your Image

I use Marshall's Pre-Color Spray to prepare the surface to accept the color. Then I begin coloring, just as children do in coloring books. I use both Marshall's Photo Oils and Marshall's Photo Pencils. The oils come in little tubes, and you usually apply the pigment with cotton swabs. By continually rubbing the print with a clean cotton ball or swab, the color becomes more and more pastel as less of the pigment remains on the photo. For small areas, I wrap a small piece of cotton around a sharpened wooden tool that comes with the set of oils and then use the point to apply color.

Marshall's Photo Pencils offer the maximum control, because they don't smear much beyond the applied area. In addition, you can sharpen them to a fine point.

When you work with oils or the Marshall's colored pencils, you can change your mind without starting over on a new print. If you make a mistake or are just not happy with an entire hand-colored photo, you can simply wipe away all the color with a liquid called Marlene (included in the set of oils), and begin again.

Once the print is finished, it's a simple matter of rephotographing it onto transparency film for slide shows or for reproduction.

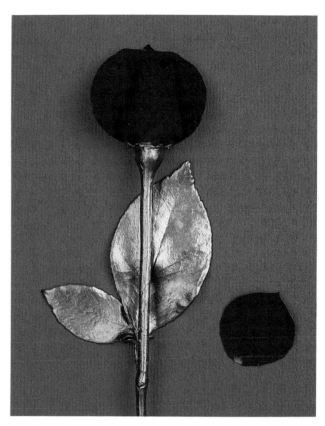

A variation of hand-coloring photographic prints is hand-coloring the actual subject. This rose was carefully trimmed and then the stem and leaves were painted with a metallic copper enamel. I used spray paint to obtain an even coat, and then placed the flower on a piece of art paper with an additional petal to complete the composition.

Technical Data: Mamiya RZ 67, 180mm lens, two Speedotron flash heads and one Photoflex soft box, Fujichrome Velvia.

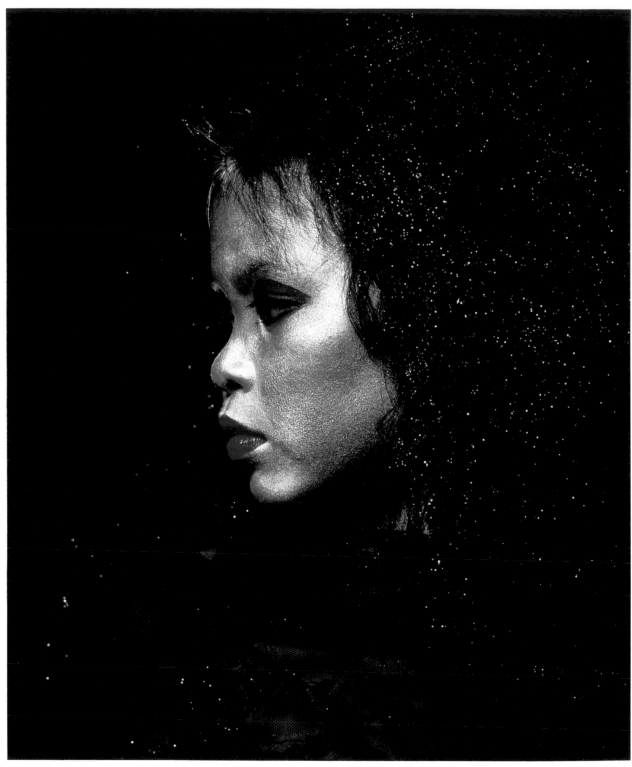

Instead of hand-coloring the young girl's photo, I actually painted her with a mixture of finely powdered aluminum mixed with an oil base to protect the skin. This nontoxic metallic application is available in costume and hobby shops.

Technical Data: Mamiya RZ 67, 180mm lens, one Speedotron flash head and one Photoflex soft box, Fujichrome Velvia.

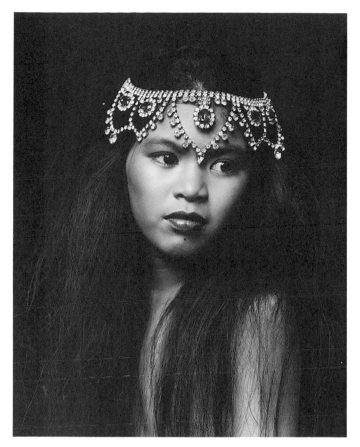

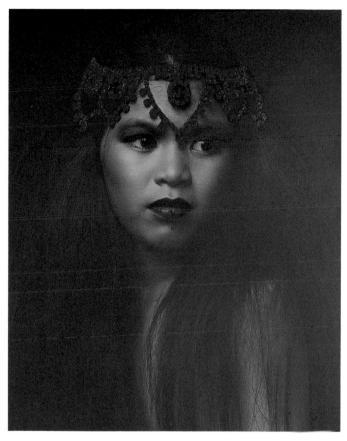

It is not necessary to color every square inch of a black-and-white or sepia-toned print. Sometimes a little bit of color in contrast to monochromatic tones can be quite dramatic. In this portrait I opted to hand-color only the jewels and the makeup with Marshall's Photo Oils. Any more than that, and the simplicity and beauty of the young girl's face would have been overpowered.

I chose this picture to be colored because it is a strong image with no distractions or complexities. I felt the introduction of color would dramatize the beautiful features of the young model. Most hand-coloring is done on images that offer patterns and designs that can be enhanced with lots of color. This shot offered just the opposite. Yet the applied color turns this ordinary portrait into what approaches a painting.

Technical Data: Young girl's portrait—Mamiya RZ 67, 180mm lens, 1/125, f/11, one photoflood, Tri-X film, tripod. Rephotographed hand-colored print—Mamiya RZ 67, 110mm lens, f/22, two Speedotron flash heads diffused by Photoflex diffusion panels, Fujichrome 50D.

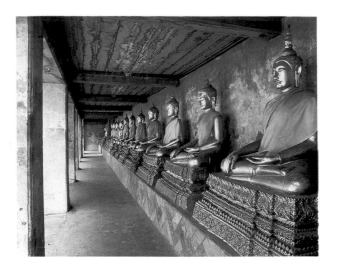

(Right and below) Hand-coloring affords you the freedom to introduce any color in the spectrum into an image, regardless of how closely it resembles reality. Thai Buddhists only wear orange robes, yet in this Bangkok temple I altered the true color to lavender. Don't let convention limit your creativity. Do whatever feels right, and if you don't like it, just wipe away the color and start again.

Technical Data: Corridor of Buddahs in Bangkok—Mamiya RB 67, 50mm lens, 1 second, f/4.5, Ektachrome 64, tripod. Hand-colored print—rephotographed with Mamiya RZ 67, 110mm lens, f/22, Fujichrome 50D, two Speedotron strobe heads using Photoflex white umbrellas for diffusion.

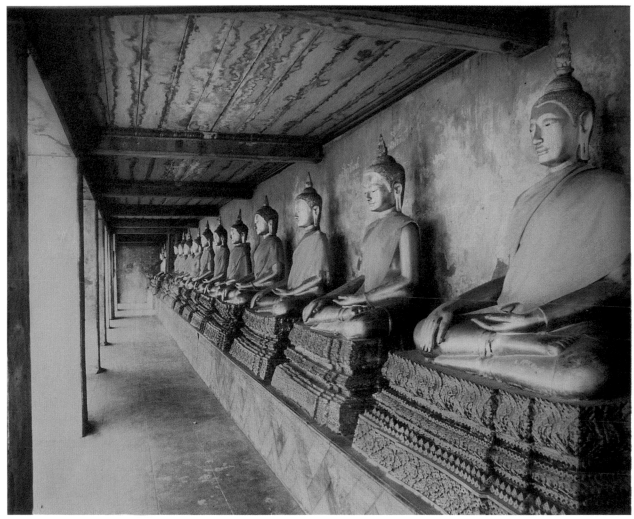

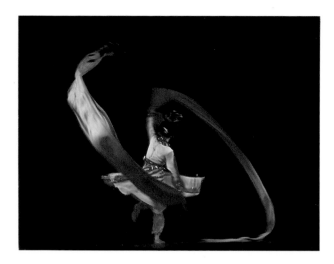

(Left and below) The Chinese ribbon dance is very famous in China. It is graceful, ephemeral and colorful. I was pleased with the original photo taken during a performance in Beijing, but I thought I could express the beauty of the dance from a different point of view.

I made a black-and-white internegative from the original transparency and then printed it on black-and-white paper. However, instead of giving the print the correct development time, I pulled it early. The black background of the stage was rendered gray. During the sepia-toning process, the gray turned brown. When I applied the transparent oils, I smoothed out the color with cotton swabs just enough to be saturated.

Technical Data: Original shot of ribbon dancer—Mamiya RB 67, 180mm lens, 1/30, f/4.5, Ektachrome 160T pushed one stop to 320 ISO. Rephotographed hand-colored print—Mamiya RZ 67, 110mm lens, f/22, Fujichrome 50D, two Speedotron flash heads and Photoflex diffusion panels.

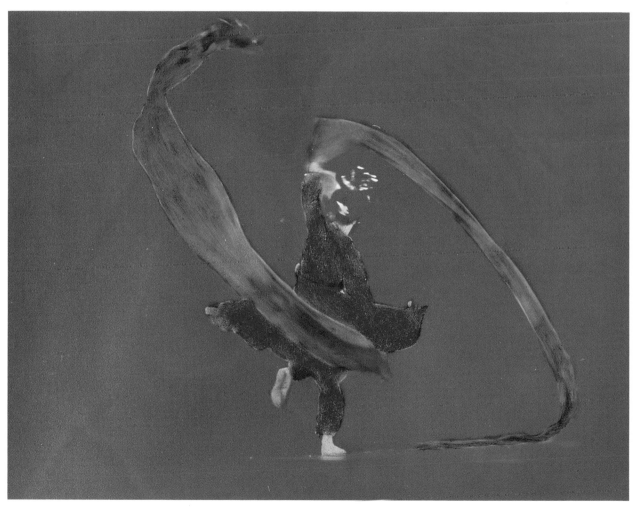

Rear Projection

Rear projection is a technique that offers you the ability to create a number of diverse images. You can add texture, for example, or create a reflection. And before you click the shutter, you'll be able to see in the viewfinder exactly what the shot will look like.

For rear projection you need only a slide projector and a translucent surface onto which you can project a photo. There are expensive screens specifically made for rear projection, but I have always used the inexpensive vellum available in art supply stores. Hang the vellum vertically, with clips attached to the bottom edge to make sure the "screen" hangs flat. Position the projector approximately three feet away from the vellum. The projected image should be kept small to maintain as much resolution as possible.

One of my favorite techniques is to place a mirror perpendicular to the vellum on the opposite side of the projector to create a reflection. When you photograph the projected slide reflecting in the mirror, the subject looks like it is at the edge of a lake.

Texture can be introduced very easily. Instead of projecting a slide onto vellum, which is smooth, you can use something with texture or design in its surface. Onionskin paper, rice paper, and textured glass or Plexiglas all produce unique interpretations of the original image. With the camera on the opposite side of the projector, these variations can be easily seen and photographed.

Another variation is to project a portrait onto a piece of textured typing paper and poke a hole with a pin in the paper where the pupil of one eye is. Rephotograph the image with a star filter. The point of light in the eye will now be a burst of light.

Some slides will work for rear projection, but most won't. Keep changing the slide until you like what you see. Just remember to keep all three planes—the slide, the screen, and the film plane in the camera—as parallel as possible.

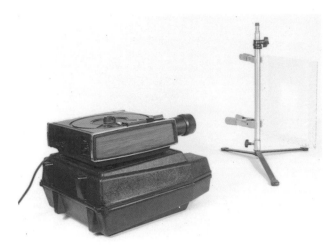

A rear projection setup is simple to make. The projector throws the original slide onto either a rear projection screen or, in this case, a piece of textured glass. The glass or screen and the slide must be parallel for maximum focus. The camera is then mounted on a tripod on the opposite side of the glass with its film plane also parallel. In this example, I taped a piece of white computer paper on the back side of the glass so the slide could be focused on its surface. The texture of the glass would then be part of the final picture.

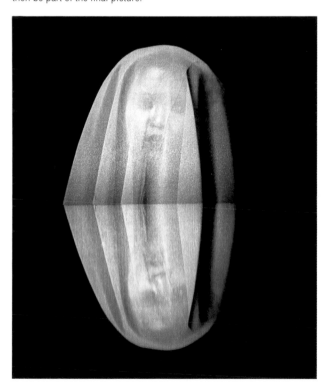

I projected onto a rear projection screen the transparency of the young girl with fabric draped over her head. I then supported a bathroom mirror against the screen, perpendicular to it, between the screen and the camera. I rephotographed the reflection with a laser beam adding a red dot of color to one of the eyes.

Technical Data: Original photograph—Mamiya RZ 67, 180mm lens, f/5.6, single Speedotron flash head and Photoflex silver umbrella, Ektachrome 64. Rear projection—same camera and lens, 1/8, f/8, Fujichrome 64T (tungsten-balanced) film, tripod.

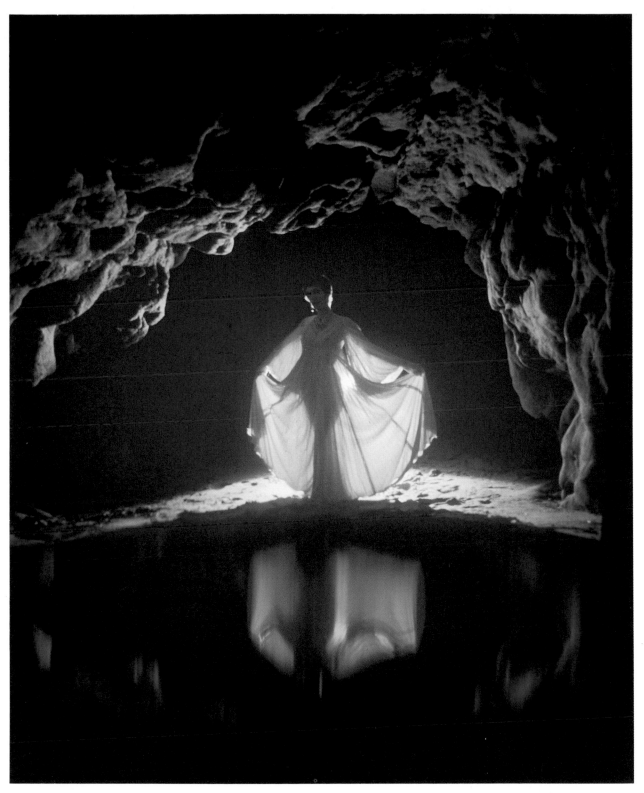

Instead of placing a mirror under the rear projection screen, this time I tried to create the most realistic-looking reflection possible. I confiscated a shallow Lucite bowl from my mother's kitchen (I'm not above anything for the sake of photography) and filled it with water. I positioned this so it was just barely touching the screen at the bottom of the picture. By framing the composition from a low angle, and by moving the camera until the edge of the bowl disappeared, I could give the impression the girl in the cave was really standing at the edge of a lake.

Technical Data: Mamiya RZ 67, 180mm lens, 1 second, f/11, Ektachrome 64, 80B correction filter to balance the daylight film with the tungsten light source of the projector, tripod.

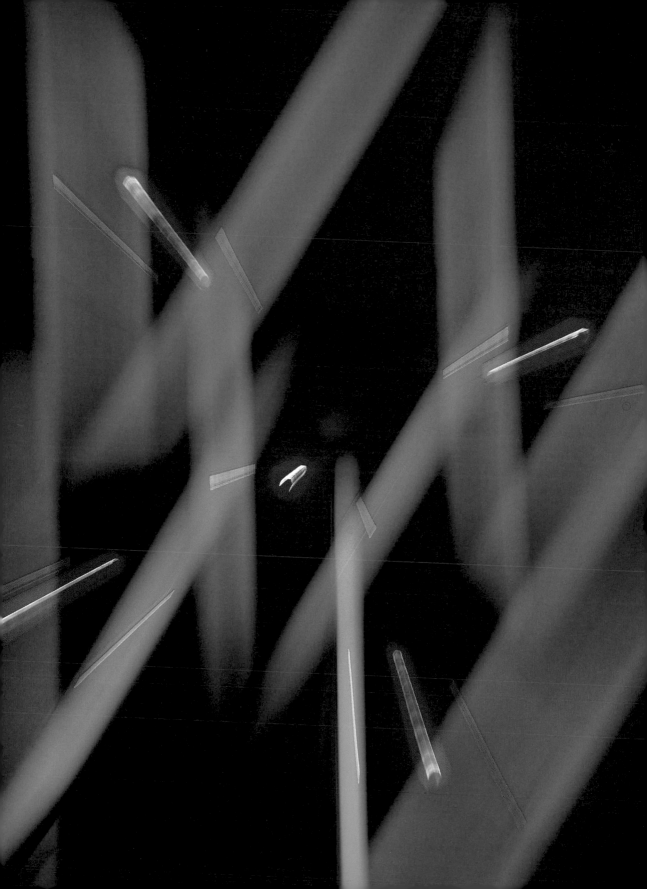

Photographic abstractions are easy to do, and they help keep your creative thinking fresh. The unpredictability of producing abstracts is part of the fun, and many times you will be amazed at what you and your camera have recorded on film. Abstracts are an important part of creating other special effects images, especially when used in sandwiching, in making multiple exposures, and with masking (each of these techniques is covered in a separate chapter).

Think of each abstract you create as a component to be combined with something later. It is true that sometimes an abstracted image can stand alone as a unique creation, but in the context of this book you will begin to appreciate that the most dynamic special effects pictures are those in which different techniques are combined into a single image. One abstract can turn out to be an important element in dozens of final composites.

Just keep in mind that anything goes in photographic creativity. No idea, no stretch of the imagination should be overlooked or discarded because it may end up producing a remarkable abstraction. Learn to take seriously all your innovative ideas, no matter how crazy they may seem.

Creating Abstractions

Abstracts come in many forms. They can be dazzling statements of swirling color or a subtle blend of earth tones. They can be strong graphic elements or can simulate the appearance of a distant galaxy. Practically any object, any location, or any condition of light or atmosphere can be the subject of an abstraction.

I frequently use found objects that catch my eye in a store, in a forest, or even in a pile of refuse to create unique abstractions. Using the simplest of techniques, which can be done with even a point-and-shoot camera, anyone can turn an ordinary subject into a wonderful abstract photograph. I look for objects with interesting color designs, strong contrasts, bold patterns and pronounced textures. Pieces of colored glass, a mound of jelly beans, fall leaves on the ground, backlit sheer clothes hanging on a laundry line in the wind, or even chipping paint on an old barn can all produce abstracts that will surprise you with their artistic applications. As you delve into the techniques described in this book, your ability to perceive artistic possibilities in the simplest of situations will increase dramatically.

Light Abstractions

Patterns of light make great abstracts. Streaking traffic, swirling rides at night in amusement parks, the sun streaming through tree branches, or a street lamp's reflection in a puddle can be turned into beautiful designs. These opportunities surround us every day.

Another type of light abstraction can be created with a black light. A black light provides neon-like color unobtainable from normal light sources. These supersaturated hues are visually shocking, especially when the blue-purple color of the black light is photographed against fluorescent dyes. The result is unworldly. I use both the black light tube, which is similar to a fluorescent tube and uses the same fixture, and the black light bulb. Because this type of illumination is out of the range of conventional photography, don't trust your light meter when you make an exposure. Bracket your shots in half f/stop increments until you get a feel for the kind of abstracts that result.

Some abstractions require no special tricks to shoot—you simply must be visually aware to see them. This design was photographed from the upper deck of a houseboat on Lake Powell in Utah. It is the sunrise reflection of a sandstone cliff in the moving water of the lake.

Technical Data: Mamiya RZ 67, 250mm lens, 1/125, f/5.6, Fujichrome 50D, hand-held. A tripod on a boat serves no purpose, other than to take the weight of the camera from your hands.

I placed three colored glass filters on a piece of translucent Plexiglas and cut black paper to fit around them. I positioned a photoflood under the set for backlit illumination. A multiple image filter provided the repetitions of the image. I determined the exposure by placing a spot meter in front of the orange filter and taking a reading. I could have used an in-camera meter to accomplish the same thing.

Technical Data: Mamiya RZ 67, 110mm lens, 1/15, f/5.6, Fujichrome 64T (tungsten-balanced) film to match the photoflood, tripod.

To create an appropriate background for spacelike images, I needed an image consisting of an "infinite" number of stars. I placed a piece of black velvet on the floor and sprinkled it with glitter. I used primarily silver glitter, with a few bits of blue and red glitter to simulate the subtle color differences in stars. A small lens aperture caused the streaks of light in some of the glitter. A single light source illuminated the set.

Technical Data: Mamiya RZ 67, 110mm lens, f/16, Fujichrome Velvia, tripod. The light source was a Speedotron power pack and one strobe head, undiffused. The exposure was first determined by a Minolta Flash Meter IV and then checked with a Polaroid back.

Sometimes abstract images are inspired by things you may run across in your home or in a local store. Browsing through a retail outlet specializing in plastics, I found some chrome Mylar etched with microgrooves for breaking up light like a prism. Instead of simply taking a picture of the play of prismatic light on the Mylar, I cut a piece of it and coiled it into a funnel. I placed another piece outside in the sun on the concrete patio, and taped the Mylar funnel around my camera lens. Looking through the lens, pointing the funnel at the Mylar piece on the ground, I could see a dazzling array of brilliant color. By playing with the focus (moving the camera away from, and closer to, the flat piece of Mylar, rather than turning the focusing ring), the myriad abstractions provided me with a couple hours of fun and creativity.

Technical Data: Mamiya RB 67, 127mm lens, #2 extension tube to allow for closer focusing, 1/125, f/8, Ektachrome 64. I used a tripod to free up my hands so I could adjust the angle of the Mylar to the sun.

(Left) A simple diffusion filter was used to create this dreamy still life. These filters come in various densities, and for this shot I used a #3, which provides heavy diffusion. I bought a used violin at a pawn shop, painted it white, and arranged it with a pile of rose petals. The lighting was a single, undiffused strobe head above the set and off to one side.

There are other methods of diffusion besides filters. You can stretch a piece of panty hose material across the lens, or shoot through petroleum jelly smeared on a skylight filter. A piece of glass can be lightly coated with matte spray (used to eliminate the sheen on glossy photographic prints) and used effectively to diffuse subjects.

Technical Data: Mamiya RZ 67, 110mm lens, f/4, Fujichrome Velvia, tripod. The light source was a Speedotron power pack and strobe head. My exposure was determined by a Minolta Flash Meter IV.

(Below) This is another type of diffused image. During a rain shower in Vermont, I pulled my car right in front of a maple tree. I turned off the engine, as well as the windshield wipers. As the rain ran down the glass, the smooth sheet of water created a natural diffusion filter. Looking through the viewfinder of my camera, the fall foliage colors were captivating. I made the exposure under the relatively dark conditions using a slow shutter speed without a tripod because, first, there was no place to set one up, and second, I didn't think it would matter since the image was so soft anyway.

Technical Data: Mamiya RZ 67, 250mm lens, 1/30, f/4.5, Fujichrome Velvia, hand-held.

Certain types of crystals have a characteristic called *birefringence*. This means that under polarized light, they break up a light source like a prism to produce dazzling colors. These crystals were made from photographic fixer used to fix the image on black-and-white photographic paper. I poured a little of the liquid on an 8x10 sheet of glass and let it air dry. The result was a design of white crystals.

Next, I placed a photoflood behind the sheet of glass and taped a piece of polarizing material (available from Edmund Scientific in Barrington, New Jersey) on the back side of the glass, away from the camera. It could have been affixed to the photoflood itself, but the heat from the light would either melt or seriously warp the polarizer.

I screwed a glass polarizing filter onto my lens. When seen through the viewfinder, there was suddenly an amazing array of brilliant colors in the crystalline patterns. As the filter was rotated on the lens, the intensity of the colors changed. These colors can only be generated when you use two polarizers, one on the lens, the other between the light source and the subject.

Whenever you photograph a flat subject, such as this sheet of glass, it's important to position the film plane in the camera to be parallel with the subject. When the glass and film plane are parallel, you can obtain maximum depth of field even at large lens apertures.

Technical Data: Mamiya RZ 67 (with built-in bellows fully extended), 110mm lens, 1/4, f/8, Fujichrome 64T (tungsten-balanced) film to match the photoflood, tripod.

(Left) This abstract image is simply a macro shot through a Lucite sculpture I found in a retail plastics outlet. It is backlit by the sun, since I shot it on my patio.

Technical Data: Mamiya RZ 67, 110mm lens, #1 extension tube, 1/8, f/22, Fujichrome Velvia, tripod. The exposure was determined by the in-camera meter in Mamiya's AE prism finder.

(Below) There are many ways of creating abstracts. This one is unique. I placed a piece of Kodak 4x5 Ektachrome Duplicating Film 6121 (any 4x5 transparency film could be used) in a black, light-tight plastic bag (photographic paper is often packaged in this type of bag), which was wrapped tightly around the sheet film and taped closed. I put the package on a piece of metal and ran an electrical charge through the film using an automotive starter and a car battery. The current passed from the starter, through the film, onto the metal plate. My "exposure" time was approximately five seconds, and I moved the film in front of the visible current so it would expose different portions of the surface of the 4x5 Ektachrome. The film was then developed normally.

The dupe film was placed in the plastic bag to enable me to work in room light. The resulting spacelike abstract can now be used for multiple exposure purposes.

Technical Data: No camera or lens was used. Don't apply the electrical charge to one spot for more than a couple of seconds or you'll run the risk of burning a tiny hole through the black plastic bag. This would then expose the undeveloped film to ambient light.

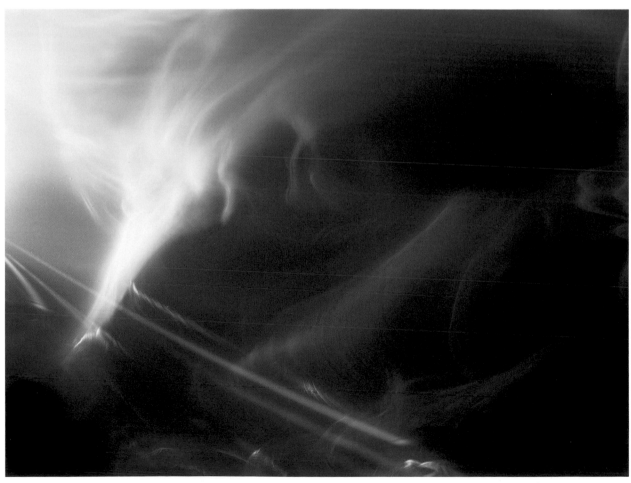

Lasers are the third major kind of light abstractions that I use. I have photographed laser abstractions on many occasions, always ending up with a new and diverse set of images. Part of the fun of shooting lasers is that the results are futuristic and spacelike. The geometric designs produced with time exposures are one-of-a-kind images. I use these frequently in conceptual composites.

Laser designs are often less than critically sharp. Because they consist of moving lights and require a long exposure to enable the abstract to unfold on the film, softening can occur. This isn't a serious disadvantage, but it does happen.

Kaleidoscope Abstracts

I have often been intrigued by images seen through kaleidoscopes, but the small hole through which one views the colorful designs is just impossible to use photographically. Hence, I constructed my own kaleidoscope specifically to capture these incredible graphics on film.

The cheapest way to make a kaleidoscope is to purchase two 12x12-inch pieces of mirror. Cut each piece in half (or have a glass cutter do it for you), so you end up with four pieces of 6x12-inch mirror. You'll only use three of the four pieces.

If you want maximum sharpness, instead of using inexpensive glass mirror tiles, purchase *front surface* mirrors to make the kaleidoscope. These are available from local glass shops (they will have to order it) or from Edmund Scientific in Barrington, New Jersey. The advantage of the front surface mirror is that no glass covers the reflective silvered surface. This means that the reflected image is sharper because it's untainted by minor secondary reflections that can occur in the glass, and because virtually no light is lost due to absorption of the glass. This is important because the faceted reflections should not appear darker than the actual image of your subject seen straight through the kaleidoscope. Front surface mirrors lose an insignificant 4 percent of light (they reflect 96 percent of the light striking their surface), while the conventional glass mirrors will absorb about 1/2 f/stop. This means that the "true" image as seen straight through the kaleidoscope would be lighter than the reflections around it.

This abstract is a close-up of a design in textured glass. The color was generated by spray painting a white poster board with fluorescent colors, then illuminating it with a black light. The glass was placed twelve inches in front of the poster board, and the camera about five inches in front of the glass. The blue-purple color at the bottom of the picture is the black light tube itself as seen through the textured surface of the glass. For my exposure, I took a normal light reading through the glass using the in-camera meter in the AE finder, and then bracketed in 1/2 f/stop increments up to two f/stops in the underexposure direction. From experience, I knew black light photography needs to be underexposed to obtain the proper saturation of the neon colors.

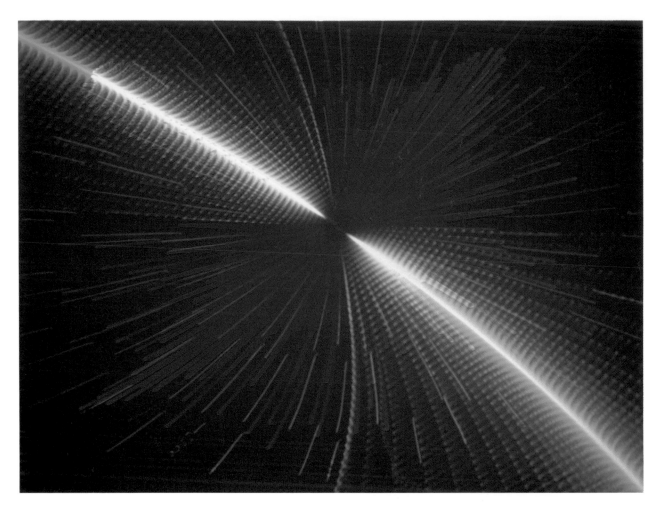

(Above and right) In many large U.S. cities, large planetariums offer laser light shows. Laser beams are projected on a white, domed ceiling and artistically manipulated. These two shots were taken during a show at the Griffith Park Observatory in Los Angeles. The exposures were pure guesswork, since a light meter isn't accurate in this kind of situation.

Technical Data: Both images—Mamiya RZ 67, 50mm lens, 5 to 10 seconds, f/4.5, Fujichrome 100D, tripod.

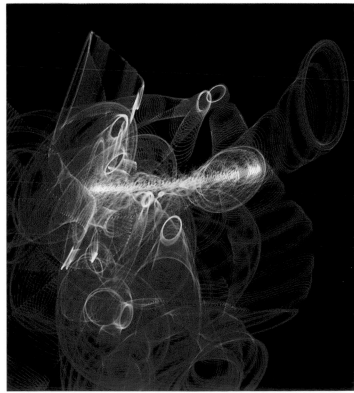

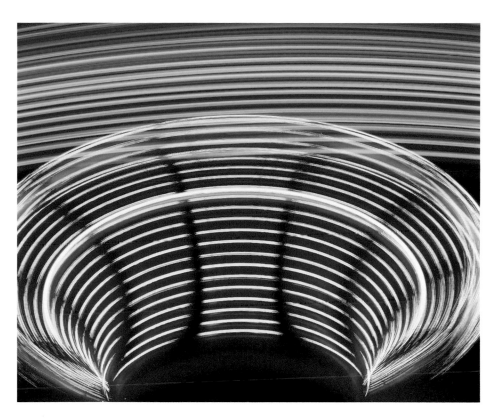

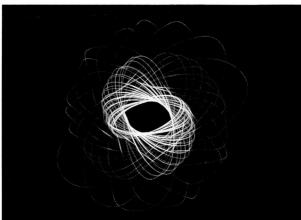

(Top) This spinning ride at Magic Mountain in Valencia, California, was a ten-second exposure. The factors that determine the shape and amount of detail in the abstract are length of exposure; whether the camera is mounted on a tripod; the tightness of the composition; and the angle from which you shoot.

Technical Data: Mamiya RZ 67, 50mm lens, 10 seconds, f/4.5, Fujichrome 50D, tripod.

(Center) This geometric design was created by suspending a small flashlight from the ceiling on a string. I placed the camera on a tripod directly beneath with the lens pointed upward. I turned the lights out in the room, gave the flashlight a twirl, and opened the shutter of the camera. As the flashlight spun, it left a trail of light on the film. The colors were created by first using a purple filter, then a green one, and finally no filter for the last few moments of the exposure. Instead of screwing the filters onto the lens (which would have taken too much time and might have jarred the camera), I held them above the lens so I could change from one color to another very quickly.

Technical Data: Mamiya RB 67 (with waist-level finder for easy viewing when the camera was aimed upward), 65mm lens, 20 seconds, f/4.5, Ektachrome 64, tripod.

(Bottom) These soft circles of light were created using pinholes in a black poster board. But instead of zooming during the exposure, I turned the focusing ring to make the shot out of focus. Each circle of light represents one pinhole.

Technical Data: Mamiya RZ 67, 180mm lens, 1/15, f/5.6, Fujichrome 50D, tripod. I placed a photoflood behind the poster board. Taking an exposure is impossible in this situation, so I used my Polaroid back on the RZ to conduct my test. The warm color of the spheres occurred because I used daylight film with tungsten lighting.

The only disadvantage of a front surface mirror is that it's fragile and scratches very easily (the small mirror in your 35mm camera is a front surface mirror). If you accidentally touch it and leave an oily fingerprint, clean it *very* gently with lens tissue.

Use very strong duct or glass tape to bind the three sections of mirror together in a triangle, with the mirrored surfaces inside. Use as much tape as necessary to prevent the mirrors from moving against each other.

The photographic technique is simple. Using a wide angle lens (such as a 24mm in 35mm photography), place the front element of the optic just inside the kaleidoscope. The wider the angle of lens used, the more reflected facets you will see through the camera. A 20mm wide angle will produce more than a 24mm, and a 16mm fisheye yields even more.

You can hand-hold the kaleidoscope in front of the camera, or you can affix the mirrors to some sort of support so they don't move during composition and exposure. I tend to use a smaller lens aperture, such as f/11 to f/22, to make sure the edges of each facet, as well as the subject, are sharp.

Zoom Blurs

The "zoom blur" technique has been around for a long time. It's an excellent way to create abstracts from many different subjects. These images can be combined with other elements to create dynamic composite photographs.

The best subjects for zoom blurs have one thing in common: They all have strong, defined areas of contrast and usually have bright colors. Patches of flowers, for example, are classic subjects because they have strong shades of color as well as highlights and shadows in their petals and leaves. The sun streaming through red maple leaves and stained glass are other examples of both color and contrast providing a perfect subject. You also can use this technique on a studio setup shot, such as a collection of backlit glass bottles, each filled with a different colored liquid. Or cut some art paper into various shapes and rearrange the pieces to create a number of different zoom blurs.

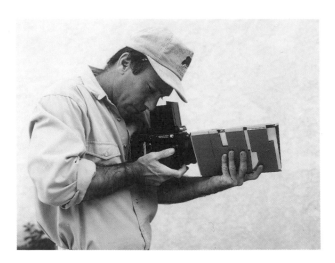

I made this kaleidoscope from three pieces of mirror. You can use it easily by holding it in your hand along with the camera. Place a wide angle or fisheye lens inside the triangulation of mirrors, and you can make a kaleidoscopic image out of anything.

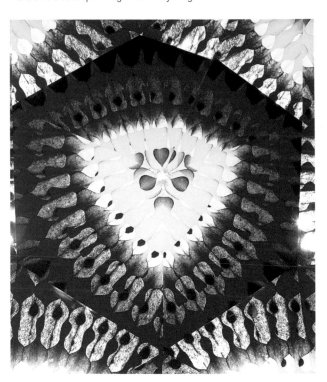

Here I've used a specially built kaleidoscope and a paper wheel, the type available through stores that carry party goods, to create an abstract. I opened the wheel, clamped it to a light stand, and then positioned a photoflood behind the translucent colored paper design. I set up the camera and kaleidoscope on the opposite side of the light and took the shot with the end of the kaleidoscope only two inches from the paper.

Technical Data: Mamiya RZ 67, 50mm lens, 1/30, f/22, Fujichrome Velvia. I used a kaleidoscope made with front surface mirrors. If you work with a 35mm camera, use a wide angle lens, such as a 24mm. The wider the angle of lens, the more reflected facets you'll capture. I either hand-hold the kaleidoscope in front of the camera or affix the mirrors to some sort of support so they don't move.

To produce a uniform zoom blur, most or all of the composition should include the colorful subject. Place the camera on a tripod. Once you have composed the image and focused in the telephoto position, make a one-second exposure. Move the zoom lens from the telephoto position to the wider angle focal length. It doesn't matter in which direction you change the focal lengths—the effect is the same. Use a long exposure so you'll have enough time to manually move the zoom ring the entire distance.

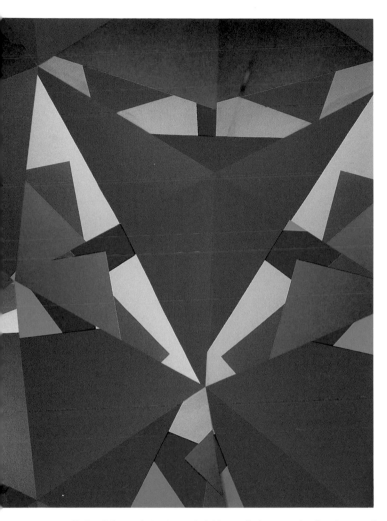 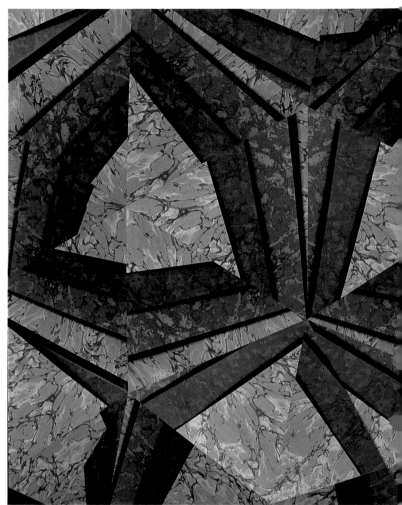

Both of these abstracts are kaleidoscopic images of colored paper. I bought several sheets of artist's paper at an art supply store and arranged them to take advantage of the reflective pattern produced by the mirrors. Because the end of the kaleidoscope was about eight inches from the opaque sheets of paper, the lighting had to come in from the side. I used two strobe heads for even illumination.

Technical Data: Mamiya RZ 67, 50mm lens, 1/30, f/22, Fujichrome Velvia. I used a kaleidoscope made with front surface mirrors. A Speedotron power pack and strobe heads illuminated the art paper.

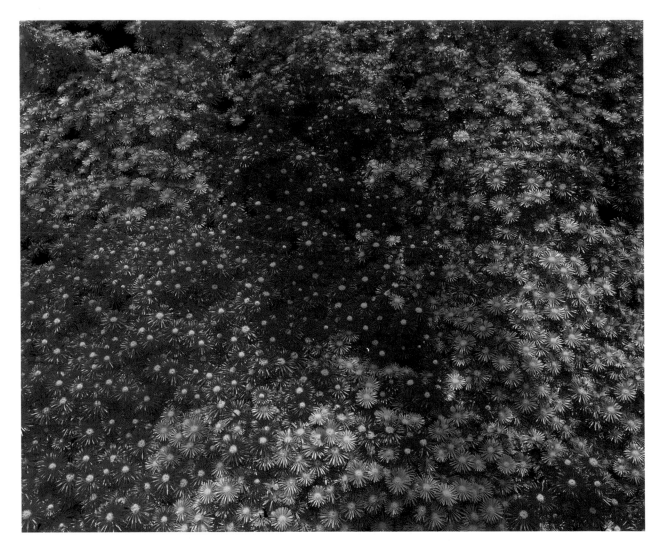

To produce a uniform zoom blur, most or all of the composition should include the colorful subject. The shot above is a straight shot of a mass of ice plant flowers. Note that the entire frame is filled with color, as opposed to including a patch of dirt or perhaps the base of an adjacent plant or tree. For the shot on the right, I placed the camera on a tripod and, during a one-second exposure, moved the zoom lens from the tele-photo position to the wider angle focal length. You can change the focal lengths in either direction and get the same effect.

Technical Data: Straight shot of flowers—Mamiya RZ 67, 250mm lens, 1/60, f/16, Fujichrome Velvia. Zoom blur of flowers —Mamiya RZ 67, 100-200mm zoom, 1 second, f/22, Fujichrome Velvia, tripod.

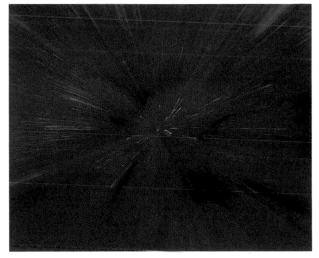

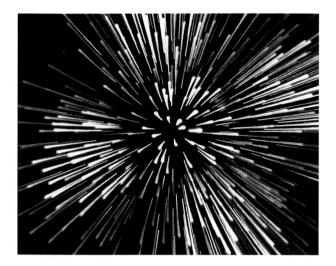

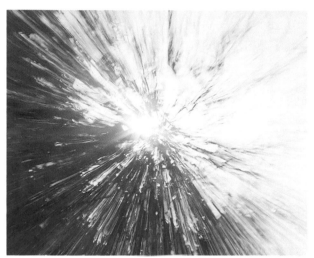

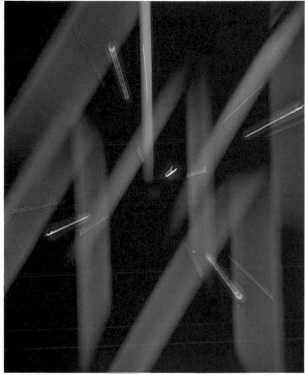

This is a unique zoom blur. I set up two black light tubes with a red light between them and zoomed the abstract design, abstracting it further. Since this type of situation prohibits the use of a conventional light meter, I determined my exposure by doing tests with my Polaroid back.

Technical Data: Mamiya RZ 67, 100-200mm zoom, 2 seconds, f/8, Fujichrome Velvia, tripod.

(Top and above) Although the subjects are quite different, I made both of these images the same way. During a one-second exposure I moved the zoom lens from the telephoto position to the wider angle focal length. I chose the long exposure—one second—to have enough time to manually move the zoom ring the entire distance. A faster shutter speed period doesn't allow enough time to do this. To create the image on the top left, my subject was a black poster board with pinholes punched through it to simulate a star-filled sky. I backlit the board with a photoflood.

In the image just above, the sun was streaming through leaves in a tree. If you zoom a very bright subject, like this one where the sun is part of the picture, the one-second exposure may let too much light into the camera, even with a small aperture. Using slow film for this technique will help, but if you still need to cut down the light, place a polarizing filter over the lens. This won't change the colors at all, but it will decrease the exposure by two f/stops.

Technical Data: Both images—Mamiya RZ 67, 100-200mm zoom, 1 second, f/22, Fujichrome Velvia, tripod. I used a polarizing filter for the image of the sun and tree branches.

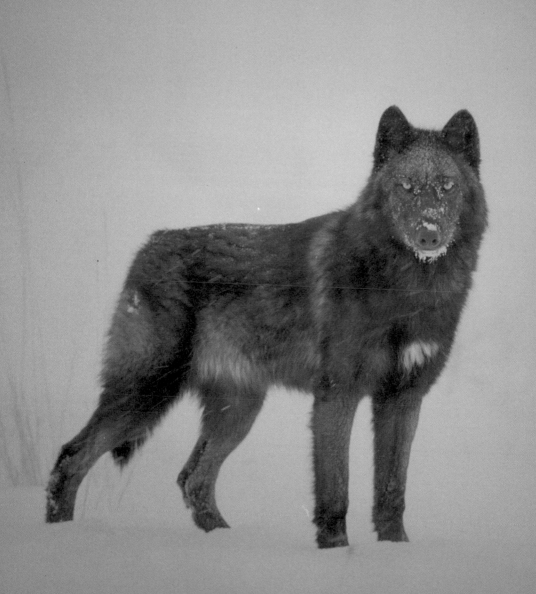

One of the most useful and creative techniques in special effects photography is called "sandwiching." *Sandwiching* involves placing two transparencies physically in contact with each other for viewing as a single image. The two images usually consist of the main subject, such as a model, and the secondary subject, such as an abstract background. It won't matter which piece of film was placed on top when you view, project or duplicate the combined image.

Sandwiching enables you to make an image look more "natural," such as adding a beautiful sky to a landscape. Or, you can combine two images that are completely unrelated to each other to create a work of art that surprises the viewer as well as yourself. An example of this might be a sandwich of a girl's face with a pattern of swirled paint, where the colorful paint replaces the skin and gives the model an other-worldly appearance.

Most of the sandwiches you try won't work. Be patient and keep trying to find the right combinations until you are pleased with the results. This technique will open many creative doors for you.

Sandwich or Multiple Exposure?

When one photo is sandwiched with another, all the white or very light areas are replaced by that second image. If you hold a slide up to one eye and look through the film, you can see that any white portion is clear. This allows the second image to show through without interference. How well the second image shows through a very light area depends on how much density is in that area.

Many people incorrectly use the terms "sandwiching" and "double (or multiple) exposure" synonymously. A *double exposure* occurs when raw stock (unexposed film) is hit with light twice—first one exposure occurs, then, on top of that, a second exposure is made on the same piece of film. Although it might seem that the two techniques would accomplish the same end, they actually produce two completely different effects, even if you use the same originals.

Here's an example to illustrate the difference in results. Let's say you want to combine a portrait of a girl with long black hair and very light skin with a colorful abstract. First, we'll sandwich the two slides. In this case, the model's light skin allows the abstracted image to show through this area of the film, so the abstract virtually replaces her skin. The black hair, on the other hand, blocks the abstract color because of the opacity of the black film that comprises the hair. The eyes and lips, which are typically darker than the skin, are relatively opaque and partially inhibit the colors in the abstract from coming through. So what you end up with is a girl with black hair and dark eyes and lips, but whose skin has become the color of the abstract. If she had been photographed against a white background, it too would be the color of the abstract.

A double exposure will produce a very different picture because the black portions of a slide are actually unexposed film. Therefore, the girl's black hair, with the exception perhaps of subtle highlights, is unexposed film. (A roll of slide film taken off the shelf in a camera store and developed, without any exposure, appears black.)

Let's assume that, in my example, the portrait of the model is exposed onto the raw duplicating stock first. Then we expose the dupe film a second time with the colorful abstract. Now, the portion of the film that constitutes the black hair (unexposed film) actually receives its *first* exposure. The light skin, on the other hand, now gets its *second* exposure. This means that the abstract replaces the hair, and the skin is actually overexposed, or washed out somewhat, because it has received two exposures.

If you used a white background behind the girl, this portion of the slide would still be white. You can't really overexpose a white area, since it can't get much lighter. However, if the girl were positioned against a black backdrop, the color abstraction would replace the black background just as it replaced the black hair. In other words, in a multiple exposure all the black or very dark areas are replaced by the second image.

When preconceiving the kinds of results you want, plan ahead. If you want a second image to replace a dark portion of the frame, use the double exposure technique. This would work, for example, for a dark background, a model's dark clothing, dark sunglasses, or a night sky. If you want a second image to show only in the light areas, while the dark parts of the picture remain dark, sandwich the two slides. This would work for a light background, a sunny sky, a tree shot in a snowstorm, sand, a fair-skinned nude, or a whitewashed fence.

Selecting Photos for Successful Sandwiches

A slide that has light—or white—areas and a strong, dark graphic shape makes an excellent sandwich. A classic example is a tree silhouette against an overcast sky. This type of contrasty image that is also simple in design lends itself well to sandwiching. You can combine many different slides with this type of shot and produce scores of great shots.

Neither original used for a sandwich should be very busy. If either the main subject or the secondary image is complex, frequently the sandwich is just too cluttered to work. A tree bare of leaves is a better subject than the same tree seen in its summer foliage.

Sometimes I'll shoot specifically with a sandwiched image in mind. The rearing horse you see on page 71 was deliberately photographed on a day when the sky was white and heavily overcast. I wanted a dark silhouette against this type of sky

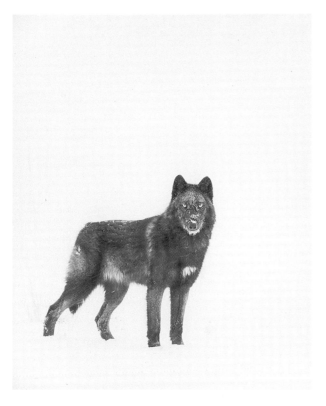

(Above left) When two transparencies are sandwiched together, each image must be translucent enough to allow the other to be seen. The original shot of the wolf was taken in a snow blizzard, with plenty of whiteness around the animal. On slide film, white represents a clear area (you can look right through it almost like a slightly tinted glass window). When this is combined with a second photograph, the clear film permits the other shot to be easily seen without interference.

(Above right) Note that the moon photo I chose for this sandwich was not photographed against a night sky. Instead, it was taken at twilight. The difference is that a night shot would have produced a black sky, whereas at twilight the sky is a deep blue. Had the sky been black, it would have been impossible to sandwich the two images because the wolf transparency would have been blocked by the opacity of a black sky.

(Right) I physically placed the transparency of the wolf in contact with the image of the moon, positioned the sandwich in my enlarger, and made a duplicate of the combination.

Technical Data: Wolf original—Mamiya RZ 67, 500mm lens, 1/125, f/6, Fujichrome 50D, tripod. Photographed from a blind. Moon—Mamiya RZ 67, 250mm lens, 1/8, f/4.5, Fujichrome 50D, tripod. Sandwich—15 seconds, f/11, Kodak 4x5 Ektachrome Slide Duplicating Film 6121, enlarger using a 100mm Schneider enlarging lens.

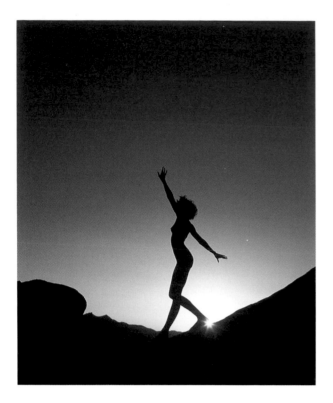

(Above) Once you have a great silhouette—whether it's of a person, an animal, a striking piece of architecture, or a tree—there are myriad possibilities for combining other images with the original. I was so pleased with the graceful pose of my model that I knew this shot could be the basis for many different kinds of effects.

An original slide doesn't necessarily have to be photographed against a very light background to make a sandwich. Even if the background is muted, as it is here, you can lighten the sandwich to a pleasing density during the duplicating process.

(Above right) If I had overexposed the sky behind the silhouette of the model and the landscape, it would have been simple to sandwich this sunset into the image of the model. It would have replaced the very light areas of the sky, leaving the silhouetted images dark. But the original photograph of the model positioned against the sunset was exposed correctly; it wasn't overexposed slightly to accommodate a second image behind it. When the sunset was sandwiched with the silhouette, the two transparencies were in fact dark when viewed together.

(Right) When I copied the sandwich onto the duplicating film, I corrected the darkness problem by increasing the exposure time one-and-a-half stops to lighten it. I also added 10 units of magenta filtration.

Technical Data: Original silhouette—Mamiya RZ 67, 250mm lens, 1/30, f/4.5, Fujichrome 50D, tripod. Sunset—Mamiya RZ 67, 350mm APO lens, 1/30, f/5.6, Fujichrome 50D, tripod. Sandwich—30 seconds, f/11, enlarger using a 75mm Rodenstock enlarging lens. Because I use 6x7 cm originals, I use either the 75mm or the 100mm enlarging lenses for most of my work. If you use 35mm slides, use a 50mm enlarging lens instead.

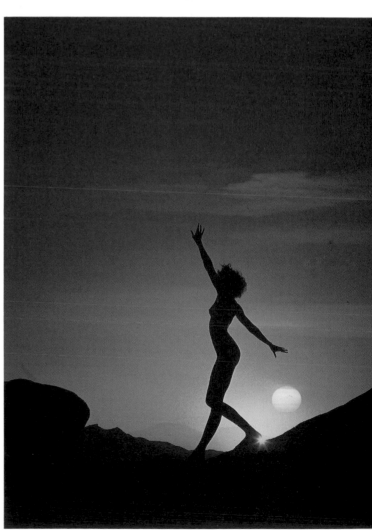

(Left) To illustrate the difference between a sandwich and a double exposure, let's see what happened when I made a double exposure of this crescent moon shot against a black sky with the same silhouette of the model that I just showed used for a sandwich. (The next chapter discusses multiple exposures in depth, but I want to show you in this example how I used one picture for both a sandwich and a double exposure.)

(Below) The black sky has now been replaced by the image of the model. That's because the black area of the crescent moon received its first exposure (black areas are unexposed film) when duped with the image of the model.

Technical Data: Original silhouette—Mamiya RZ 67, 250mm lens, 1/30, f/4.5, Fujichrome 50D, tripod. Crescent moon—Canon EO1 (35mm), 300mm lens, 1/60, f/8, Fujichrome Velvia. Double exposure—Each exposure was 10 seconds, f/11, Kodak 4x5 Ektachrome Slide Duplicating Film 6121, enlarger using a 75mm Rodenstock enlarging lens for the 6x7 film and 50mm lens for the 35mm film.

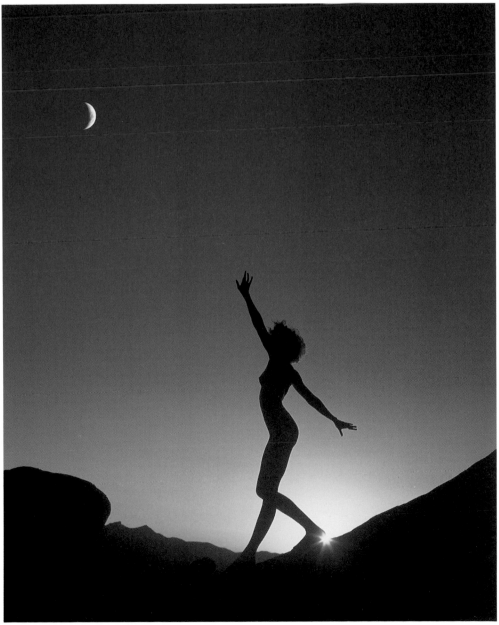

because I knew that it could be sandwiched with many different types of natural, dramatic skies. If the horse had been shot against a blue sky, whichever slide was combined with the animal would then have a strong blue tint to it.

Sandwiched images are frequently related to each other. For example, a silhouette of a mountain range can be combined with a sunset. Both are shots of nature, and they complement each other. The mountains, taken on an overcast day, needed a beautiful sky to make the picture dramatic. The sunset, perhaps lovely by itself, is enhanced with the graphic shape of mountain peaks.

The same mountains, however, might just as well be combined with a kaleidoscope abstract or a night shot of zoomed lights at an amusement park. Similarly, the colorful sunset might be combined with the face of a young girl, where the sun is placed on one of her eyes and the cloud patterns streak across her face. These sandwiched images are examples of combining two shots that aren't related to each other, but artistically they serve a creative purpose. With sandwiching, anything goes.

When I create sandwiches, I work at my light table. I first select many different abstracts and lay them all out on the backlit Plexiglas. These usually include shots of fireworks, colorful textured glass, out-of-focus flowers, sunsets, zoom blurs, tree branch patterns in the snow, and any other interesting designs of color, pattern or texture I find as I look over my stock of images.

Next, I choose another group of images that represents interesting graphic shapes. These could include human figures (such as faces or bodies), mountains, animals, architecture, cityscapes, monuments (such as the Eiffel Tower, the Washington Monument, or the huge statue of Christ above Rio de Janeiro), an airplane, an insect, or dozens of other subjects. I place these next to the first group and then start combining images. I'll hold a zoom blur in back of a nude, and if that doesn't work I'll sandwich the nude with a sunset, or the zoom blur with the buttes of Monument Valley. A motorcyclist leaping in the air could be sandwiched with streaks of light taken of an amusement park ride at night, or a seagull in flight could be combined with backlit cumulus clouds. I keep rearranging the combinations until I find one I like. Then, I dupli-

cate it so both originals can be used in other combinations.

Storing Your Sandwiches

Although you can leave the two slides physically together, I strongly recommend that you duplicate your new image. Once you have a high-quality dupe, the two originals can be separated and recombined with other slides to create additional sandwiches. A powerful shot of lightning, for example, could be combined with several tree silhouettes, a rearing horse, an old Victorian house, and many other photos you may have in your stock library. If you didn't duplicate the combination and left the lightning slide mounted with one of a tree silhouette, none of the other sandwiches would be possible.

Another advantage of duplication is that when two pieces of film are mounted in a plastic or cardboard mount, the shallow depth of field of projection lenses can't keep both images in critical focus during a slide show. When they're copied onto slide duplicating film, you'll only be projecting a single piece of film.

If both original slides were properly exposed, the sandwiched combination will usually appear to be underexposed when projected on a screen or printed onto photographic paper. Rectify this problem by making a duplicate of the sandwich using a longer exposure to lighten the second-generation image. Even a sandwich that looks one or two stops too dark can be lightened to a normal density by making a good dupe. (If you use a 35mm on-camera duplicator, move the flash closer to the camera in half-inch increments to lighten it, since your duplicator is set at a fixed aperture.)

You also can adjust the positioning of the two slides when duplicating—something that is not possible when physically mounting them. Ideally, when two transparencies are sandwiched together, with one of the images placed squarely on top of the other, the two photographs will be positioned correctly with respect to each other. Sometimes, however, you'll want to offset one of the shots for a better composition, and this presents problems when you make the duplicate.

With 35mm slides, where the slide holder of the duplicator is made to accommodate a mounted

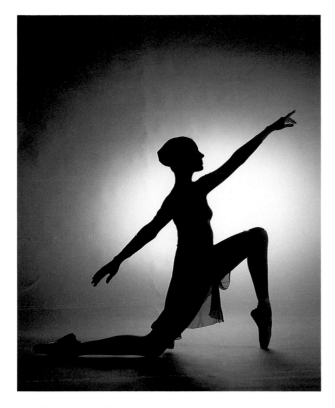

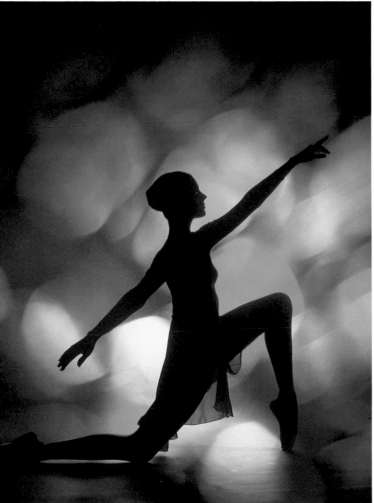

(Above left) Dark figures against white backgrounds provide superb sandwich material. This ballet dancer was placed in front of white background paper highlighted with a spotlight. (Unfortunately, the paper was somewhat wrinkled, but the imperfections virtually disappeared when I made the sandwich.)

(Above right) I created the abstraction used for this combination by placing the camera inside a Mylar cone while shooting another piece of Mylar reflecting sunlight. The colors come from defracted light, which is bent by microscopic lines etched in the surface of the chrome Mylar.

(Left) The lightest areas of the image of the dancer, especially the background, have been replaced by the abstract. The dark areas, particularly the silhouette, remain dark. Note also that the colors of the abstract appear brighter in the lightest areas right behind the silhouetted figure and grayer at the top of the image, where there was more density in the film.

Technical Data: Dancer—Mamiya RB 67, 180mm lens, 1/60, f/8, Ektachrome 64, tripod. The lighting was a single tungsten spotlight. Mylar abstract—Mamiya RB 67, 127mm lens, #2 extension tube, 1/125, f/8, Ektachrome 64, tripod. Sandwich—12 seconds, f/11, Kodak 4x5 Ektachrome Slide Duplicating Film 6121, enlarger using a 100mm Schneider enlarging lens.

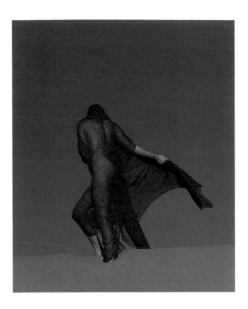 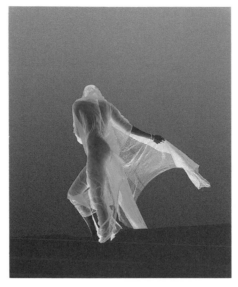

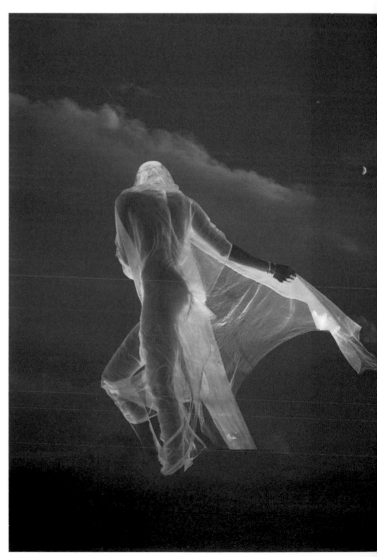

(Top left) One of the most important aspects of creating outstanding special effects images is the combination of two or more techniques in one photograph. This composite, for example, combined the negative transparency technique with the technique of sandwiching. The result is more than a simple combination of pictures. It consists of both positive and negative elements with interesting contrasting colors.

The original shot of the model in Death Valley, California, was taken using only a single piece of red fabric that the wind pressed against the model's body.

(Top center) This transparency was then copied onto duplicating film using an enlarger, but instead of developing the dupe normally in the E-6 line of chemistry, I had the lab process it in C-41. The film was exposed through 30 units of green (remember, a green filter produces magenta and purple hues in negative). The dupe gave me the complementary color scheme of the picture, plus all the light and dark tonal values were reversed. The shadows became light, and the highlights ended up looking like shadows.

(Top right) I sandwiched the negative image that had been filtered green with this positive shot of sunset clouds in Arizona. The rising moon was not superimposed, since it really was in the sky when I photographed the pink clouds.

(Right) The colors in both images were altered with respect to the originals when the sandwich took place. This was nothing I did directly, but resulted from the combination of the two transparencies in physical contact with each other.

Technical Data: Original model shot—Mamiya RZ 67, 180mm lens, 1/125, f/5.6, polarizing filter, Fujichrome 50D, hand-held. Negative image—6 seconds, f/11, Kodak 4x5 Ektachrome Duplicating Film 6121, enlarger using a 100mm Schneider enlarging lens, and then processed in C-41 (I underexposed the duplicate so when the film was processed negative it would appear lighter). Clouds—Mamiya RZ 67, 127mm lens, 1/8, f/4, Fujichrome 50D, tripod. Sandwich—14 seconds, f/11, Kodak 4x5 Ektachrome Slide Duplicating Film 6121, enlarger using a 100mm Schneider enlarging lens.

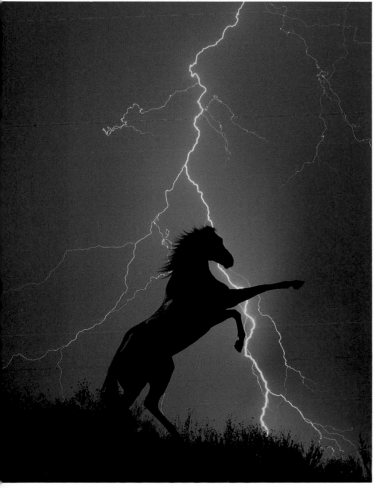

(Above left) My all-time favorite image is the result of a simple sandwich. It was important to shoot the rearing horse against a clean background so the sandwiched image wouldn't have to compete with distracting elements. The sky was the most convenient answer. It was also important that the weather was overcast, so the sky would photograph white. If the weather were sunny and the sky were blue, any sandwiched transparency would have a deep blue cast over it. Although this could be eliminated with heavy filtration during the duping process, it was far easier to avoid the problem.

I exposed for the sky, which meant that the horse would be rendered as a dark silhouette. I was actually standing below the horse on the slope of the hill, which forced the camera angle to aim upwards, eliminating any possible trees or power lines close to the horizon.

(Above right) Originally, I had conceived of combining sunset cloud formations with the horse. I did in fact successfully create several of these images. But then it occurred to me to try lightning, and this was the shot that really made the entire effort worthwhile.

(Left) The sheen on the horse's back, which originally reflected the overcast, white sky, appears in the final sandwich to reflect the magenta glow of the lightning bolt.

Technical Data: Horse—Mamiya RZ 67, 250mm lens, 1/125, f/5.6, Fujichrome 100D, hand-held. Lightning—Mamiya RZ 67, 250mm lens, f/5.6, Fujichrome 50D, tripod. I left the shutter open at night until the lightning flashed and then closed it. Sandwich—15 seconds, f/11, Kodak 4x5 Ektachrome Slide Duplicating Film 6121, enlarger using a 100mm Schneider enlarging lens.

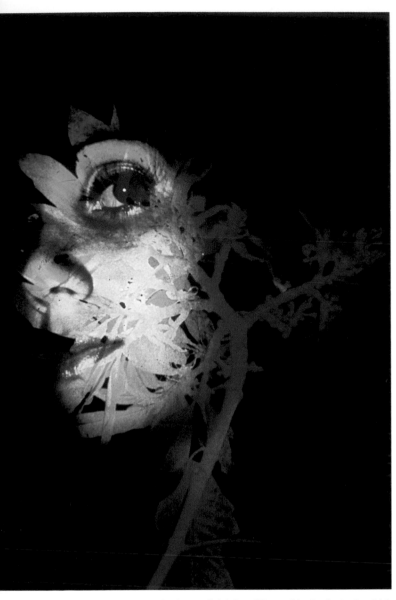

This is an example of a sandwich in a 35mm slide duplicator in which the diffusing panel was not used. I created the hot spot in the center of the frame, surrounded by darkness, by pointing the camera directly at the photoflood light source without any softening of the harsh light.

The branches had been photographed originally on black-and-white film. I had mounted the actual negative in a 35mm slide mount and rephotographed it using a red filter. The portrait of the model was also taken on black-and-white film, printed normally, and then hand-colored light blue. Then I photographed the print.

These two slides were then sandwiched and duplicated on Fujichrome 64T. Instead of using duplicating film, I opted for a contrast gain with a normal daylight film.

Technical Data: Both originals were shot with a Canon F1, 100-300mm zoom, on Plus-X film. The sandwich exposure was 1/4 second. The aperture is preset in the duplicator, and the light reading was taken directly from the in-camera meter. No tripod is necessary when making the sandwich because the slide duplicator and camera become a single unit, and they don't move with respect to each other.

slide, you'll have to take both images out of the original mounts and place them in a third mount that allows movement of the film. Cardboard heat-sealing mounts are perfect for this. Don't seal the cardboard with heat; instead, simply tape it closed. This won't glue the two halves together, thus allowing the film to be positioned as you wish.

When I project sandwiched images onto duplicating film in the darkroom, the negative carrier of my enlarger won't allow two offset transparencies to fit in it. Therefore, I must improvise by using two pieces of 1/8-inch matboard, with corresponding windows cut in them, for my negative carrier. By raising the enlarger, I can crop the unwanted peripheral portions of the transparencies out of the duplicated composition. This leaves me with the best section of the sandwich.

The Dust Problem

Dust makes duplicating transparencies a challenge. When you sandwich images, the problem is doubled because instead of two surfaces to clean, you now have four surfaces. Unfortunately, film develops electrostatic charges that attract dust particles, and when two pieces of film are placed together, the problem is exacerbated.

The only solution to this situation is to work in very clean surroundings. Don't have carpet or rugs on the floor. Use compressed air to blow the dust off each surface of the transparencies. If you want to spend the extra money, antistatic devices are available for darkrooms. But these costly accessories are not necessary if you are meticulous in your habits. I've been duplicating slides for twenty years and have never used an antistatic device. (For more on cleaning slides, see page 24.)

Once the sandwich is placed in your duplicating unit, examine the entire area of the image for specks of dust. In large, bright areas, like a sunset sky, dust will be more obvious and consequently more damaging to the final result. In portions of the frame such as a forest or a jumble of buildings, dust specks will be harder to find and won't negatively impact the sandwich as much as particles in the sky.

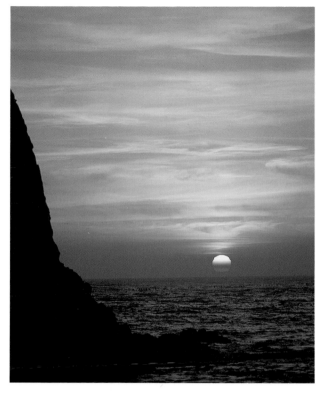

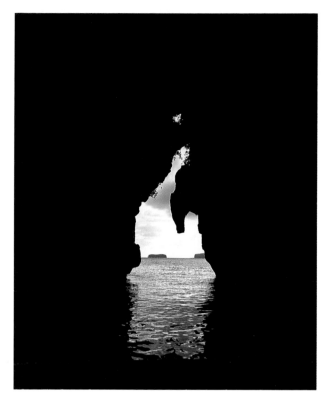

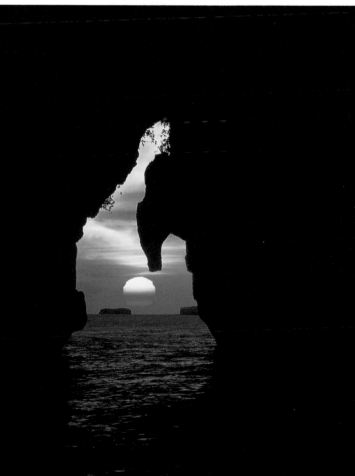

(Above left and above) Most of your sandwiches will have one slide placed squarely over the other. Sometimes, however, you'll want to offset one of the shots for a better composition, and this presents problems when you make the duplicate. I wanted to combine this sunset with a cave on a South Pacific island near Fiji, but the horizon line of this image didn't fit that of the cave.

(Left) I projected the sandwiched images onto duplicating film in the darkroom, improvising a negative carrier from two pieces of 1/8-inch matboard, with corresponding windows cut in them. (The negative carrier in my enlarger won't permit offsetting two transparencies.) By raising the enlarger, I can crop the unwanted peripheral portions of the transparencies out of the duplicated composition.

When executing the same technique with 35mm slides, take both images out of the original mounts and place them in a third mount that allows movement of the film. Insert the two images into a cardboard heat-sealing mount and tape it closed. Because this won't glue the two halves together, you can position the film as you wish.

The result is a scene that didn't exist when I was there—but that looks perfectly real.

Technical Data: Cave—Mamiya RZ 67, 50mm lens, 1/125, f/5.6, Fujichrome Velvia, hand-held in a boat. Sunset—Mamiya RZ 67, 180mm lens, 1/30, f/5.6, Fujichrome Velvia, tripod. Sandwich—12 seconds, f/11, Kodak 4x5 Ektachrome Slide Duplicating Film 6121, enlarger using a 75mm Rodenstock enlarging lens.

(Right) I made a litho positive of the portrait of my model (see pages 100-102 for more about this technique), and then sandwiched it with a C-41 conversion of Joshua trees taken in southern California. Instead of shooting the trees originally with E-6 processing and then making a C-41 duplicate, I had the lab develop the slide film right out of the camera in C-41.

Technical Data: Trees—Canon EF, 50mm lens, Ektachrome 64. Portrait—100mm macro lens. Sandwich—rephotographed using a 35mm duplicator, a single photoflood and slide duplicating film.

(Below) Sandwiching doesn't always mean two different photographs combined into one. It can also indicate the enhancement of a single image by combining it with a texture or color. This moody shot of St. George Island in Venice, Italy, was originally photographed with a blue Cokin filter. Using my duplicating setup, I sandwiched a black-and-white canvas texture with the original transparency. I photographed a stretched painter's canvas on black-and-white film, and then used the actual negative to combine with the color shot of Venice.

Technical Data: Venice—Mamiya RZ 67, 360mm, 1/4, f/11, blue Cokin filter, tripod. Texture—Mamiya RZ 67, 110mm lens, Tri-X film developed normally. Sandwich—12 seconds, f/11, Kodak 4x5 Ektachrome Slide Duplicating Film 6121, enlarger using a 75mm Rodenstock enlarging lens.

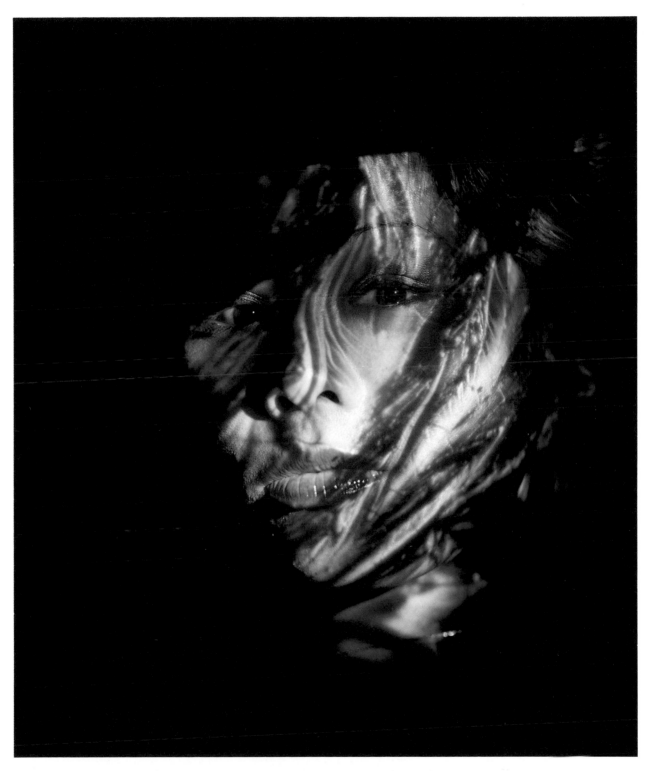

You can simulate a sandwich by using a simple technique that doesn't require any darkroom work at all. You can project a slide onto another subject, like a face or body, a canvas or stucco surface, white bricks, wood, and many other objects. The depth of field of the projected image is shallow, so it's best to limit yourself to relatively flat surfaces. Since the light source you'll use is tungsten (the projector bulb), either use a tungsten-balanced film such as Fujichrome 64T, or use daylight-balanced film with an 80A or 80B correction filter. In this example, I projected an abstraction of vitamin C crystals I had taken in a microscope onto my model's face.

Technical Data: Mamiya RZ 67, 180mm lens, 1/4, f/5.6, Fujichrome 64T, tripod. The camera was positioned directly behind the slide projector with the film plane as parallel as possible to the girl's face for maximum depth of field.

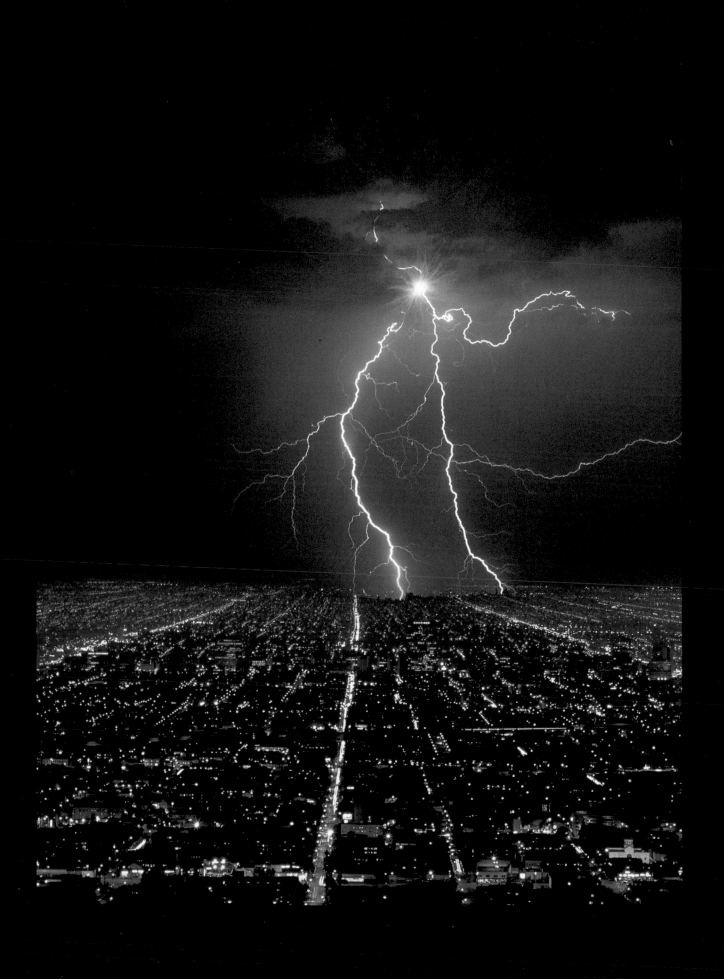

O f all the techniques used in special effects photography, multiple exposures offer the greatest potential for creativity. Multiple exposures allow you to produce images that are truly unique, combining elements to make more dramatic landscapes, adding exotic backgrounds to portraits, and inventing scenes that could never exist in the real world. You truly have total control over reality as portrayed in your photographs. There are no constraints at all.

The technique of multiple exposures requires the most previsualization of any technique described thus far. You must be able to picture in your mind's eye how the finished composite will look. Indeed, sometimes you'll be wrong and the final result will be better than you imagined! This has happened to me many times. But the starting point requires that you at least have the mental picture that two or three (or possibly more) photos can make a dynamic composite image when artistically combined. From this initial previsualization, you will experiment until the result you want is achieved.

Some multiple exposures are accomplished easily; others require painstaking accuracy in placing the various elements used. But the degree of difficulty has no bearing on the success of the end result. Oftentimes simplicity in technique produces the more exciting images.

What Is a Multiple Exposure?

A multiple exposure occurs when two or more exposures are made on a single piece of film or photographic paper. In some cases, the placement of each element is critical, with no room for error. In other instances, the alignment of the components that comprise the final picture is less important. For example, it's critical that the horizon lines of a landscape and the sky you add to it are perfectly aligned; placement is less important when you put a moon into a sky.

As you plan a multiple exposure, remember that any dark portion of one picture will allow any other picture element from another transparency to *replace* it when the two are combined in a multiple exposure. With transparency film, the light part of the frame will virtually deny another picture element from combining with it because: highlight + another exposure = overexposure. (This is the opposite of what happens with sandwiching; see page 64.)

For example: Say you take a picture of a model wearing a black blouse and white pants, and then you double expose this image with an expanse of green lawn. In the composite the grass will replace the blouse (in other words, where there was black there will now be a green lawn) and the white pants (a highlight) will combine with the grass in a way that will produce an overexposed portion of the film, i.e., washed-out grass.

Keep this example in mind, and you'll be able to predict the way many multiple exposures will look before you click the shutter.

What Makes a Successful Multiple Exposure?

A successful multiple exposed image is the result of planning and forethought. Not all combinations work. In fact, it's easy to put two or three images together and have nothing but a confusing mess.

Simplicity is extremely important when conceptualizing multiple exposures. I usually use only one dominant element, so all of the attention can be focused on the subject. The other images that are combined with the subject are supportive. They either function as a unique background, add a texture or splash of color, or interact with the subject in some way.

Here's an example of how this works. I took a studio shot of model Nicole Compton in Las Vegas against a black background. I wanted to portray the glamour and glitz of Vegas, so I double exposed a zoom blur of neon lights in the background. Although a lot of color and sparkle are in the picture, it's essentially a simple composition: a single subject framed by a colorful background. (See the actual photo on page 83.)

This principle works for any number of images. I decided to alter the background and foreground of a photo of a church. I sandwiched the image of the church with a sunset sky to give drama to the background. Then I made a second exposure to enhance the foreground with an aerial shot of clouds. These two shots support the photo of the church and contribute to the spiritual feeling. They don't distract from the subject by competing with it or by adding clutter. (See the actual photo on page 85.)

Sometimes multiple exposures are conceived well in advance (and all first-generation, in-camera multiple exposures must be planned), like the Las Vegas composite. I planned the shot, took the component transparencies, and then combined them in the darkroom. In other situations, elements come together later, as did the church floating in the clouds. I placed several transparencies on a light table, including a Taos, New Mexico, church; about a dozen sunsets; and a few cloud patterns. I held a couple of images together, decided if they made artistic sense and then tried others. I liked the sunset/church combination, and as a fluke tried the addition of the clouds as a double exposure. I loved the result and have since made several variations along the same theme.

Three Ways to Make Multiple Exposures

I prefer to make multiple exposures on film, rather than on photographic paper. Once you have an original composite image on film, you can make duplicate transparencies and prints easily. If the original special effect is done on paper, you must make a copy negative or copy transparency before it can be duplicated or published. The price you pay for this is reduced resolution, because your creation will be an additional generation away from the camera originals.

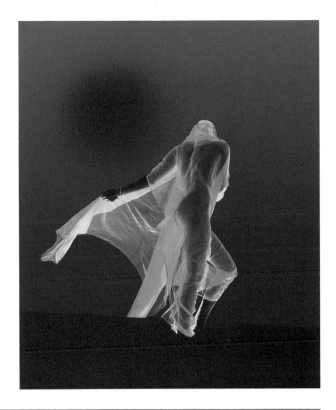

(Top left) Some images can be used for both sandwiches and multiple exposures. In the last chapter, I demonstrated how a shot of a model on the sand dunes of Death Valley was used in a sandwich. Here, the same image will be double exposed with a new element: Earth.

(Above) When you double expose two photographs onto a third piece of film, the portions of this film that receive both exposures can be overexposed. The easiest way to prevent overexposure in this case was to create a dark, soft-edged sphere in the sky into which Earth could be placed. I placed the dupe film on the Unicolor easel in the dark and then covered it with the plastic protective section that came with the easel. I turned on the light and projected the transparency of the negative image onto the easel. I selected an area of the sky to place Earth, and I carefully drew a rough circle right on the plastic divider.

Next, I took a wire coat hanger that had been straightened and taped a small, round paper cutout on the end of it. This was my dodging tool. A *dodging tool* is a small opaque object used to block an enlarger's light from striking a portion of film or paper during an exposure. You can hold back the light for all or part of the exposure. I turned off the room light, uncovered the dupe film on the easel, and made the first exposure. During the ten-second exposure, the opaque paper cutout was suspended between the enlarging lens and the dupe film. By vibrating my hand as I held the dodging tool, I prevented the enlarger's light from striking that portion of the sky. The vibration in my hand gave the sphere a soft, attenuated edge.

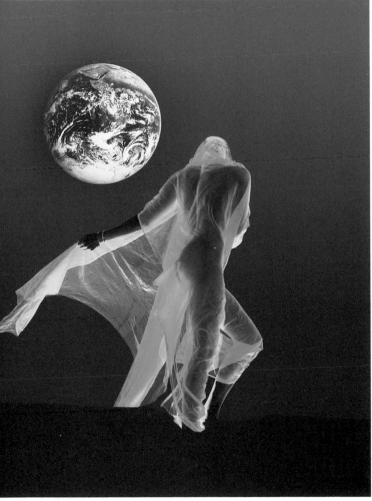

(Bottom left) Next, I covered the exposed piece of film again and turned the room light back on. I replaced the negative image of the model in the enlarger's negative carrier with the transparency of Earth (the white border around Earth was opaqued out to black). I turned on the enlarger light with the enlarging lens open to its widest aperture for ease of viewing, and repositioned the easel such that Earth was placed within the circle that had been defined earlier. The distance from the projected transparency to the easel determines the size of Earth in the sky. Once everything was in position and the lens was closed down to the predetermined aperture, I turned off the room lights, removed the plastic cover from the dupe film, and made the second exposure.

I then placed the 4x5 sheet of duping film in a light-tight box and took it to the lab for developing.

Technical Data: Both exposures—10 seconds, f/11, 75mm Rodenstock enlarging lens. Exposure was determined by testing. The print of Earth came from the Johnson Space Center in Houston, Texas. It was free, since it's in the public domain.

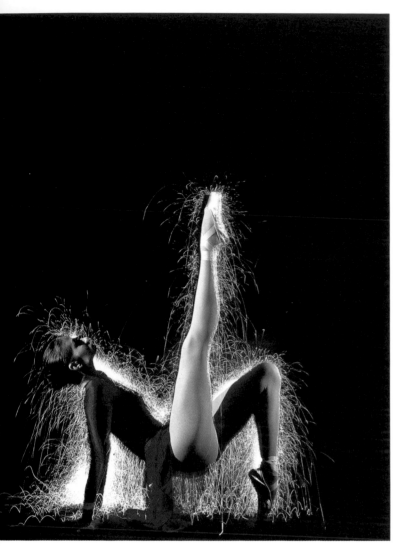

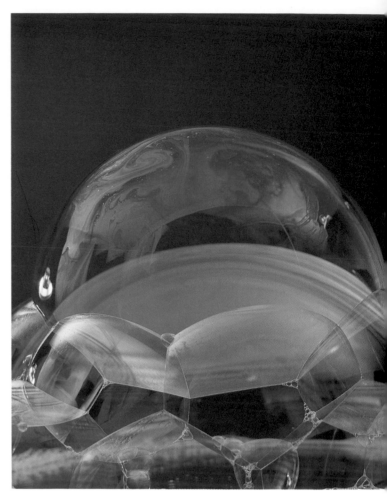

The photo session of the dancer produced mostly conventional studies, except this one favorite shot. I placed my model in front of a black background and asked for a unique pose. Two strobes were set up, one on either side of her. The camera was mounted on a tripod and, when the room lights were turned off, I locked open the shutter (with a locking cable release) and walked behind the model. After she assumed her pose and assured me her balance was stable, I lit a bundle of four sparklers. Using the dancer's body to hide the burning sparklers from the camera's view, I moved them up and down her form while they burned. The exposure lasted about thirty seconds. In that time, the sparks flew out in all directions and were recorded on the film.

I'm not visible in the shot because I was wearing dark clothes, but also because the sparklers were so brilliant—many f/stops brighter than my face—that the latitude of film couldn't expose both the fire and me correctly. Using a small lens aperture guaranteed that I would be invisible.

With the dancer still holding the same pose, I went around to the camera and fired the two strobes to illuminate the front of her. Then I closed the camera's shutter.

I photographed the bubbles in my living room. To record the beautiful pearlescent colors in soap bubbles, it's necessary that they be close to a large, white surface. This can be a soft box, a large white sheet, or even a large, bright window. It is the whiteness that allows the camera to see the dazzling color swirls in the soap solution. This bubble solution was simple dishwashing soap. I prefer either Joy or Dawn, mixed about eight parts water to one part soap. You can blow the bubbles onto a glass surface with a plastic straw.

I placed the glass plate on which the bubbles were formed only twelve inches away from a Photoflex soft box suspended directly above. I mounted a Speedotron strobe head inside the box and suspended both on a boom as a single unit. This could also have been done by mounting portable flash units above a large, white sheet, but I chose the convenience of the soft box. If you use a sheet, make sure it is ironed smooth. The bubble surface is like a mirror and will definitely reflect wrinkles in fabric.

If you watch the colors on the surface of the bubble swirl about, you'll see many wonderful designs. However, they don't last long. In only a few seconds they lose their color and then, shortly afterward, the bubble bursts. Therefore, be quick in recognizing and shooting a nice pattern. Determine your exposure with either a flash meter or a Polaroid test. Small apertures are important for maximum depth of field.

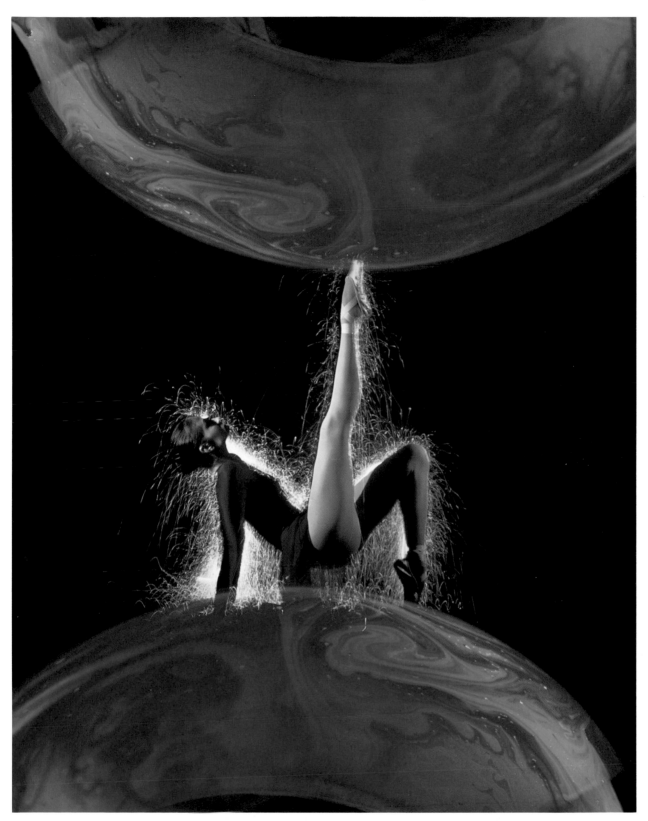

I projected the dancer's form onto the easel and sketched it on the plastic divider that covers the dupe film. Then, with the cover removed in the dark, I made the first exposure. Next, I put the shot of the bubble in the negative carrier and positioned it. I used only the top portion of the bubble, since the bottom of the original shot wasn't attractive and would only detract from the final composite. I made two different bubble exposures: one just above the dancer's foot, and one below her, suggesting she was supported by the colorful surface. To make the second bubble exposure, I simply turned around the easel and repositioned it under the enlarging lens.

Technical Data: Dancer—Mamiya RB 67, 127mm lens, f/22, Ektachrome 64, tripod. My lighting equipment was two Speedotron heads and Photoflex soft boxes. Bubbles—Mamiya RZ 67, 110mm lens, #2 extension tube, f/16, Fujichrome 50D, hand-held. All three exposures in the darkroom were 10 seconds at f/11 using the Schneider 100mm enlarging lens.

I preconceived this shot before either picture element was on film. The costume was rented from a local supplier. Model Nicole Compton was photographed against black background paper in the living room of a friend of mine in Las Vegas. I used two undiffused strobe heads.

The background is a zoom blur of the brilliant neon lights on the Las Vegas strip.

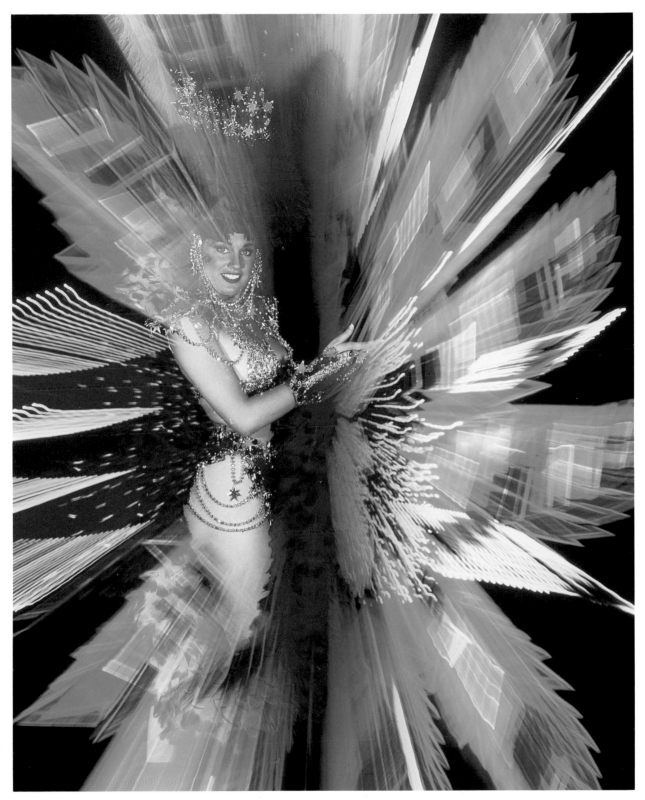

I double exposed the two images onto dupe film in the darkroom. During the neon lights exposure, I used a dodging tool to hold back exposure from the middle of the picture area to allow Nicole to show through the lights.

Technical Data: Nicole—Mamiya RB 67, 110mm lens, f/16, two strobe heads, Fujichrome 50D, tripod. Zoom blur—Mamiya RZ 67, 100-200mm zoom, 1 second, f/11, Fujichrome Velvia, tripod. The com-posite was made in the darkroom using a Saunders enlarger with a 75mm Rodenstock enlarging lens, 10 seconds, f/11, Kodak 4x5 Ektachrome Slide Duplicating Film 6121. During the exposure of the background, I held back a little exposure (using the dodging technique) in the middle of the frame so the brilliant color of the lights wouldn't interfere with Nicole's figure and costume. My dodging tool was a wire coat hanger with a small piece of black paper taped to it.

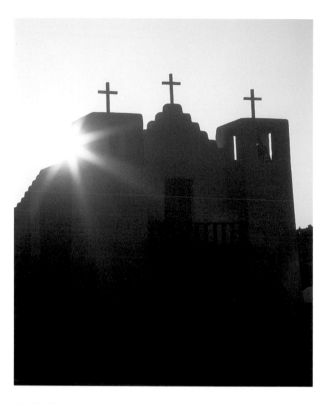

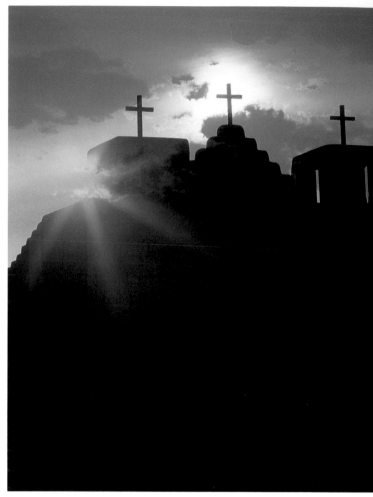

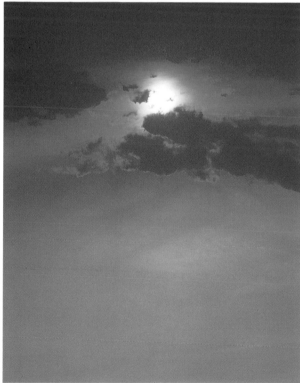

At the time I photographed the components of this double exposure, I didn't have any idea of using them in a composite. About two years later I was looking for images that might work as multiple exposures and decided to try a religious theme. The resulting composite was exciting to produce.

The four original images are: a Florida sunset taken from the balcony of a hotel room; clouds shot from an airplane window over Hawaii; the silhouette of the church in Taos, New Mexico; and a stained glass window taken in Los Angeles.

(Above) First, I sandwiched the church silhouette with the sunset, carefully placing the ball of the sun behind the center cross.

(Right) I placed these two pieces of film in the negative carrier of the enlarger and exposed them onto duplicating film. Then, with the dupe film covered by the plastic divider on the easel, I turned the room lights on and replaced the sandwich with the transparency of the clouds. I then turned off the room lights, positioned the projected image correctly over the easel, and made the second exposure.

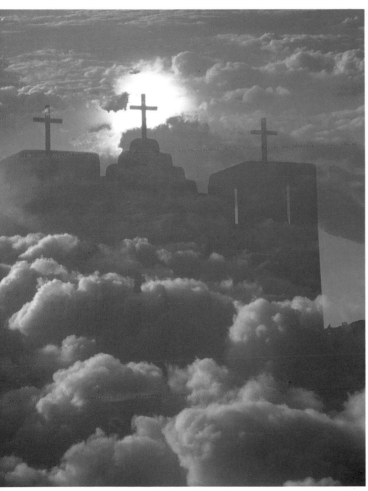

(Above) As a variation on this theme, I double exposed the church silhouette (without the sandwiched sunset) directly with the stained glass.

Technical Data: The exposure for the projected sandwich (church and sunset) onto the dupe film was 20 seconds at f/8. Note that this exposure time is longer than normal because there are two pieces of film that the enlarger's light must pass through. The cloud exposure was 10 seconds at f/11.

Both exposure times in the second double exposure were 10 seconds at f/11. A 100mm Schneider enlarging lens was used for these two composites.

The camera data is as follows: Taos church—Mamiya RB 67, 180mm lens, 1/125, f/5.6, Ektachrome 64, hand-held; aerial clouds—Mamiya RB 67, 180mm lens, 1/250, f/5.6, Ektachrome 64, hand-held; sunset—Mamiya RB 67, 360mm lens, 1/125, f/8, Ektachrome 64, tripod.

It is virtually impossible to capture a dynamic lightning strike during a beautiful sunset, so I decided to improve upon nature and create such a phenomenon.

This is a straightforward double exposure except for one thing: The lightning had to be reduced in size to fit nicely within the dark cloud. This would be easy to do, except that it's important to avoid showing the edge of the smaller picture when it's exposed into the larger one. I prevented the edge from showing by using a pen to poke a hole through a piece of black construction paper. The paper became my vignetting tool for printing the lightning.

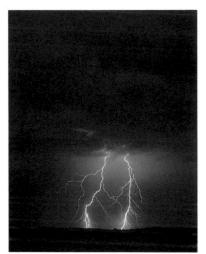

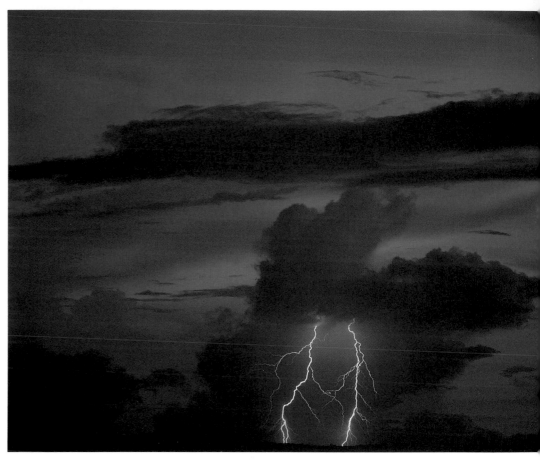

First I exposed the sunset clouds onto the dupe film. I outlined the shape of the black cloud on the white plastic divider so I knew exactly where to put the lightning. After I made the exposure and put the divider in place, I replaced the cloud shot with the lightning. I lowered the enlarger to reduce the size of the second image. I refocused, positioned the easel properly, turned off the lights, and then placed the black paper with the hole in it under the enlarging lens. During the exposure, the image of the lightning went through the hole so the edges of the frame disappeared. I kept the hole moving slightly during the exposure to make sure it didn't leave any unwanted impression on the film.

Technical Data: A Mamiya RZ 67 and a 250mm lens captured both the sunset and the lightning. The clouds were exposed at 1/8 second at f/5.6, and the lightning was exposed at f/4.5 with the shutter open until the flash discharged. Both were made on Fujichrome 50D with a tripod. The exposure time in the darkroom for the clouds was 10 seconds at f/11. The lightning exposure was 20 seconds at f/11 to compensate for the inevitable light loss due to the edge of the hole in the black paper intruding into the picture area. I used the 100mm Schneider enlarging lens to make the multiple image.

Always plan your exposure carefully. In most cases, when both slides are of average density, you should underexpose each exposure by one-half to one full f/stop. If you combine three slides, each one should be underexposed by one and one-third f/stops. But this is true only if the elements in the various originals will be superimposed over each other. If the components don't actually touch — such as double exposing the moon in a black sky with a city skyline, where the moon floats above the city without touching it — no exposure compensation is necessary.

First-Generation, In-Camera Multiple Exposures

Most of the better 35mm cameras today offer a multiple exposure feature that allows you to make up to nine exposures on a single piece of film (you can increase this number by shooting eight exposures and then resetting the multiexposure button to "one"). If you have an older 35mm camera, refer to the instruction manual to find out if you can make two or more exposures on the same piece of film. The majority of medium-format cameras also permit multiple exposures.

The advantage of making multiple exposures in the camera is that the original composite is composed of only first-generation images. This means that the result will give you the sharpest picture possible. A darkroom composite produces a second-generation composite, which should be sharp, but not as sharp as a direct in-camera image.

There are, however, disadvantages to creating in-camera multiple exposures. First, if one of the images doesn't work, the entire composite is ruined. For example, let's say you want to double expose a girl's face with a pattern of rose petals. First, you take the portrait of your model. Then, you shoot the petals. The result may be great, but if the girl just happened to blink when the shutter fired, her eyes will appear to be closed — and the shot is worthless.

Another disadvantage is that precise placement of picture elements is difficult, if not impossible, to achieve. You can closely approximate the positioning of subjects such as people, the sun or moon, mountain ridges, buildings and so on. But if you need critical alignment, where one image ends at the precise point where another begins, you can only achieve this in the darkroom.

Having said this, in-camera multiple exposure is a viable technique that can produce exciting images with little effort or expense.

Second-Generation, In-Camera Multiple Exposures

You can maintain maximum control over the final composite image if you combine two or more images that already exist in your files. Although you will then produce a second-generation photo, you won't have to guess how it will look. And if the combination doesn't please you, you can easily do it again or replace one of the components to improve the composition.

The easiest way to achieve this is with a simple 35mm slide duplicator. These devices are available through camera stores, and they usually cost less than $100. (See pages 22-24 for more information on using this kind of duplicator.) To create a double exposure, simply insert the first slide into the holder, photograph it, and then, after cocking the camera's shutter (but not advancing the film), insert the second slide and take another exposure. Depending on the camera system you have, the TTL meter should be able to read the sunlight for a proper exposure if the sun is your light source, but you must conduct a series of tests to determine the proper distance from the end of the duplicator to the flash. With correction filters, of course, you can mix film and light source. For example, if you shoot daylight-balanced film but use a photoflood to make the exposures, use an 80B filter to balance the film with the color of the light.

When you copy slides, it's crucial to maintain the cleanest environment possible. This is especially true when working with double exposures, because you have twice the number of surfaces to keep clean. The film must be completely free of dust, scratches, and imperfections in the emulsion. Once in a while, you'll find that a shallow scratch or emulsion flaw won't show in the duplication process. This happens because the light source is diffused by the white Plexiglas diffusion panel, and the soft illumination wraps itself around the flaw and seems to smooth it out.

(Above) Most of the time a double exposure will consist of two different images. In this instance, I photographed the same Japanese bridge twice, with two different filters. I first took the shot using a magenta filter, and then took the second using a cyan filter. I purposely did not use a tripod so the two exposures of the bridge would not be in register. I underexposed each exposure by one f/stop.

Technical Data: Canon EOS 1, 100mm lens, 1/125, f/5.6, Ektachrome 64. The filters were colored gels from a camera store.

(Left) This abstract flower image is a result of a unique application of multiple exposure. It is the same composition photographed thirty-two times on the same frame *without a tripod*. I hand-held the camera, purposely making each exposure a little out of register with the previous ones. Similar to composing the shot for a zoom blur, this technique requires that a majority of the frame be filled with color and contrast. A large expanse of blue sky, for example, wouldn't work if it were a predominant part of the composition.

The trick is determining the exposure. In fact, once you know the formula, it's quite easy. The proper exposure for this kind of multiple exposure is as follows: The number of f/stops that you must underexpose the photo is the *exponent of two that equals the number of exposures you want to make.* For example, my photo of the flowers was 32 exposures. Two to the 5th power equals 32. Therefore, 5 is the exponent of 2 that gives you 32. So, I underexposed the picture five stops from what my light meter dictated. The original reading was 1/125 at f/5.6. Five stops underexposed is 1/1000 at f/11. Here is a list that will help you for other numbers of multiple exposures: 4 exposures equals 2 stops underexposed, 8 exposures equals 3 stops underexposed, 16 exposures equals 4 stops underexposed, 32 exposures equals 5 stops underexposed, and 64 exposures equals 6 stops underexposed.

Consult your camera manual to learn how to make your particular camera give you multiple exposures.

Technical Data: Mamiya RZ 67, 127mm lens, 1/1000, f/11, Fujichrome 50D, hand-held.

Second-Generation Darkroom Multiple Exposures

The technique I use to make composite images from the medium-format originals taken with my Mamiya RZ 67 system can also be applied to 35mm photography. Instead of using a slide duplicator, I put the original images—one at a time—in an enlarger (using a 50mm enlarging lens for 35mm slides and a 75mm or 100mm enlarging lens for 6x7 transparencies) and project them onto Kodak's 4x5 Ektachrome Duplicating Film 6121. This method has several advantages over the other two already discussed in this chapter:

1. The dichroic color head on an enlarger offers many possibilities for color correction and color enhancement. It's a simple matter of dialing the amount of filtration using a calibrated scale.

2. Virtually any amount of enlargement is possible using the enlarger. For cropping purposes, 35mm slide duplicators are usually limited to 4X enlargements.

3. Enlarging lenses are considerably sharper than the inexpensive fixed focal-length lenses in slide duplicators. I have found that Rodenstock lenses are the sharpest.

4. You can achieve critical focusing by using a grain focuser. Precise focus is challenging with inexpensive slide duplicators, especially with a fixed small aperture lens. A small f/stop means that little light is transmitted through to the viewfinder, which in turn means that it is difficult to determine the sharpest point of focus.

5. You can easily spot dust particles with the grain focuser while the original lies in the negative carrier. They can then be removed before the composite exposure is made.

6. When you create the multiple exposure on a large piece of film—2^1/4 inches square, 2^1/4 x 2^3/4 inches, or 4x5 inches—it is much easier to strategically place picture elements. This is true whether you use the technique of masking (see Chapter Seven) or simply align components visually.

7. Burning and dodging are possible when making individual exposures during the multiple exposure procedure. This permits you to selectively add or take away density from any portion of the original transparency. *Burning*

means that you allow additional exposure to a portion of the image while you hold back exposure from other parts. *Dodging* is the term that denotes holding back exposure from a specific area of the picture while permitting the rest of the photo to receive light.

A large majority of multiple exposures don't require critical placement of the picture elements. In other words, if I put a laser abstract into a shot, it's not terrible if it ends up one-eighth of an inch from the spot where it was intended.

With this type of approach, composite images are easy to construct with a Unicolor easel (see pages 18-19 for a more detailed description). The plastic dividers that come with the easel are used to cover the dupe film between exposures. You can turn the room light on so you can place the second original in the negative carrier and compose it as you wish. Then remove the divider, make the second exposure, and cover the film again. In this way, you can make all of the exposures until the composite is completed.

To place each picture element in the correct position, I cut a small piece of white paper to fit on top of the divider. After I tape it into place, I use it to draw the placement of each picture element. If I'm combining a perspective grid with a bubble, and the edge of the grid must touch the bottom of the bubble, I'll draw a straight pencil line on the paper. When I place the perspective grid in the enlarger, I align it with the line and then make the exposure.

It's important that the plastic divider be in the exact same position when aligning the various picture elements. When all of the dividers on the easel are in position, there's a little "play" in the way they fit together. Therefore, when I project one of the transparencies onto the paper taped to the divider, I apply pressure against the divider, forcing it into the corner of the easel. I do this every time I align subsequent picture elements, ensuring that the plastic divider is always in the exact same position. If I want to add more elements with successive exposures, I simply mark a pencil spot on the paper and make my exposure to coincide with that. In most cases, I can place the two photographs just where I want them. But if my alignment is a bit off when the film is processed, I just do it again.

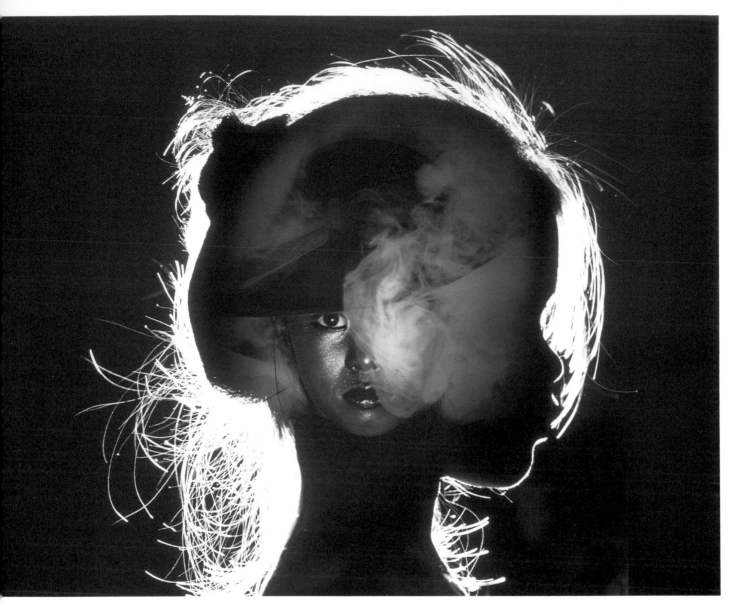

Wedding photographers use a technique for combining two head shots of the bride into a single, elegant double exposure. One of the images is a silhouette and the other is a normal portrait. The shot you see here exemplifies the same concept, but it hardly belongs in a wedding album.

The silhouette used in this example was taken with extreme back-lighting so the hair would really glow. My light source was a six-dollar photoflood placed about two feet in back of the model. The same girl in metallic blue makeup was photographed using a fog machine I rented. The even illumination was provided by two undiffused Speedotron strobe heads. I then double exposed these two pictures onto duplicating film. The dark portion of the silhouette allowed the blue portrait to be superimposed into that area cleanly.

Technical Data: Both originals—Mamiya RZ 6X7, 180mm lens, Ektachrome 64. Exposure data for the silhouette was 1/125, f/8; for the blue portrait, f/16. The composite was made on Kodak 4x5 Ektachrome Slide Duplicating Film 6121 using my Saunders enlarger, 75mm Rodenstock lens; each exposure on the dupe film was 10 seconds at f/11.

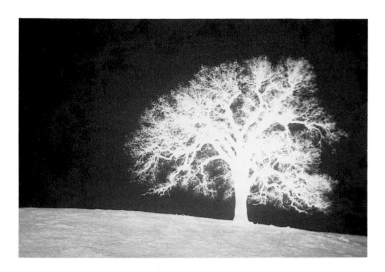

You can use a simple 35mm duplicator for many effects. This is a double exposure of a black-and-white negative (mounted in a 35mm slide mount and shot with a yellow filter) and a sky filled with dramatic clouds that was taken with a red filter. First the tree was exposed, then the clouds. I determined both exposures by the in-camera meter.

Technical Data: I took the original black-and-white shot of the tree with a Canon F1, 200mm lens, on Tri-X film rated at 320. The clouds were exposed with a 100-300mm zoom and a 25A red filter on Ektachrome 64. The sandwich was made with duplicating film and a photoflood. My exposure, based on the in-camera reading, was 1/8 second for the tree and 1/2 second for the clouds.

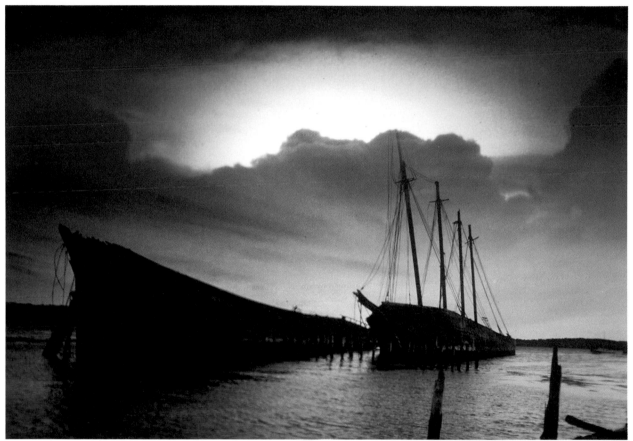

These old, rotting schooners in Wiscassett, Maine, were photographed against an overcast sky. To improve the picture, I went through a two-step process. First, I sandwiched some Hawaiian clouds with a Florida sunset and copied the sandwich onto 35mm duplicating film.

The second step was making the double exposure. It was important to prevent the overcast sky from washing out that portion of the sunset where the two would be superimposed above the schooners. To accomplish this, I used a piece of cardboard as my dodging tool to block the exposure of the white sky. I held the cardboard about six inches away from the end of the 35mm duplicator (between the duplicator and the light photoflood) to make sure that the edge of it was sufficiently out of focus. This prevented a harsh line between the sky and the horizon in the composite image. The result of this action, before the second expo-

sure occurred, was ships against a dark sky.

When I added the exposure of the clouds/sunset, I needed to prevent the clouds in the lower part of the frame from being superimposed over the ships. I used the same dodging technique, but this time I held the piece of cardboard to block the *bottom* of the cloud picture as it was exposed into the ships.

This type of dodging is not precise, but in many types of special effects it can work quite well. Several attempts may be necessary before you're satisfied with the results.

Technical Data: The ships were photographed with a Canon F1, 24mm lens, on Kodachrome 64. The clouds and sunset were shot with the 100-300mm zoom lens also on Kodachrome 64. I made the composite on 35mm Ektachrome Slide Duplicating Film.

(Above) Sometimes I like producing bizarre images simply for shock value. I chose a shot of an ancient Mayan skull that I had photographed in the Museum of Anthropology in Mexico City.

(Above right) I chose to combine this with an eye from a shot of a red-eyed tree frog. I made a simple mask for the frog's eye by punching a hole in black construction paper, which effectively blocked out the entire frame except that outrageous red eye (the better to see you with, my dear!).

(Right) For the double exposure, I first projected the skull onto the 4x5 duplicating film. Having marked the positions of both eye sockets on the plastic divider, I sandwiched the transparency of the frog with the punched black paper—such that the eye appeared in the hole—and double and then triple exposed the eye into the skull.

Technical Data: All exposures were 10 seconds at f/11 using the Schneider 100mm enlarging lens. Skull—Mamiya RZ 67, 110mm lens, 1/4, f/2.8, Ektachrome 64, tripod. Frog—Mamiya RZ 67, 180mm lens, f/16, flash, Fujichrome 50D, hand-held.

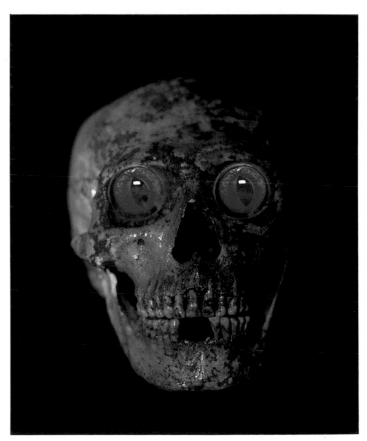

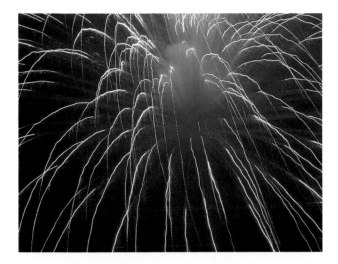

(Top) I usually shoot fireworks on the Fourth of July to increase my stock of abstracts. Spectacular bursts of fire in the night sky lend themselves to many uses when combining images. I used this shot as part of a double exposure I created for Westlight, my stock agency in Los Angeles, as a representation of New York as an exciting and dynamic city.

(Center) I shot the original nighttime image of the Manhattan skyline, taken from Brooklyn, on daylight film. The mercury vapor and fluorescent lights of the city were recorded as a greenish hue, but I thought they would look better against the red fireworks as a blue or cyan color.

(Bottom) When I made the first exposure on the dupe film, I dialed 30 units of cyan on my dichroic color head on the Sanders enlarger to change the color of the sky. On my system, every 90 units of color decreases the light output by one f/stop. Therefore, by adding 30 units of cyan, I had to increase my exposure by 1/3 stop. The fireworks shot was full of color and needed no correction. I simply made a second exposure and added it to the buildings of New York.

Technical Data: Manhattan—Mamiya RZ 67, 180mm lens, 10 seconds, f/5.6, Fujichrome 50D, tripod. Fireworks—Mamiya RZ 67, 110mm lens, f/5.6 with the shutter open until the burst exploded in the sky, Fujichrome 50D, tripod. The exposure time to create the composite in the darkroom for the city was 13 seconds at f/11 with 30 units of cyan *in addition to* the normal filter pack. The fireworks shot was exposed at 10 seconds at f/11, which is my standard time for properly exposed single transparencies. A different bulb and condenser would probably require a different exposure time. I used the 75mm Rodenstock enlarging lens for both images.

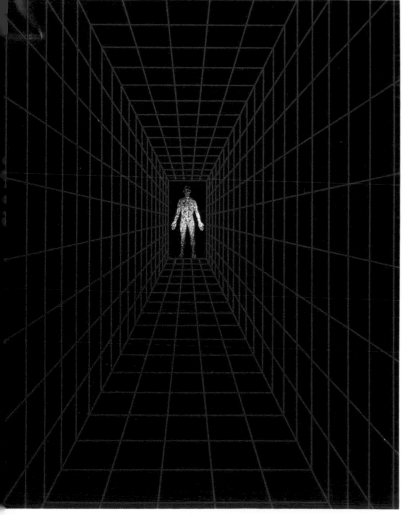

(Above left) I was looking for interesting perspective grids when I discovered that art supply stores carry some unique designs by the same companies that manufacture press-on lettering. I photographed the grid on black-and-white litho film (see pages 100-102 for a complete description of this technique) and produced a negative image: white lines on a black background.

(Above) I made the figure of the man by using the plastic shell of "Visible Man," a science model, available in toy stores, that teaches children about human anatomy. The colors in the plastic come from the use of two polarizing filters, one placed over the camera lens and the other positioned behind the man. Actually, the polarizer behind the figure wasn't a glass filter, but rather it was an eighteen-inch-square piece of polarizing material I bought from Edmund Scientific. I hung this material behind the plastic shell of the human figure and placed the photoflood on a light stand behind that. By turning the filter on the camera, I produced a multitude of colors in the plastic.

(Left) I carefully sketched the outline of the grid's inner rectangle on the plastic divider so I knew where to place the man. The man had to be reduced in size to fit inside the innermost rectangle, so I lowered the enlarger considerably to accomplish this. When the enlarging lens is only a few inches from the easel, it's impossible to position a grain focuser underneath for critical focus. The only solution I've found to this problem is to use a loupe and focus from the side. I reverse the loupe and move it back and forth until I find the critical point of focus. Then I turn the focusing knob on the enlarger until I can determine that the projected slide is focused. This is admittedly awkward, but I don't have any other solutions. When the two images were double exposed on dupe film, I added 90 units of red to the grid.

Technical Data: Exposure for the grid was 20 seconds at f/11; the polarized man was 15 seconds at f/11. Both shots were made with the 75mm Rodenstock enlarging lens. Human figure—Mamiya RZ 67, 110mm lens, two polarizing filters, 1/4, f/8, Fujichrome 64T, tripod. The light source was a single 3200 Kelvin photoflood.

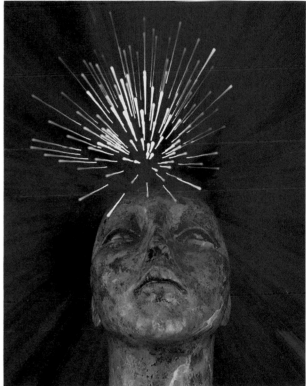

(Top left and right) Two of the component frames in this triple exposure were created using zoom blurs (for an in-depth description of technique, see pages 58-59). The magenta abstract is a zoom blur of flowers, while the streaks of light are a zoom blur of pinholes punched into a black poster board.

(Above) First, the mannequin, which I had purchased from a commercial display company, was exposed onto the duplicating film. Then I sketched the shape of the head on the plastic divider and marked the general features of the face.

(Above) I then exposed the magenta zoom blur over the mannequin, and finally positioned the streaks of light just above the head. Note that no exposure compensation is necessary here. Normally, when two or more images are overlaid, their combined exposure produces overexposure. But the way I put these three images together avoided this problem. Remember, when you have multiple exposures of two or more images together, black is unused film and a shadow—even one with detail—will permit another shot to be placed into it, usually without adjusting the exposure. Here, the mannequin head is partially in the shadow of the flower zoom blur, and the darker side of the face combines with the magenta streaks without any need for compensation. The bright lines of light actually overexpose whatever they are placed over—but this is precisely the desired effect.

Technical Data: Both zoom blurs—Mamiya RZ 67, 100-200mm zoom lens, 1 second, f/8, Fujichrome Velvia, tripod. Mannequin—Mamiya RZ 67, 110mm lens, f/16, Photoflex soft boxes and two Speedotron strobe heads, Fujichrome Velvia. All three exposures in the darkroom were 10 seconds at f/11 on dupe film. The enlarging lens was a Schneider 100mm.

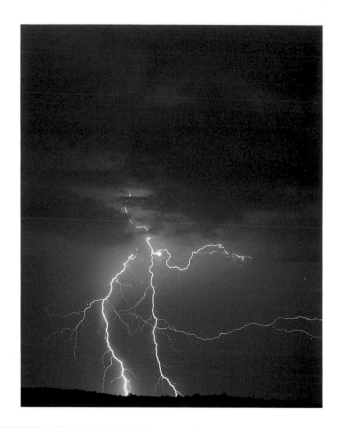

I had a night panorama of Los Angeles that needed something exciting in the sky, so I added a lightning bolt and a laser abstraction. I've used night pictures of lightning in many double and triple exposures because they work so well. The brilliant bolts are surrounded by relatively dark portions of sky, into which any other image can be added. The lightning strike (left) included in this composite image was taken in Arizona during the monsoon season (July and August). When shooting lightning at night, just open the shutter of your camera until the one or more flashes take place, and then close the shutter. If the lightning bolts are in the distance, an aperture of f/4 to f/5.6 works well with 50 ISO film. If the storm is close or directly overhead, it's best to use f/8 to f/11.

(Above) I chose a laser abstraction I had photographed during an eight-second period in a laser light show. It's impossible to predict what kinds of images will result under these difficult shooting conditions. It's best, therefore, to shoot a lot of film, hoping to get something good.

(Left) The panorama of Los Angeles was the first exposure on the dupe film. On the white, plastic cover that fits over the 4x5 sheet of film on the easel, I projected the transparency of the city and carefully drew the horizon line. This gave me a reference point. I then placed a single dot where I wanted the laser to go. When I exposed the dupe film, I held back exposure from the sky using a small, opaque piece of matboard. In other words, I held the board under the enlarging lens during the ten-second exposure so that the edge of the shadow fell on the horizon. This dodging technique prevented light from striking this portion of the dupe film, thus rendering the sky black because no light reached it. If this weren't done, when the lightning was double exposed it would combine with the pale green sky, washing out the drama of the bolt.

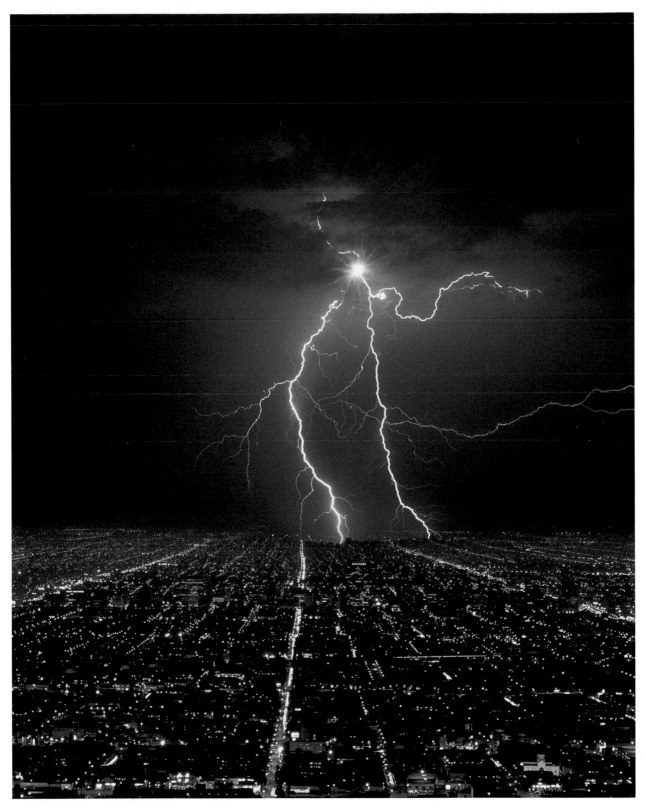

The second exposure was the laser abstract. With the plastic divider in place protecting the duplicating film from unwanted exposure, I projected down and positioned the laser transparency where I had earlier marked the dot with a pencil. I turned the lights off, removed the plastic cover, and made the second exposure.

The lightning bolt replaced the laser shot in the negative carrier, and I made a third exposure after positioning the burst of light as I wanted it.

Technical Data: Panorama of Los Angeles—Mamiya RZ 67, 110mm lens, 10 seconds, f/4, Fujichrome Velvia, tripod. Laser image—Mamiya RZ 67, 110mm lens, 5 seconds, f/4, Fujichrome 100D, tripod. Lightning—Mamiya RZ 67, 180mm lens, f/4.5 with the shutter open, Fujichrome 50D, tripod.

All three exposures in the darkroom were made at 10 seconds with a 100mm Schneider enlarging lens set for f/11. During the dodging procedure, I moved the matboard slightly at the horizon to prevent the imprint of a hard line.

Subjects photographed against a black background can easily be combined with other images. But what happens if you want to combine elements that were not photographed against black? What if you want only part of the background, or none at all? You use high-contrast masking technique to do this.

Masking is a procedure whereby you can literally separate a subject from its background and then combine that subject with another background. Some subjects are easier to separate than others, but with enough patience this technique is the ultimate in photographic manipulation. Masking has such a wide range of applications that it opens up unlimited possibilities for creating virtually anything you can imagine on film.

Understanding the procedure is relatively simple. The challenge is to be technically precise. In other techniques, such as creating abstracts, you have a lot of room for error. In fact, sometimes your errors can be exciting images. Not so with high-contrast masking. Sloppy technique will result in a photograph that looks like a mistake instead of a work of art. Follow the techniques precisely as explained and you will be amazed at what you can create.

What Is Masking?

When you mask a photograph, you actually separate the subject from the existing background so it can be placed into another photograph cleanly—without any part of one image superimposed on any part of another image. The two components touch each other only at their edges.

A simple example of this type of application is replacing an unwanted background with another image. Let's say you took a shot of a zoo animal, but some wire mesh shows in the background. You would use masking to remove the animal from its cluttered, original background and place it in a picture of out-of-focus foliage. The masking technique lets you make the final composite appear as natural as possible. If your tastes are more avant garde, you could use high-contrast masking to replace the pupil of someone's eye with the sphere of Earth.

To explain the masking procedure step by step, I must first introduce high-contrast lithographer's film (generally called simply "litho film"). Litho film has been around for a long time; if you're familiar with using it, feel free to skip this next section. If you haven't used litho film for a long time and are a bit rusty, or if you've never experimented with it, you'll be intrigued with the creative possibilities it offers.

High-Contrast Litho Film

With conventional photography, a contrasty image means that the shadows have lost much of their detail and become very dark, and the highlights have likewise lost their fine detail and become somewhat washed out. Litho film takes contrast to the extreme. All middle tones are eliminated, and the resulting picture is seen literally as black and white—no grays at all. However, when you look at a piece of litho film, it doesn't actually *look* black and white; it looks black and clear. Only when the image is reproduced as a photographic print or, as in the case of this book, on a printed page, will it look black and white.

Any original photograph can be turned into a high-contrast image using litho film. A slide, a color negative, a black-and-white negative, and even a print from your family photo album can be rendered high contrast. You can make a litho positive or a litho negative from any original.

The commercial name of each brand of high-contrast film usually reflects the name of the manufacturer. For example, Kodak's product is called Kodalith. The Nacco Company calls theirs Naccolith. Litho film is available in 35mm rolls as well as sheet film. It comes in boxes of 4x5, 8x10 and even larger. For masking purposes, 35mm high-contrast film is impractical because the image area is just too small for accurate pin registration (more about that later). The masking examples in this chapter were done with the convenience of the 4x5-inch size.

Exposing the Film

Turning an original photo into a high-contrast black-and-white image is actually very easy. Unlike color slide duplicating film, the litho material can be used with a darkroom safelight so you can see what you're doing. However, the amber safelight normally used when working with black-and-white printing paper will fog the litho film. Litho film is *orthochromatic*, which means it's insensitive to red light. Therefore, the safelight can *only* be red. Red safelights are available in any camera store that sells darkroom supplies. Don't take a shortcut and use some other red bulb, such as a Christmas tree light. The shade of red will be wrong, and it won't work.

When handling litho film, dust is less of a problem than when you work with slide duplicating film because (1) you don't work in total darkness, and (2) any dust introduced on the litho copy can be easily eliminated. You can, therefore, make a contact print (the original is placed in physical contact with the unexposed litho film) to get maximum sharpness in the combined image. If the original image is a color or a black-and-white print, photograph it using slide or negative film, and then use that piece of film to contact with the 4x5 sheet of litho film. Alternately, in the darkroom you can cut a piece of litho film to fit across the film plane in your camera (with the emulsion side toward the lens). Close the back of the camera, turn the room lights on, and photograph the print directly on the piece of high-contrast black-and-white film. Then the film is developed as described below. You can only get one shot per load, so to speak, but it works beautifully.

(Above) It can be frustrating to take a shot that would be perfect for a sandwich except for some obvious flaw. This church window photographed on the island of Moorea in Tahiti was unfortunately very dirty, and the sky behind it was washed out. I had waited for more than an hour for the bird to return to its perch (it had flown out of the church when I walked in), and I knew there was potential for this picture.

(Above right) Masking can be used for cleaning up silhouettes. I made a duplicate of the original photo onto the black-and-white litho film, which gave me a high-contrast negative. I then selectively applied, with a fine brush, dabs of the black, viscous liquid called Opaque to fill in all the unwanted clear areas on the film. (The dirt, which was dark on the positive, was now clear on the negative.)

(Right) When this negative image was then duplicated onto litho film, I obtained a positive (in photography, just like in mathematics, a negative of a negative is a positive), but this time it was perfectly clean and ready to accept the sandwich of the sunset.

Technical Data: Original church window—Mamiya RB 67, 180mm lens, 1/60, f/4.5, Ektachrome 64, hand-held. Sunset—Mamiya RZ 67, 360mm lens, 1/30, f/6, Fujichrome 50D, tripod. Sandwich—10 seconds on dupe film using a Schneider 100mm enlarging lens at f/11.

The contact print is simple to make. Place a sheet of litho film on the enlarger's baseboard, directly under the lens, and position the original on top of it. The two pieces of film must be emulsion to emulsion. The emulsion side—the surface that actually comprises the picture—of a piece of film is the dull side. To make sure the litho copy is as sharp as possible, the two emulsion surfaces must be in physical contact with each other. To guarantee complete contact, a piece of clean, one-eighth-inch-thick glass covers the two films. When you switch on the enlarger, the white light makes the exposure. The actual exposure time will vary depending on the density of the original. You'll have to experiment to get the best results.

It's also possible to make a contact print without an enlarger or darkroom timer. Any flat surface will suffice in place of the enlarger's baseboard. Working under the red safelight, place the original transparency on top of the 4x5 litho film, put the sheet of glass over both films, and then use any overhead bulb for the exposure (since you're working in black and white, the color temperature of the bulb isn't relevant). The second hand on your watch can measure the time. Your exposure will depend on the intensity of the bulb, the distance of it from the film, and the exposure time.

Developing the Film
Litho film is easy to develop. There are only three steps. After exposure, place the 4x5 sheet in a small tray of "A" and "B" developer. These two chemicals, available in either liquid or powder form, are stored separately but are mixed together to make the solution of working developer. Once you've prepared them according to the instructions, use equal amounts of each. Depending on the size of the tray, you might mix ten ounces of part "A" with ten ounces of part "B."

Leave the litho film in the developer for two minutes. If you find that you've given too much or too little exposure, don't change the development time to compensate. Instead, alter the length of exposure. The full two minutes will ensure that the image produces pure blacks. Make sure you agitate the developing film during this period.

The second step, the stop bath, halts the action of the developer. You can use tap water or the usual solution for normal black-and-white printing.

The last step is the fix. This is also the same chemical used for black-and-white paper. The film should be fixed for five or ten minutes. Wash the sheet film in running water for ten minutes and then hang it up to dry in a dust-free environment. If you don't have a drying cabinet, the best place for this is a shower stall or bathtub. After the film is hung on clips, close the bathroom door and any windows to minimize air currents that might deposit dust on the wet film. If you have a difficult time waiting the half hour for the film to dry (I am really describing myself), you can use a hair dryer to dry it in about two minutes.

Fixing the Imperfections
When you study the developed litho film, you'll notice that the black areas are solid black except for a few "stars" or white specks that are present. If you underexposed the film, you'll have many of these specks. But even with the correct amount of exposure these annoying little bits of clear film will most likely be where you don't want them.

To eliminate the stars, apply a gooey substance called Opaque. This stuff comes in either black or red in a little jar; any camera store that sells darkroom supplies carries it. It's applied with a tiny, fine-haired brush available in art supply stores. Working on a light table will make life a lot easier. Some of the stars are so small it's difficult to retouch them with the unaided eye, so use a loupe to watch the tip of the brush as it applies the Opaque to cover the imperfection. In this way, any dust particle can also be eliminated. The Opaque dries in a few minutes, depending on how thickly you apply it. A hair dryer can shorten the drying time.

The overall contrast of the picture is now *almost* as high as possible. To obtain the *highest* contrast possible, which is the objective, you still must make one more generation of the litho image. Contact print the retouched litho film onto a new piece of film to have a piece that's perfectly black and perfectly clear. After the stars are removed on this film, you'll be ready to be creative.

Combining Lithos With Color
We're now ready to discuss masking. But before we do, I want to suggest some interesting possibilities for using the high-contrast film in conjunction

When you study the developed litho film, you'll notice that the black areas are solid except for a few "stars" or white specks.

You can use the technique of sandwiching a litho positive with a color image to improve on reality. This photo of the famous statue of Christ in Rio de Janeiro had been taken against a rather boring sky. I produced a high-contrast copy, separating the statue from its background. This was then sandwiched with a beautiful sunset from my files and rephotographed on duplicating film.

Technical Data: Original photo of statue—Mamiya RZ 67, 350mm APO lens, 1/16, f/5.6, Fujichrome Velvia, tripod. Sunset—Mamiya RZ 67, 350mm APO lens, 1/125, f/5.6, Fujichrome Velvia, tripod. Sandwich—15 seconds, f/11, enlarger using a 75mm Rodenstock enlarging lens.

To eliminate the stars, apply Opaque. It dries in a few minutes, depending on how thickly you apply it. A hair dryer can shorten the drying time.

with color. If the image on the sheet of litho is graphically strong—such as a beautiful tree on a hillside, a face, a statue, a rearing horse, etc.—you can sandwich this picture with a color transparency and then duplicate it on duping film. (Sandwiching is covered in Chapter Five.)

When one photo is sandwiched with another, all the white or very light areas are replaced by that second image. How well the second image shows through depends on how much density is in that area. Because the clear area on the litho film lets the color image come through unimpeded, litho film works extremely well for sandwiches. Here's an example of how this works. I took a portrait of a young model whose face had been painted with a nontoxic gold makeup. Several years later, I decided to convert this shot to a litho positive to combine with another image. When I made the litho positive, her face became clear. I then sandwiched a portion of a soap bubble design with her face and "painted" her face with the bubble design.

Try a variation of this where you develop the litho sandwich in C-41 chemistry (described on page 30). If you sandwich a litho positive tree with a negative transparency of a sunset (the sunset had been duplicated and developed in C-41 to get the negative) and then copy the combination on duplicating film that is processed in C-41, the result will be a white tree against a positive sunset.

Masking

Masking is the process of combining two images into a single photograph without overlapping them. Instead, they abut each other so perfectly that they appear to have been together all the time. To create this illusion, create a mask that will eliminate any unwanted portions of an image.

A mask is a perfectly black and perfectly clear piece of litho film that blocks unwanted elements of an image from exposure. You'll need at least two masks for each combination: one mask to separate the subject from its background and the other to create an "opening" for the subject against the new background. All the picture elements must be precisely placed for the composite to look "real."

(Top) To create the metallic gold appearance of my young model, I bought a special nontoxic gold makeup at a store that specializes in costumes and theatrical effects. The makeup is actually finely powdered brass mixed with oil. I applied the color as evenly as possible with a small brush and allowed it to dry.

(Above) I already had a bubble abstract I wanted to combine with this portrait. The bubble solution used was dishwashing soap blown onto the glass surface with a plastic straw. I placed the glass plate on which the bubbles were formed only twelve inches away from a Photoflex soft box suspended directly above. I mounted a Speedotron strobe head inside the box and suspended both on a boom as a single unit. When I saw a pattern I liked, I quickly shot it.

(Left) I made a litho positive of the portrait. Note that the face and other light areas are clear now.

(Below) I sandwiched the portrait with the bubbles, enlarging it when I projected it on the duplicating film. There are actually four ways to sandwich two images together. First, you can combine the two photographs exactly as they appear when you hold them. Second, you can flip one of the shots relative to the other. Third, one of the images can be turned upside down before it is sandwiched; and fourth, the upside-down picture can then be flipped. When I sandwiched this litho portrait with the bubbles, I examined all four combinations and settled on this one as my favorite.

Technical Data: Gold portrait—Mamiya RB 67, 180mm lens, f/5.6, Ektachrome 64. I used a single portable Vivitar flash diffused with tissue paper taped to the flash. Bubbles—Mamiya RZ 67, 110mm lens, #2 extension tube, one Speedotron strobe head inside Photoflex soft box suspended on boom, f/16, Fujichrome 50D, hand-held. Sandwich—30 seconds, f/11, enlarger using a 75mm Rodenstock enlarging lens.

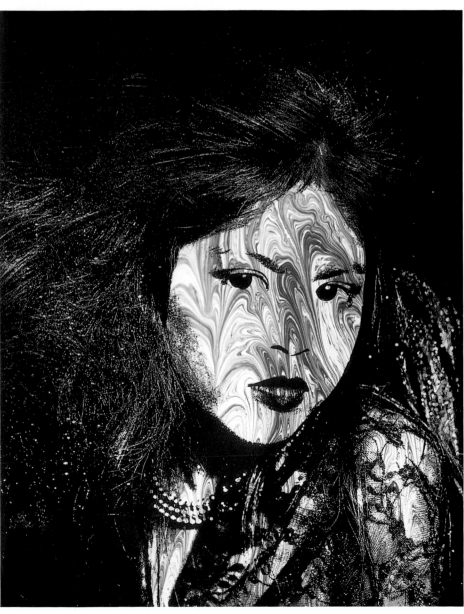

(Above) A variation of combining litho images with color is to produce the opposite of a black silhouette. You can instead make the subject a white shape against the background. In this example, the litho shot of the horse was sandwiched with a negative landscape (the original photo for the landscape was developed in C-41 chemistry) and then printed onto duplicating film. This dupe was developed in C-41 again, turning the litho into a negative image (making it white) and making the negative landscape into a positive (a negative of a negative is a positive).

Technical Data: Horse—Mamiya RZ 67, 250mm lens, 1/250, f/4.5, Fujichrome 100D. Landscape—Mamiya RZ 67, 180mm lens, 1/60, f/8, Fujichrome 50D processed in C-41 chemistry at a photo lab. Sandwich—enlarger with a 100mm Schneider lens, 6 seconds, f/11, Kodak 4x5 Ektachrome Duplicating Film 6121.

(Opposite page) Masking is very difficult using a 35mm duplicator, but with practice and resolve you can manage to perfect it. This gull was masked into an abstract flower background, but instead of pin registration I used lines and circles on the ground glass in the viewfinder to align various portions of the photo. This way I knew where the edge of the bird ended, for example, and where a flower began.

Using the split-image focusing aid on the ground glass, I moved the slide of the bird (and its mask) so that a particular spot on the wing just touched a memorable point on the circle around the split-image. The next mask that was double exposed into the same piece of film would be oriented to the same spot. This is far from precise, but with several tries you can make it work.

Technical Data: Original shot of bird—Canon EF, 200mm lens, Ektachrome 64. Flowers—Canon EF, 50mm macro lens, Kodachrome 64. The abstraction of colors in the flowers came from sandwiching a C-41 copy with an Ektachrome infrared copy of the same flower. The bird was then combined with the brilliant colorful background using the positive and negative litho mask. When the bird was exposed into the composite, I used a red filter.

The key to precision in masking is the use of registration pins. These are two small, metallic pins taped to a smooth surface, such as glass, that hold the pieces of film used to make a composite. The pins are positioned so they correspond precisely with the location of holes punched in the film. By laying the film onto the pins, all the elements in the picture will be in register—every time you lay the film on the pins the film will be in the exact same position, and each picture element will be in the precise position it will occupy in the composite. This permits you to make composites with total control. The edge of one picture can perfectly abut the edge of another.

There are two ways of making the final composite. If your enlarger has a negative carrier that can accommodate the registration pin assembly, you can project the masked photographs onto duplicating film. If not, you must contact print them onto the duplicating film like I do. It's true that dust will be a problem with contact printing at this stage, because you now must work in the dark (unlike when you made the original litho masters). Take precautions to keep the pieces of film clean.

The best way to explain the masking technique is to take you through the procedure step by step with a specific example. But first, we need to go over the materials and equipment you'll need. Before you turn off the lights and begin to make your composite, arrange these materials and memorize their locations:

- two 4x5 masks: a litho master positive and a litho master negative
- compressed air
- registration pin assembly taped down directly under the enlarging lens
- two-hole punch
- sheet of glass
- box of dupe film
- empty light-tight box to hold the exposed dupe film when you're done
 (Any lab will give you a discarded light-proof 4x5 box; they are thrown away all the time.)

To make the memorization process easier, I place several of these items so they touch some part of me: The compressed air nozzle is on my lap, the empty film box is under one foot, the sheet of glass is leaning against an ankle, and so on.

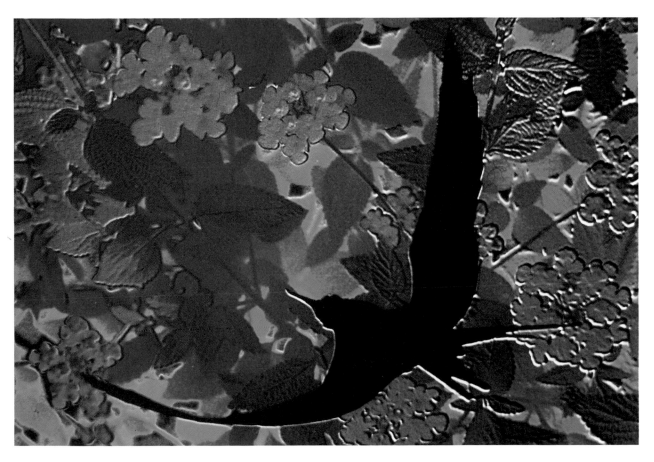

(Above left, above right) The two photographs to be combined are an albino barred owl and the stalactites in the Nerja Cave of southern Spain. The owl had to be separated from its background and inserted into the image of the cave.

Step 1. (Right) With the room lights off and a red safelight bulb turned on, I positioned a 4x5 sheet of litho film on the baseboard of my enlarger directly under the enlarging lens. I placed the transparency of the owl on top of the 4x5 sheet. The emulsion of the high-contrast film faced up, and the emulsion of the color transparency faced down, placing both emulsion surfaces in close contact with each other for the sharpest possible result. Several times I used compressed air to free both pieces of film from dust. I placed a clean sheet of glass on top of both films. My first exposure was a guess, but it was a good one. With the lens about seven inches from the glass, I made a ten-second exposure at f/4 with a 75mm Rodenstock lens. The sheet film was developed for two minutes in "A" and "B" developer, inserted in a tray of water for thirty seconds, and then fixed. When I saw that the exposure was good, I washed the film and then dried it with a hair dryer. This was the *first litho negative*.

Step 2. (Above left) Using Opaque and a fine-hair brush, I painted out the eyes, making the entire owl black. This was the *first **retouched** litho negative*. I inserted this piece of film into the two-hole punch and punched two holes in it.

Step 3. (Above right) When the Opaque dries (a hair dryer is handy for the impatient), the first retouched litho negative is now contact printed again onto a 4x5 sheet of litho film. This time, however, the new piece of film is punched with two holes *before* the exposure is made. I fitted the unexposed litho film on the registration pins first, and then the litho negative, emulsion to emulsion. My exposure this time was less because light can pass through clear film much easier than it can through continuous tone color transparencies. I used a six-second exposure at f/4. After development was complete and the new film was dried, I had the *first litho positive* exactly in register with the first retouched litho negative.

Step 4. (Left) In the first litho positive, the owl is completely clear (or, as it is reproduced in this book, white), and the unwanted background elements are clear also. With Opaque, the background could be cleaned up by blacking out everything except the owl. When I painted out all the clear portions of the background and dried the Opaque, the result was the *master positive*.

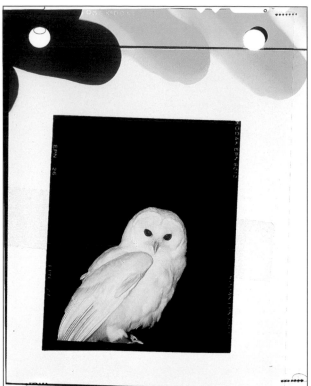

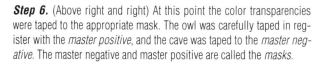

Step 5. (Above left) Under the red safelight, another unexposed sheet of litho film was punched with two holes and placed on the registration pins. On top of that, the *master positive* was also put on the registration pins and covered by the one-eighth-inch-thick piece of glass. I made the exposure for six seconds at f/4. When this new piece of film was developed and dried, I had the *master negative*.

Step 6. (Above right and right) At this point the color transparencies were taped to the appropriate mask. The owl was carefully taped in register with the *master positive*, and the cave was taped to the *master negative*. The master negative and master positive are called the *masks*.

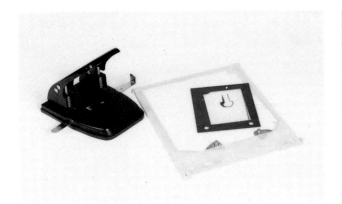

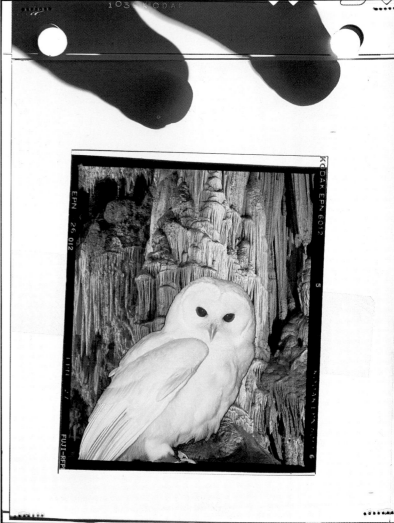

Step 7. Set up your equipment so you can find it in the dark. Select the aperture on the enlarging lens, set the timer for the proper exposure, and make sure the filter pack is adjusted correctly for the particular emulsion being used. Keep accurate notes of all the data for any adjustment later.

With all lights turned off, open the box of unexposed dupe film, remove one sheet, and close the box again. Feel for the notch cut into one corner of the 4x5 sheet and orient the film so that this notch is in the upper right corner. The emulsion side of the film is now facing up.

Insert the sheet film into the two-hole punch and pull down on the lever. You now have two holes, appropriately spaced, in the unexposed dupe film. Feel for the pin registration assembly and put the punched film on the pins.

Pick up one of the masks taped to its corresponding color transparency (it doesn't matter in which order the masks are exposed) in one hand and the compressed air can or nozzle in the other. Blow the air on both sides of the masked image as well as the duplicating film lying on the registration pins. Now, place the masked image over the dupe film on the pins.

Pick up the one-eighth-inch-thick piece of glass at the edge, being careful not to get fingerprints on the portion that will lie on the film. Blow it free of dust with the compressed air. Place the glass over the two films on the registration pin assembly, apply gentle downward pressure on it, and hit the button on the timer to make an exposure.

Now, remove the glass and the masked image, keeping the dupe film in place. Pick up the mask that's taped to the other transparency, blow it clean, and place it on the registration pins. Lay the glass on top of the two films as before, press firmly to make close contact between the mask and dupe film, and make the second exposure.

Step 8. Remove the glass, take the second mask off the pins, and place the exposed duplicating film in the empty light-tight box for development either at home or at a custom lab. Then turn the room lights back on.

Make sure you put a label on the box, such as: One sheet of 4x5, process E-6, normal (normal means you're not pushing or pulling the film). And always seal the box with a couple pieces of tape to prevent anyone (including yourself) from accidentally opening the box and ruining the film.

Once the film is developed, analyze the results for color balance, exposure, and how well the two pictures fit together. The notes you keep will enable the entire process to be repeated if any aspect of it didn't work out to your satisfaction.

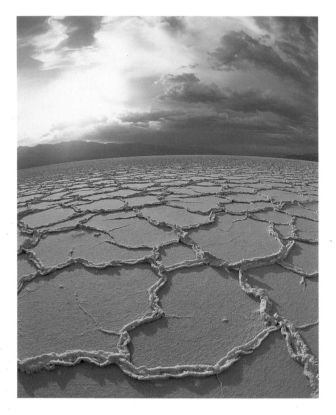

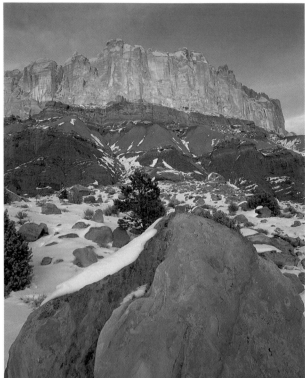

(Above left, above right) I started with a photo of the salt flats at Death Valley and a mountain scenic taken at Capital Reef National Park.

(Right) I duplicated the shot of Capital Reef onto normal slide duplicating film and then developed the dupe in C-41 chemistry made for negative films. This produced the complementary photographic colors you see here.

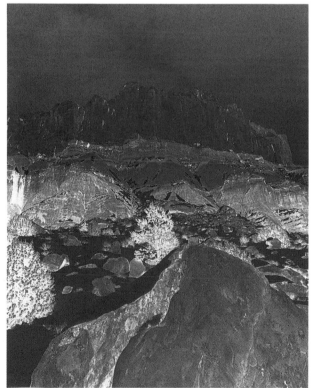

(Left) The image of the moon is really a styrofoam ball with plaster splattered on it to create "impact craters" that I photographed against black velvet with harsh side lighting to simulate the sun.

(Above) Using Kodalith high-contrast black-and-white film, I made a litho positive and a litho negative of the salt flats image to define the horizon line of the final composite. When I had finished the retouching and contacting, the litho master negative had a clear sky and black foreground, while the litho master positive had a clear foreground with a black sky. I punched both films with registration pins for exact placement of the horizon—where the blue mountains will meet the salt flat. This is crucial because the bottom of the mountains must be precisely placed against the salt flats or the photo won't look realistic.

(Left) I projected the various components with a darkroom enlarger onto 4x5 duplicating film. (This can be done with a simple slide duplicator and 35mm film, but you won't have as much control over the precise placement of the elements.) All three exposures were determined by previous testing.

For the first exposure, I sandwiched together the original salt flats shot and the litho master positive and placed them on the registration pins affixed in the enlarger and projected onto the duplication film.

Second, I sandwiched the blue mountains with the litho master negative and placed them on the same registration pins affixed in the enlarger and exposed onto the same piece of film.

Finally, I exposed the moon image into the sky without any litho mask at all.

Technical Data: Both the salt flats and the mountains were originally shot with the Mamiya RZ 67. For the mountains, I used a 50mm wide angle lens, and for the salt flats a 37mm fisheye lens. The mountains were taken with Fujichrome 50D at 1/125, f/5.6; the salt flats were exposed on Fujichrome Velvia using the same camera settings. The mountains in negative appear blue because they were photographed at sunset, and the complementary color for yellow is blue. I altered the color of the salt flats by dialing in a filter in the enlarger during the duping process.

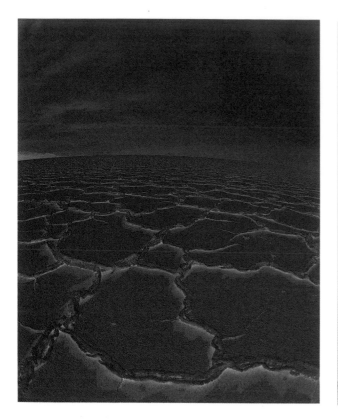

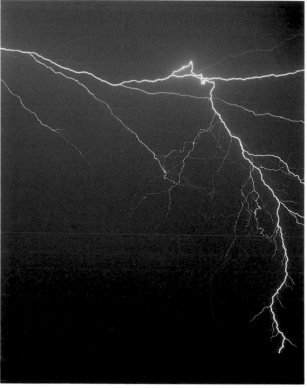

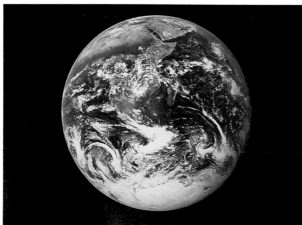

This composite consists of three pictures: Earth, which came from a free 8x10 print supplied by the Johnson Space Center in Houston, Texas; lightning, taken during the monsoon season of July and August in Arizona; and the salt flats of Death Valley, which I duplicated and then developed in C-41 to get the negative image.

The bottom half of the lightning and the top half of the Death Valley scenic (taken with a fisheye lens, which accounts for the curved horizon line) were masked off. The hemispherical Earth was inserted into the scene using another mask. This composite is a triple exposure.

The first exposure was a sandwich of the salt flats with a mask that was entirely black in the sky portion of the frame. I added 90 units of magenta on the dichroic color head.

The lightning with the other mask (black ground, clear sky) was sandwiched in register with a litho negative half-Earth (black Earth, clear film background). I made the half-Earth mask by taping a piece of black litho film across the Earth, obliterating half of it. I dialed in 45 units of magenta.

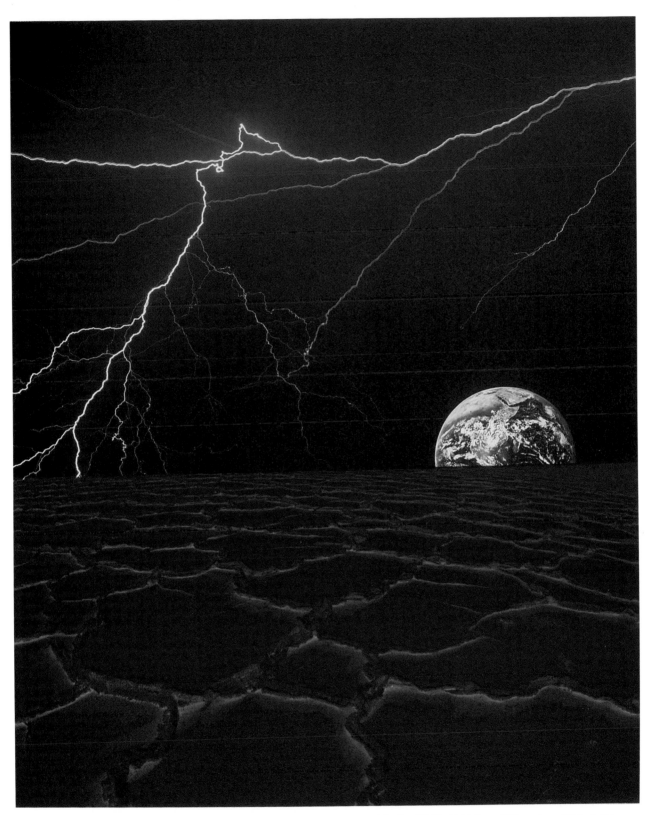

The half-Earth transparency was printed with the litho positive mask (clear Earth, all black background). Again, I taped a piece of black litho film across the transparency of the Earth, blocking out the bottom half, making it appear as if it is sitting on the horizon.

Technical Data: All original transparencies were photographed with the Mamiya RZ 67. Lightning—250mm lens, f/4.5, Fujichrome 50D. Death Valley landscape—37mm fisheye, 1/125, f/5.6, Fujichrome Velvia, duplicated and developed in C-41. The print of the Earth—copied with 110mm lens, f/16, Fujichrome 50D. The illumination was two Speedotron flash heads diffused with Photoflex white umbrellas.

Most of this book has been devoted to techniques for achieving many kinds of special effects. Those of you interested in going beyond creating special effects to successfully marketing your work should know that there is a vast potential for selling innovative and conceptual photography. This chapter explores markets for special effects images and the types of images photo buyers purchase.

Most successful photographers receive an assignment and then create images based on an art director's or editor's guidelines. For the most part, I have always done the opposite. I make photographs because I love the art of it, and then I look for the market. This is a more financially insecure route, but in the end it has proven to be far more rewarding. My artistic freedom has not been compromised and I still have made a very good living on doing what I love to do.

Your ability to sell your work will depend on your creativity in making images as well as your innovative approaches to marketing your work. In addition, it is important to be aware of the constantly changing trends in photography. Many of the special effects techniques that appeared in photo magazines in the late sixties and early seventies are considered old-fashioned today. Other effects often get recycled every twenty or thirty years. Ideas explored even as early as the forties have been revived. Keep abreast of these trends and your work will be sought after once you let photo buyers know that you're vying for a niche in the marketplace.

Markets for Special Effects Images

Advertising agencies, stock photo agencies, magazine and book publishers, calendar and paper products manufacturers, and newly developing outlets for multimedia imagery all use special effects images.

More and more often, photography is used less literally and more conceptually. It no longer is enough to show a product; the product must be shown in a setting that tells potential consumers something about it. For example, a computer monitor might be shown floating in space to show it's the product of the future. Abstracts can often be sold as backgrounds for a product or a slogan. A laser abstract could be used behind a new robotic device for industry or behind a group portrait of the cast of Star Trek (either generation).

The clever use of lighting or color or an intriguing juxtaposition of picture elements can imply excitement, adventure, love, and a host of other emotions that can attract viewers. A shot I did of an old attic was used on a Beach Boys compact disc cover. The picture was originally taken on black-and-white film, sepia-toned and then hand-colored.

Executing Specific Concepts

Whether you market your work to advertising agencies, stock photo agencies, editorial art buyers or directly to consumers, the special effects photographs chosen for publishing will either evoke an emotion or fulfill a concept. You must be able to show clients that you can think conceptually and produce a variety of appropriate images.

Let's look at how a marketable concept such as "stress" might be interpreted in a special effects image. Certainly one of the important challenges in the lives of many people is dealing with stress. Work situations, family problems, hard economic times, and the rising crime rate can generate a sense of frustration, helplessness or anger. This is not only a hot topic for popular magazines and books; many companies market products and services designed to help us handle our tumultuous lives. There are travel agents ("Relax in Hawaii"), health clubs ("Exercise that stress away"), mass transit services ("Avoid rush hour traffic; let us

drive"), and business consultants ("If we help your employees reduce their stress levels, they'll be more productive").

I wanted to create an unusual visual interpretation of the concept of stress. A friend had been experimenting with live plaster molds of faces and limbs, and I thought this suggested an interesting approach. I thought the clenched fists placed just under the mannequinlike face would convey the message.

Subliminal Messages

While many special effects images are used in situations that require brilliant color and strong lighting contrasts, there is also a demand for subtlety. Soft colors, muted tones and diffused lighting play an important role in projecting feelings of romance, peacefulness, charm, grace, love and beauty.

You can, of course, create beautiful subtle images with hand-coloring (see pages 36-45), but the easiest technique for creating a sensitive or moody image is using a fast film and pushing it two or three f/stops. The grain of the film is multiplied many times, and contrast is lowered significantly. The color becomes muted, appearing in some instances to be almost neutral. I prefer to use Agfachrome 1000 for this technique. For a picture of model Bonnie Rienstra posing in a forest clearing, I rated the film at 4000 ISO, pushing it two stops. The overall effect is similar to that achieved with a diffusion filter, but no filter was used.

You might want to experiment with using photograms to create soft, subtle images. Any object that is placed on photographic printing paper in the darkroom and then exposed to light will leave an imprint on the paper. (For more on working with photograms, see pages 34-36.) If you make a black-and-white photogram of a translucent subject such as a crumpled piece of sheer fabric or beautifully shaped maple leaves, you'll get a variety of shades of gray for a soft, subtle background. Color printing paper offers great creative potential when you have objects that are both colorful and translucent. Flowers are perfect subjects, because the enlarger's light passes through the thin petals and makes watercolorlike impressions on the printing paper.

I wanted to produce a shot that would show an original interpretation of the concept of "stress." I persuaded a friend who makes live plaster molds of faces and limbs to make a cast of my face and fists. It took us two evenings to work out the problems of making the cast—the biggest problem was making sure I would be able to breathe with the mold over my face. We finally chose to place a plastic straw in my mouth so it would project through the goo. The only drawback was the need to touch up the lips with a carving knife because the plaster molded around the straw, which pressed against the skin on my lips, leaving an unwanted mark on the cast.

I set up strong, directional lighting to photograph the three pieces because the harsh shadows and high contrast would fit the concept well. I placed a single, undiffused Speedotron flash head above and to one side of the face, creating the classic Rembrandt lighting (a triangle of light forms on one cheek and the shadow of the nose crosses the corner of the mouth below the triangle). The face and fists were resting on a piece of black velvet that was spread out evenly across the floor. I used velvet because it's the best material for absorbing light, and I didn't want even a hint of exposure anywhere around the plaster. If I had used black background paper instead, some detail would inevitably show in the paper.

Technical Data: Mamiya RZ 67, 110mm lens, f/22, Fujichrome Velvia, flash exposure determined by a Minolta Flash Meter IV.

Your work will sell well if you produce images that express a concept. The idea conveyed can be simple and familiar, such as a classic car jazzed up with a star filter, evoking feelings of nostalgia. It can be as exotic as a stylized tiger on the prowl, which says "power," "cunning" and "grace." The art director for *On the Prowl* was looking for something that visually represented that title. I showed him a normal picture of a tiger, but he preferred the conceptual version.

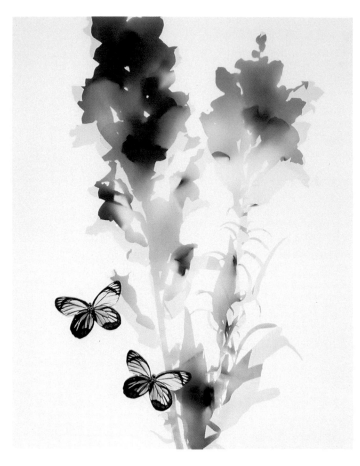

(Left) Photograms made on color printing paper produce beautiful images that resemble watercolors. Because they are both colorful and translucent, flowers are excellent subjects for photograms. You can make photograms even if you don't have a color enlarger. You need only the chemicals and paper. Precise color matching is not necessary, so just let the color emanate from the flowers or whatever else you want to place on the paper. Photograms can be used alone or as part of a photo montage with other picture elements (see pages 34-39 for a detailed discussion of this technique), as shown in this image, where I added the two butterflies.

Technical Data: The flowers were placed on an 8x10 piece of Kodak Ektachrome Type 22 color printing paper and exposed to light for 35 seconds. The flowers were not flattened but were allowed to rest naturally on the paper. I used a Saunders enlarger, a 75mm Rodenstock lens at f/5.6, and no filtration. The butterflies were printed from original slides, cut out, and laid on the 8x10 photogram and rephotographed. To copy the montage, I used a Mamiya RZ 6X7, 110mm lens, f/16, two Speedotron strobes diffused by Photoflex diffusion panels, and Fujichrome Velvia. The exposure for the copy was determined by a Minolta Flash Meter IV.

(Below) I took this shot of model Bonnie Rienstra posing in a Vermont forest clearing with Agfachrome 1000 film. I rated the film at 4000 ISO, which is a two-stop push. Note the softness in the picture even though Bonnie was surrounded by patchy sunlight. The highlights on her legs and hat have a slight flair to them, similar to the effect achieved with a diffusion filter, but no filter was used. The autumn foliage in the scene has little color and looks almost neutral.

Technical Data: Mamiya RZ 67, 180mm lens, 1/125, f/16, Agfachrome 1000 pushed to 4000 ISO, hand-held.

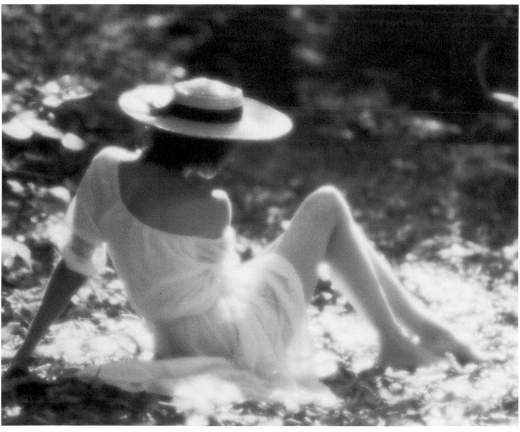

Geometric Shapes

The textbook market consumes thousands of pictures every year as new books are published. A single biology book, for example, could use a thousand photographs. One concept that is often requested, especially for mathematics books, is the geometric shape. If the book is to hold the students' attention, it must show squares, cubes, polyhedrons, parallelograms, trapezoids, spirals, spheres and paraboloids in an interesting way. Although these shapes can be shown by unaltered, literal photographs—a photo of a satellite dish shows what a parabola looks like—many abstract images are used as covers, chapter openers, or explanatory illustrations supported by text.

I wanted to submit an entire series of geometric shapes to my stock photo agency, so I challenged myself to come up with as many creative approaches as possible. For example, a textbook could use a simple, solid-colored square to show what a square is. But I thought a more exciting representation could be achieved if a colorful square were shown against a perspective grid. I chose this particular interpretation because the graphic elements of the picture are bold, and boldness often sells. Grids are used to represent high technology, infinity and space—ideas that are very relevant today—so I felt the grid would make the picture more appealing to the textbook market.

This unusual visual interpretation of a square was an easy shot to make. I purchased the background grid at an art supply store and placed a piece of shiny blue vinyl material on it. Then I took a picture of the design. (Note that not every special effects shot requires special techniques. Even though this is a normal shot, it falls into the category of special effects because of how it looks.)

Technical Data: Mamiya RZ 6X7, 110mm lens, f/16, two Speedotron flash heads diffused by Photoflex diffusion panels, Fujichrome Velvia. The exposure was determined by a Minolta Flash Meter IV.

The Future

The companies who design and manufacture the products that thrust us into the future need exciting imagery that symbolizes their forward thinking. High-tech products are generally promoted with unique, powerful, and often futuristic-looking images. A futuristic image is not necessarily just one with a high-tech, science fiction look; it can show how something ordinary might be done in an extraordinary way in the future.

There are several other markets for futuristic images. Magazine art directors often use such images, as do poster companies, corporate annual reports, trade show displays, and product packag-

ing. You can increase the profitability of your creative efforts by selling one type of image to several markets. For example, a motorcyclist flying over the moon could sell to Kawasaki as an ad, as a dynamic poster, and as the cover of its annual report. The concept behind the picture, of course, is that if you own this type of motorcycle, you can be and do anything.

In one image I created a stylized city skyline where the buildings are actually circuit boards. I felt this image could be used for an annual report cover, a full-page magazine ad, or even an enlargement for a trade show display.

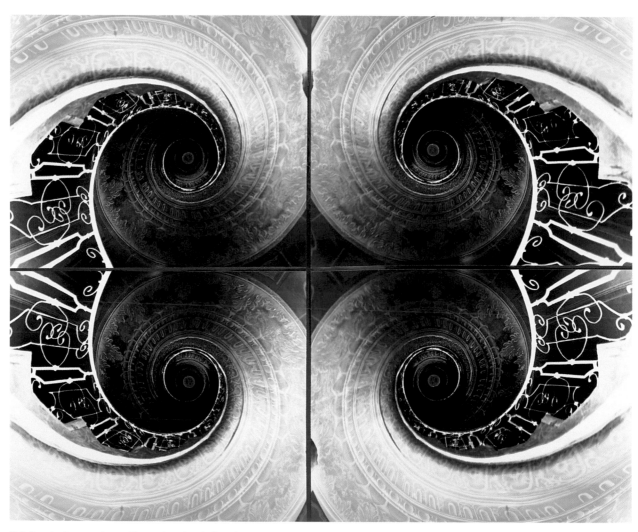

This is actually a montage of four prints. I took the original photograph of a spiral staircase in a monastery near Vienna with a fisheye lens. The design of the image was powerful; it reminded me of a nautilus seashell. I thought it could become an exciting addition to a collection of images portraying geometric shapes that I was working on.

I made a negative print from the transparency by placing the original in the enlarger and printing onto Type C (negative acting) color printing paper. I made two prints with the correct orientation, flipped the original in the negative carrier, and made two prints of it upside down. I carefully arranged the four prints into a symmetrical design and rephotographed the composite image. I used a thin strip of blue tape to hide the edges of the prints.

Technical Data: Mamiya RZ 6X7, 110mm lens, f/11, two Speedotron flash heads diffused by Photoflex diffusion panels, Fujichrome Velvia. The exposure was determined by a Minolta Flash Meter IV.

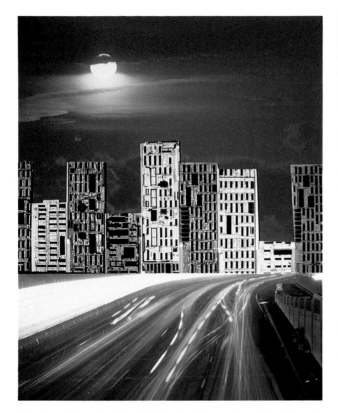

This is a picture of a stylized city skyline that consists of circuit boards. The composite image consists of three shots: the sunset, an arrangement of circuit boards, and freeway traffic at night. I borrowed the old boards from a computer repair shop with a fifty-dollar deposit to guarantee I would return them in usable condition. To get the rich color in the green boards, I positioned them on a glass coffee table and set up my strobe underneath for direct backlighting.

I used the technique of masking (see Chapter Seven for a step-by-step description of the technique) to combine the three images into a single photograph so perfectly that they would appear to have been together all the time. I assembled the three components with a positive and a negative litho mask of the imitation skyline. Pin registration kept the sky from intruding into the circuit boards.

Technical Data: All original components were photographed with the Mamiya RZ 67. The composite was made with a Saunders enlarger, a 75mm Rodenstock lens, and Kodak 4x5 Ektachrome Slide Duplicating Film 6121. I used my Unicolor easel to hold the dupe film.

The crescent Earth suspended above a doorway was created as a conceptual image for a multimedia presentation. The idea of "looking toward the future" or "expanding your vision" was used as the dominant theme in a corporate motivation series. Fast-paced, visually stimulating multiple slide projector presentations run by computers are a big business today. The firms that subcontract to large corporations sometimes have their own in-house staff who create the storyboards and imagery used in the shows, but they also use outside talent. When a photographer is an idea person as well as an image maker, art directors appreciate the creative input. They will often go out of their way to use it.

Technical Data: The 8x10 print of Earth was obtained free of charge from the Johnson Space Center in Houston. I copied the print onto slide film and then covered a portion of the Earth with a black circle I had cut out of paper. The crescent Earth was one of the components of the final image.

The doorway was originally a photo of a church door. I made a litho negative of it and sandwiched a sunset through the door. This sandwich was then double exposed with the crescent Earth using a Saunders enlarger, 100mm Schneider lens, and Kodak 4x5 Ektachrome Slide Duplicating Film 6121.

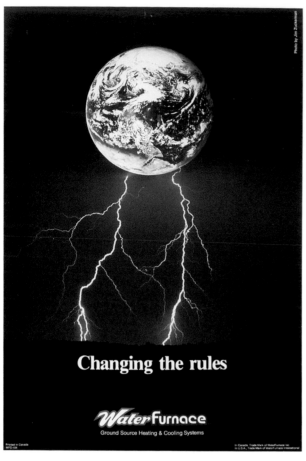

Changing the rules

*Water*Furnace

Ground Source Heating & Cooling Systems

This picture was originally published in *Petersen's Photographic Magazine*. I was contacted by Water Furnace, a Canadian firm involved in renewable energy resources. They wanted to use the shot as a promotional poster, which you see here.

Technical Data: Lightning—Mamiya RZ 67, 250mm lens, f/4.5, tripod. The shutter was open that night until the bolt discharged, and then it closed. The Earth is the same photo from the Johnson Space Center seen elsewhere in this chapter. I made the double exposure with a Saunders enlarger with 75mm Rodenstock lens, 10 seconds at f/11.

The Advertising Market

Advertising agencies make up the largest market for special effects images. Ad agencies must develop eye-catching advertisements that capture the attention of consumers to promote everything from million-dollar computer systems to ten-dollar plumbing fixtures. To stand out from the rapidly increasing crowd of similar ads, many agencies choose special effects images to attract attention.

Art directors at advertising agencies use photography to express in visual terms the concepts they want to get across to the public. For example, an art director recently commissioned a kaleidoscopic image from me to express the concept of "brilliant color." An image of lightning emanating from the earth attracted the attention of a Canadian company involved in solar energy and natural heat recovery systems. To them, it implied that our planet is full of renewable energy.

The Editorial Market

Many publications use special effects photography to draw attention on newsstands and in bookstores. Both brilliant colors and unusual imagery are often requested specifically to grab the consumer's eye as it scans the scores of covers on the racks.

Magazines that are available on newsstands are especially open to new cover ideas that will make their publications stand out in the public's eyes. The strength of the cover has considerable impact on monthly sales. One magazine that frequently uses my work has told me that it has experienced as much as a 20 percent variation in newsstand sales between two consecutive months.

Cover art usually serves as a lead-in to a feature article in the magazine, so some magazines are more likely to use special effects than others. Publications in the fields of science, medicine, psychology, computers and art are prime candidates, as are publications dealing with any New Age subjects. Business and finance magazines also use conceptual shots to illustrate their lead stories. For example, they might show a man in a twentieth century business suit marching through an alien landscape (created in the darkroom with C-41 chemistry and multiple exposure) as a lead-in to an article on a rapidly changing market.

MetroColor. Endless Possibilities.

Like the versatile kaleidoscope that produces colorful combinations, the Goss MetroColor is the press for virtually unlimited color, anywhere you want it. Goss stacked couple technology, pioneered and perfected in the pressroom, makes color possible and affordable. Because MetroColor is compatible with Metroliner, Metro-Offset, and Headliner Offset presses, training press and maintenance crews is easier, and startup time and costs are reduced. MetroColor also means that the configuration you choose today can be changed tomorrow. MetroColor. The possibilities are endless. Rockwell Graphic Systems - The Americas, Rockwell International. Phone: 1-708-850-5600. Fax: 1-708-850-6310.

Rockwell International

...where science gets down to business

RM2-GNA-21363
MetroColor Spread Ad
Rockwell Graphic Systems
Prepared By:
Bozell/Detroit
313/645-6170

I recently sold this kaleidoscope picture to an agency hired by Rockwell International to promote a new multimillion-dollar printing press that prints newspapers in color. Rather than show a photograph of the huge press, the art director persuaded Rockwell to show an image that embodied the concept of "brilliant color." I was hired to produce an image that was identifiable as being taken through a kaleidoscope and asked to show specific colors, including the shade of blue in Rockwell's logo.

I built a kaleidoscope and took about 200 pictures to offer my client a large variety from which to choose. The decision makers liked my work so well, they changed their concept to buy two shots instead of one.

They elected to run the two pictures in consecutive months in a trade journal for the printing industry. As you can see here, it was indeed ablaze with color to attract the attention of the readership.

Technical Data: I made the kaleidoscope of three front surface mirrors (see pages 55-58 for more on how to do this) and used the Mamiya RZ 67 with a 50mm wide angle lens to photograph colored paper in a studio. I used two Speedotron strobe heads without diffusion, and determined the exposure by tests on Polaroid film. (The Mamiya RZ accepts a Polaroid film pack.) The lens aperture was f/11. Fujichrome Velvia accentuated the color.

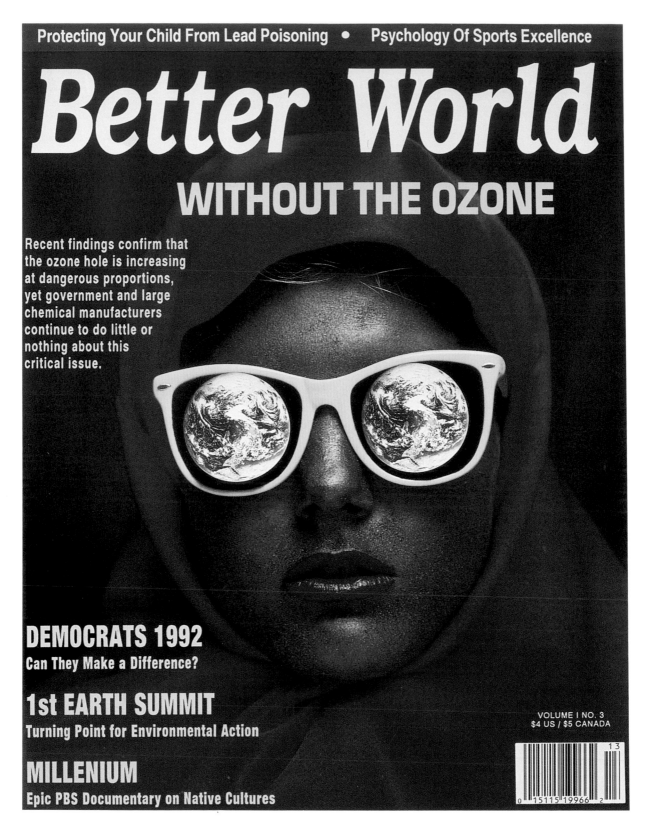

Better World

WITHOUT THE OZONE

Recent findings confirm that the ozone hole is increasing at dangerous proportions, yet government and large chemical manufacturers continue to do little or nothing about this critical issue.

DEMOCRATS 1992
Can They Make a Difference?

1st EARTH SUMMIT
Turning Point for Environmental Action

MILLENIUM
Epic PBS Documentary on Native Cultures

VOLUME I NO. 3
$4 US / $5 CANADA

13
0 15115 19966 2

I sold this rather bizarre picture to *Better World* magazine to complement its lead article on the destruction of the ozone layer. The model was painted with a blue makeup and she wore a bright red piece of fabric pulled tightly over her hair. To enable me to multiple expose the Earth in each side of the yellow glasses, I carefully cut a piece of black velvet to fit each lens and glued the material in place.

Technical Data: Portrait of the model— Mamiya RZ 67, 110mm lens, f/11 with a single portable flash head, undiffused. The image of the Earth is the same one used in the picture of the Earth and the door on page 123. Triple exposure—Saunders enlarger, 100mm Schneider enlarging lens, Unicolor easel, Kodak 4x5 Ektachrome Slide Duplicating Film 6121.

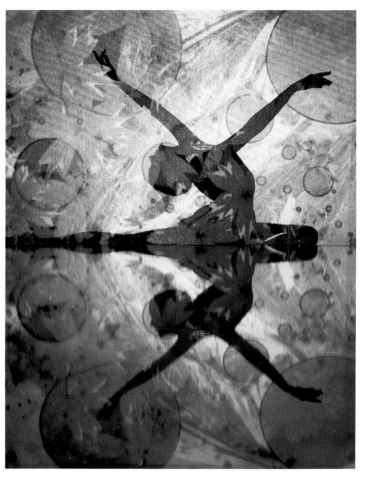

Articles in magazines usually feature a strong image as a lead-in to stimulate interest in the subject at hand. This shot was created for an editorial piece on multiple personality, but the story was canceled and the shot never used.

Technical Data: Original portrait—Mamiya RB 6X7, 180mm lens, 1/60, f/8, available light, T-Max black-and-white film. I made two identical litho positives and sandwiched them back to back. The texture and color come from a textured art paper sandwiched with the high-contrast double portrait.

Several national photography magazines are published in this country as well as in Europe, Australia and Japan. Many how-to articles are required every month to fill their pages with interesting material. If you can write, or if you can team up with a writer, you'll find that it's not difficult to get published. This image was reproduced as a full page in *Petersen's Photographic Magazine*, along with a detailed description of how it was made.

Technical Data: The original photo of the dancer was converted to a high-contrast image on litho film and then sandwiched with a microscopic image of the chemical hippuric acid. I then projected this sandwich onto a rear projection screen and rephotographed with a mirror placed against the bottom of the screen. All shots were made with the Mamiya RZ 67. Both the dancer and the rear projection shot were taken with a 127mm lens. The sandwich was copied onto Kodak 4x5 Ektachrome Slide Duplicating Film 6121 1:1, meaning that the size of the dupe image equaled the size of the original sandwich, which was 6x7cm. (I always make two 6x7s on a 4x5-inch piece of dupe film to save money.) I then projected this copy onto the rear projection screen with a Linhof 6x7 projector and photographed the copy with the mirror.

Sometimes the tie-in is not clear. I sold a picture of a woman with a blue face wearing yellow-rimmed sunglasses with the Earth superimposed in each lens to *Better World* magazine to complement its lead article on the destruction of the ozone layer. Perhaps the magazine editors liked the metallic blue skin of the model, implying what may happen if we continue destroying this fragile protective layer that encircles the Earth. For whatever reason, the editors loved the shot, which has been well received in the market, too. As a result of many people seeing that image, I've received several calls from other companies wanting me to produce special effects images for them.

Book covers also use special effects images. Although some of these involve computer-generated images or special printing techniques (holograms, for example), science fiction novels, computer software books, photography books, mysteries, children's books, even romances can use images created with multiple exposures, sandwiches, hand-coloring and other common techniques.

The Fine Art Market

Fine art photography is seen on posters, calendars, greeting cards, postcards and framed prints. Much of what you see features conventional imagery. But this doesn't mean special effects images won't sell in this market. A clever concept involving special effects could become an image for an entire line of paper products. Perhaps you could produce a body of work using nature as the theme, but your images would be imbued with ethereal, pastel colors from hand-coloring or have a soft, dreamy quality from heavy diffusion and grain. If you march to the beat of a different drummer, you could develop a group of wild and zany shots to target the humor market. Your photos could present crazy take-offs on nursery rhymes. "The cow jumped over the moon" and "three blind mice" could be done with photo montage as illustrations for greeting cards.

Remember, many images that appear to be realistic may be special effects images showing what could have been. With sophisticated darkroom skills, you can do virtually anything without leaving a trace. A photo that shows white horses running through a river with gorgeous mountains in the background may include mountains that were taken from another transparency. A romantic couple in clothes and hairstyles from the 1940s are shown kissing in front of the Eiffel Tower—but both images were shot on separate pieces of film in the 1990s. At the other end of the effects spectrum are images that look more like paintings or illustrations than photographs. Both have a place in the fine art market.

Stock Agencies

Since images in the files of a stock agency can sell for virtually anything, there are no specific guidelines to follow. There are no art directors sketching a layout design for you, no product or service to direct your creativity.

The most successful special effects pictures submitted to a stock agency must be able to fit into several different concepts. I have created spacelike images that could be used to communicate any of these ideas—space exploration, zero gravity manufacturing, extra-terrestrial life, the future, high technology ahead of our time, adventure, brilliant ideas—for any type of editorial piece, advertisement, multimedia presentation, trade show display, movie poster, packaging of an electronic game, or cover of a futuristic science fiction book.

It is also quite possible that one of the these shots could end up being used in a way that hadn't even occurred to me. For example, last year one of my composites of lightning and storm clouds ended up in a brochure promoting a new company that manipulates images by computer. Their megabuck computer couldn't retain the subtlety in a lightning glow when it was combined with clouds, so they used one of my stock photos. I never would have thought that I could do something in my darkroom that a sophisticated computer couldn't handle. But when you submit pictures to a stock agency, anything is possible.

Paper companies are firms that produce and market greeting cards, calendars, posters, designer pads of paper, and dozens of other products. They use a large variety of images. A significant number of them could be described as ethereal in quality—soft colors, perhaps a light texture, and combinations of hues that evoke a mood. Floral subjects are used over and over again in countless ways, so I created a line of pictures that would fit in with the psychology of this market.

Technical Data: To achieve the pastel qualities of this flower, I photographed it onto Fujichrome Velvia and had the lab develop the film in C-41 chemistry, giving me a negative image with the comple-mentary colors of what I saw with my eyes. I then sandwiched a home-made black-and-white texture with the flower and copied it onto dupe film, but I overexposed the dupe to convert the saturated negative colors into pastel shades. Flower—Mamiya RZ 6X7, 110mm lens, #1 extension tube (to enable me to focus closely), 1/15, f/11, tripod. Texture—piece of burlap shot with Tri-X black-and-white film. The actual 6x7 black-and-white negative was sandwiched with the flower when the dupe was exposed. I made the duplicate using the Saunders enlarger, 75mm Rodenstock lens, 15 seconds, f/8.

(Right) A frequently used image in both editorial and advertising is the Earth. For a unique, creative rendition of our planet, I combined it with a perspective grid and lightning. The lightning bolts suggest energy, which is much in the news today, and the grid implies the future.

Technical Data: I drew the perspective grid by hand on poster board and then photographed it using litho film. The litho film was originally a 4x5 sheet, but I cut it in half under a red safelight and placed one piece in an empty Mamiya RZ film back. I used a 110mm lens. (This can also be done easily with a 35mm camera.) My lighting for the poster board was only a single photoflood. When this single piece of film was developed, I had a litho negative: white lines, black background.

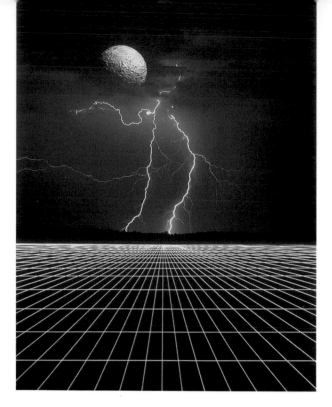

The lightning is the same used in the image shown on page 97. The Earth is the same shot from the Johnson Space Center that has already appeared in this chapter. The composite was a straightforward triple exposure onto Kodak 4x5 Ektachrome Duplicating Film 6121 with my Saunders enlarger, 75mm Rodenstock lens, f/11. Both the Earth and lightning were exposed with the normal filter pack and a 10-second exposure, but for the grid exposure I dialed in an additional 90 units of yellow. This forced me to increase the exposure time to 20 seconds, since 90 units of color on my enlarger equals one f/stop loss of light.

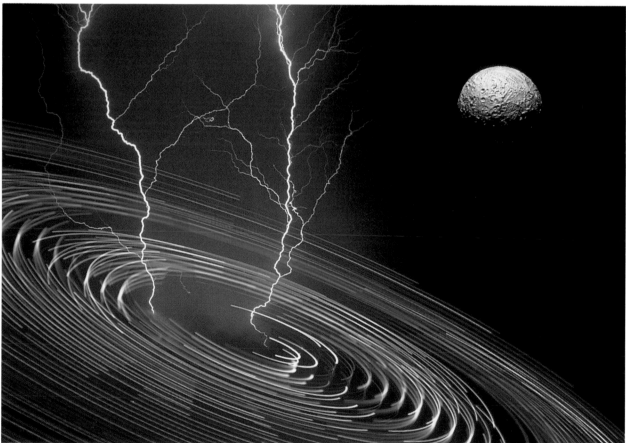

New frontiers in modern technology are often associated with space, so I've produced a number of images that graphically illustrate this concept. I use laser abstracts, streaks of light, pinpoints of light for stars, simulated planets, perspective grids and lightning.

Technical Data: Circular pattern of light streaks (shot of an illuminated ride at night in a southern California amusement park)—Mamiya RZ 67, 110mm lens, 10 seconds, f/8, Fujichrome 50D, tripod.

Lightning—Mamiya RZ 67, 250mm lens, f/4.5, shutter opened at night until the bolt discharged and then closed, tripod. Planet (12-inch styrofoam ball that was plastered to imitate impact craters and photographed against black velvet with strong sidelighting from a single photoflood)—Mamiya RZ 67, 110mm lens, 1/8, f/16, Fujichrome 50D (daylight-balanced film was used with tungsten illumination to produce a warm color), tripod.

When I travel, interesting artifacts that have the potential for stock photographs usually find their way into my suitcase. This beautiful mask was purchased in Venice, Italy. I thought it could work for several types of sales. I could see it as the lead picture for an article on masks, on Venice, or on Italian craftsmanship. It could also sell as an eye-catching ad for an airline that flies to Italy. Although the artistry in this leather mask was superb, I took the original studio photograph of it through several manipulations until it was striking in both color and dimension and then submitted it to my stock agency.

Technical Data: The mask was originally photographed on sand with a Mamiya RZ 67, 110mm lens, 1/125, f/8, Fujichrome Velvia, available light. The original transparency was then printed onto Kodak 4x5 Ektachrome Duplicating Film 6121 that was developed in C-41 chemistry, producing a negative transparency with complementary colors to the original. I then sandwiched the original with the negative copy and taped them together in register. That's why the image looks both positive and negative. This was then printed onto dupe film with heavy green filtration (90C, 110Y). An 8x10 print was made of the green mask, and I then used watercolor paints to make the eyes blue and to color the details around the eyes magenta. A final transparency was made by copying the 8x10 print.

The type of abstracted colors seen in this manipulation of a Chinese tiger tapestry was more common in the late 1960s and 1970s, but the image is still relevant today. My stock agency, through subsidiaries in Hong Kong, Singapore, Seoul and Tokyo, makes a large number of sales to companies in Asia. Hence, I created this strong, challenging tiger for both editorial as well as commercial use in the emerging Pacific Rim market.

Technical Data: The original photo of this tiger is an image on a tapestry. I made a duplicate of the slide onto Ektachrome 64 (I didn't use dupe film because I wanted a gain in contrast for drama), using an inexpensive 35mm on-camera duplicator. The dupe was developed in C-41 chemistry to get a negative transparency. I then sandwiched the original with the negative copy and rephotographed the combination on Fujichrome 50D rather than dupe film. Canon F1, 100mm macro lens, f/11, Vivitar 285 on-camera flash, Fujichrome 50D.

Index